KIND OF
A BIG DEAL

KIND OF
A BIG DEAL

How *Anchorman* Stayed Classy and

Became the Most Iconic Comedy of

the Twenty-First Century

SAUL AUSTERLITZ

DUTTON

DUTTON

An imprint of Penguin Random House LLC
penguinrandomhouse.com

Copyright © 2023 by Saul Austerlitz

DUTTON and the D colophon are registered trademarks of
Penguin Random House LLC.

All insert photographs courtesy of Debra McGuire unless otherwise noted.

LIBRARY OF CONGRESS CATALOGING-IN-PUBLICATION DATA
has been applied for.

ISBN 9780593186848 (hardcover)
ISBN 9780593186862 (ebook)

Printed in the United States of America
1st Printing

BOOK DESIGN BY KATY RIEGEL

To Gabriel,

the top story in my world

Contents

Contents

Author's Note

THIS BOOK FEATURES more than sixty new interviews with cast and crew members of *Anchorman* and others, including director and cowriter Adam McKay, and star and cowriter Will Ferrell, as well as previously published interviews and reporting. In making use of unpublished material, including early versions of scripts, I have chosen to standardize spelling and punctuation throughout. All mistakes, of course, remain my own.

KIND OF
A BIG DEAL

Introduction

EVERY JANUARY, I welcome a new group of students to my classroom at New York University. After the preliminaries and icebreakers and perfunctory reading of syllabi, I slide open the tray of the classroom's DVD player and slip in a disc. And every year, when the DVD arrives on its landing screen and the students realize what movie we will begin our journey together with, I am greeted by an admixture of cheers, groans, and puzzled silence that never ceases to fascinate and surprise me. But before I get to the responses, I suppose I should explain myself.

One of the great and all-too-rare pleasures of teaching is to watch a student reconsider an opinion or impression that they held without knowing precisely why they held it. I show *Anchorman* that first week of Writing About American Comedy to dive into the deep end of a debate we have been collectively having in American culture for decades about the meaning, import, and value of comedy.

I put on *Anchorman* and ask my students to watch it with an eye to how they might put the movie in context. We watch together, and

then in our discussion, their initial confusion—why is the professor showing us this silly movie?—is sometimes overcome. We settle into the story of the wildly popular San Diego newscaster Ron Burgundy (Will Ferrell)—who surpasses no one in his fawning self-love—and the ways in which his world is changed, and threatened, by the arrival of his colleague and future love interest Veronica Corningstone (Christina Applegate), and a nearly infinite array of themes and subthemes reveal themselves: the rise of second-wave feminism, masculine fragility, media satire, the grown-up Peter Pan protagonists of so many comedies of the early 2000s.

We put our heads together and begin to talk about Will Ferrell as a cultural phenomenon, about the conjoined nostalgia and mockery of comedic depictions of the past, the influence of *Saturday Night Live* on American culture in the last five decades, the feminist impulses of Veronica Corningstone, the ways in which the film asks us to laugh at Ron Burgundy's odious antics while also holding him at a notable distance, and I can sense a new path of inquiry opening up for (at least some of) my students. But before we can get to discussing any of those topics, we must first wrestle with an unavoidable reality of *Anchorman*: It is really fucking funny.

OF ALL THE film's scenes, the one that often prompts the most classroom discussion comes when Veronica confronts Ron in the newsroom, prompting the two newscasters to trade barbs, and Ron to reach deep into his store of misogynistic insults in an effort to hold Veronica at bay.

The confrontation begins slowly. Ron Burgundy has commandeered the office VCR to study clips of his Emmy speeches from

years past, pressing a lowly underling into a likely unwanted role as polisher of his rhetorical trophies. ("Turn the music off! I'm still talking!" a profoundly agitated Ron shouts at the orchestra as they attempt to play him off. Ron watches himself and murmurs, "I don't even remember doing it.") Ron's ego parade is keeping Veronica from her work, and she hovers in the background as Ron stares lovingly at his own on-screen image.

They begin to argue, and Ron escalates the conflict. From his perspective, Veronica is not merely a workplace rival but the embodiment of all threats to masculine authority everywhere. "I'm not a baby. I'm a man." (Not something you want to have to say out loud.) "I am an *anchor*man!" Hidden inside Ron's retort is the belief that an anchorman is the highest form of man, man at the peak of perfection. "You are not a man," Veronica retorts. "You are a big fat joke!"

Here is where Ron gets weird, and where we get our first deep insight into the uglier crevices of his caveman brain. Ron is ridiculous, but we also see here just how harmful he can be when his masculine privileges are questioned. "I'm a man who discovered the wheel and built the Eiffel Tower out of metal, and brawn," he brags. "That's what kind of man I am." The course of human history has been compressed into two singular accomplishments, each called to represent a kind of ingenuity and muscularity that Ron defines as masculine. Ron is a man with a nice head of hair and a gorgeous blue suit and little more but has rendered himself the inheritor of all human accomplishments throughout history. Moreover, he has craftily edited women out of this tale. History is the story of great men and their accomplishments. Ron places himself at the tail end of this potted history, standing poised to reap the bounty of all human accomplishment and accept it on behalf of men and men alone. (It is telling that earlier in the film, Ron says, in response to Champ's

[David Koechner] not knowing the definition of the word *diversity*, "I believe that diversity is an old, old wooden ship that was used during the Civil War era," with Brick [Steve Carell] nodding along to every word.)

Ron's heated claims are silently undermined by the presence of a poster of what looks like Veronica herself, blurred but clearly visible over his left shoulder. The image gives the scene the feeling that Ron is arguing not only with the real Veronica but with an apparition or an invisible presence as well. Veronica has rattled him, and his men's-rights temper tantrum is perhaps the result of her having taken up residence, rent-free, inside his mind.

By now, Ferrell has dropped his right eyebrow. Ron Burgundy is about to lower the boom. "You're just a woman with a small brain. With a brain a third the size of us. It's science." Ron jerks up the side of his mouth at *us*, with a what-can-you-do shrug to accompany it. He shakes his head and tilts it disparagingly at Veronica at *It's science*, his body language telegraphing his just-the-facts misogyny. In this moment, Ron channels every threatened masculine underachiever, forced to lean on others' accomplishments in the hopes of feeling better about himself. He is speaking to an audience that he conceives of as being solely other men; note the *us*, with its implicit drawing of gendered sides for this playground brawl.

Veronica is our ally here, taking the blows of a cruel world and fighting back on our collective behalf. Veronica understands the terms of their debate and is frustrated with Ron's intransigence. "I will have you know," she begins, "that I have more talent and more intelligence in my little finger than *you* do in your entire body, sir!" Veronica raises her pinkie when she says "little finger," and while her comments are ostensibly devoted to her talent and intelligence, one cannot help but see the ghost of a schoolyard taunt. Here is

Veronica's representation of Ron's body, or to be precise, one particular part of his anatomy, and her depiction is not flattering.

While Ron ranges the course of history and biology to come up with his factually challenged assaults, Veronica cuts to the chase. Her hastily appended *sir* does not do much to dampen the force of her blow, and Ron and Veronica exchange a series of rapid-fire insults: "You are a smelly pirate hooker." "You look like a blueberry." "Why don't you go back to your home on Whore Island?" Ron's cheek quivers on *pirate hooker*, and Veronica similarly trembles on delivering her line. It is telling that Ron's insults circle around the same idea: that the polished, self-confident Veronica is some kind of prostitute, selling herself for money. Men are their accomplishments, and women are nothing more than their bodies, to be purchased by men at their leisure.

Ron's insults are cruel but also creative and, in the context of the movie, quite funny. They are also relatively generic. Ron is resorting to the epithets favored by every thin-skinned man convinced any woman who does not favor him must be lowly and despicable. They can be reused for any woman, while Veronica's are personal and targeted. She is responding to his blue suit (which is truthfully quite striking), not to some platonic ideal of men's suits. But after being called a hooker and a whore, Veronica wheels in the big guns. She knows it, too, as witnessed by her pausing midway through, assessing whether she really wants to say it: "Well, you . . . have bad hair."

Veronica raises an eyebrow once she finishes, as if to silently ask Ron what he thinks of that. It was bad enough when Veronica was insulting Ron's manhood; now she is reaching into the core of his being, the most precious part of his anatomy, and seeking to tear away a chunk of his self-esteem. Ron is rattled. He furrows his brow in disbelief, and his voice drops to a whisper: "What did you say?"

"I said your hair looks *stupid*." Veronica dances closer to him with each word, relishing the realization that she has, at last, found Ron's weak spot.

We cut to an ultra-close-up of Ron's eyes, in which twin nuclear explosions detonate. His eyes look like two fiery comets skidding through space, and as they explode, Ron shrieks, seizes Veronica by the shoulders, and sends her flying over the desk, knocking over an array of office supplies. "Let 'em work it out," Champ shouts, holding back the crowd, and Brian (Paul Rudd) agrees: "It's between the two of them." Veronica staggers upright, grabs a typewriter from the desk, and flings it at Ron's head, then leaps off the front ropes of the desk and pile-drives Ron to the ground. Veronica reaches into her purse and sprays Ron with Mace, then grabs an antenna off the television set and whips him with it. Ron grabs the canister of Mace but only succeeds in spraying himself once more. (In an alternative version of this scene, which did not make it into the final cut of the film, Ron asks Veronica to marry him and sings to her as she beats him mercilessly.)

ALL THIS CASUAL cruelty raises a question that might feel somewhat peculiar within the pages of a book devoted to the subject: Just why do people like *Anchorman*, anyway? The simplest answer is to merely reiterate the obvious. *Anchorman* is a comedy, and a very funny one at that, and people enjoy the prospect of laughing at high-quality jokes.

Having established that, let's try poking at the dirt a bit more. People love *Anchorman* because it offers viewers a comically twisted sense of superiority. Ron Burgundy and his colleagues are boorish,

sexist dolts, too clueless and self-involved to even realize how offensive they are.

Every generation likes to believe itself the first to ever be truly enlightened. Revisiting the past, especially in a comedic vein, offers the distinct pleasure of laughing at the limitations and blind spots of the past. (Cue the New Testament quote about the mote in your brother's eye and the beam in your own.)

Ron Burgundy is a clownish mascot for the bad old days, when men were men and men were obnoxious blowhards. Haven't we all advanced so far since the time when any of this behavior was acceptable? *Anchorman* asks us.

A great deal of preparation went into filming the scene. Applegate and Ferrell reviewed what each of them would do to the other and made sure that they were comfortable with the physicality of the scene. They also rehearsed it extensively, with Applegate making use of a foam-rubber typewriter to launch at Ron's temple.

Ron's fabled masculine brawn, inherited from those bygone builders of the Eiffel Tower, serves him well at first, but by the time Ed (Fred Willard) arrives to break up the fight, Ron is red-faced and breathless, having been literally whipped by Veronica. It is symbolically fraught, as well, that the weapon Veronica seizes is a TV antenna. (In the original script, she reached for a curtain rod.) Ron is being humiliated with the very tool of his chosen profession, the metal that connects him to his beloved viewers. Veronica has seized control of the antenna and is using it to publicly thrash him.

EVERY YEAR, I show *Anchorman* to my students at NYU, and every year, it feels like a subtly different film. Annual rewatches make for

a fascinating scientific experiment, and each visit with *Anchorman* is affected by events in my own life and in the world at large: the election of blatant misogynist Donald Trump as president, the rise of the #MeToo movement. We are forever adjusting our response to the movies we love, calibrating our reactions and finding ourselves changed by our experiences—personal and collective—each time we arrive again.

If I feel a bit iffier about a handful of *Anchorman*'s jokes than I once did, I also feel more secure in the knowledge that *Anchorman* arrived here first, considering questions of toxic masculinity, emotional sadism, and culturally approved cruelty long before the culture at large did.

We develop special relationships with the comedies we love. We watch them over and over again. We select favorite scenes that we force our friends or our children (or our students!) to sit through as we cackle heartily. We quote them in casual conversation and use them in our Twitter bios and our email signatures. We imagine ourselves into their spaces. We make them our own. We even take umbrage with their missteps and failed attempts at humor.

A good comedy is like a magic trick. A great comedy is like actual magic. It is to start with nothing and create something that might ease the burdens of others for a brief, wonderful moment. It is to bring a group of talented people into a room with nothing more than an idea and emerge with a work of art that will convince a roomful of people to temporarily set their troubles aside and laugh.

Of all the comedies of the past twenty years, *Anchorman* is perhaps the one with the most dedicated fan base, still able to quote vast swaths of the film's script by heart. It is that rare movie able to get fans to snicker at the mere thought of, say, Ron Burgundy's pre-

broadcast vocal warm-ups ("The arsonist has oddly shaped feet") or Brian Fantana donning the foul-smelling Sex Panther cologne. *Anchorman* is the film that, more than any other, has defined the course of twenty-first-century comedy to date.

Anchorman is the product of two *Saturday Night Live* alumni with a gift for improvisational comedy and a yearning to create a ludicrous ode to the newscasters of their youth. What began as a screenplay about plane crashes and cannibalism turned into a story of roiling misogyny and professional jealousy in the hothouse world of local television reporters; and what started as an oddball film crammed onto the 2004 release calendar transformed into one of the most acclaimed and beloved comedies of its time.

To properly tell the story, then, we must start at a particularly chaotic moment in the nearly fifty-year-long history of *Saturday Night Live*, when a disastrous season had led to a wholesale turn-over of the show's cast and writers. Two young men had been brought in as fresh blood for *SNL*: one a veteran of the Chicago improv- and sketch-comedy scene with a penchant for letting his routines drift wildly out of control, and the other a performer from Los Angeles with a deceptively milquetoast appearance and a willing-ness to give every joke, no matter how inconsequential, his utmost. They would meet for the first time at 30 Rockefeller Plaza in the fall of 1995.

PART 1

Let the Games Begin

CHAPTER 1

Blowout

EVERY FEW YEARS, the headlines would recur. "Saturday Night Dead," they would crow, sure that now, at long last, the venerable sketch show had reached a nadir from which it could not possibly recover. By the mid-1990s, there had already been a few such phases for *Saturday Night Live,* with perhaps the most famous being the post–Eddie Murphy doldrums of 1984–85, in which Harry Shearer had quit the show midseason and writer Larry David, still nearly a decade away from becoming a household name with *Seinfeld,* loudly tendered his resignation to showrunner Dick Ebersol (during the brief interlude in which *SNL* creator, Lorne Michaels, was not involved with the show) and then, rethinking his rash decision, slunk back to work the following Monday as if nothing had happened.

For the 1995–96 season, a new roster of performers, including Darrell Hammond, Jim Breuer, Nancy Walls, David Koechner, and Will Ferrell, rebooted *Saturday Night Live* after the departure of stars like Mike Myers and Adam Sandler and a dispiriting previous incarnation featuring the likes of Janeane Garofalo (who also quit

the show midseason) and Chris Elliott. Who were these strangers, and what had they done with *Saturday Night Live?*

It's inevitable, on entering a new workplace, to quietly assess your new coworkers. The early verdict on new repertory player Will Ferrell was that he was undoubtedly going to be the dud of the new class. New writer Harper Steele thought he looked like a frat boy, stiff and almost aggressive in his plainness. There were quiet conversations among the new writers and cast members about what he was doing there. Surrounded by potentially exciting new talents, Will Ferrell was not going to be able to keep up. In this cast of nobodies, Ferrell was dismissed as the biggest nobody of all.

Adam McKay spotted Ferrell at one of the first gatherings of the new cast and assumed that he was present to be the straight man, there to offset likelier stars. But it took only the first read-through for McKay to realize how mistaken he had been. This unassuming-looking doofus was capable of anything, and soon writers were all competing to pen sketches for Ferrell, the breakout star of the new *Saturday Night Live.*

COMEDY, WE MAY have heard before, is often a byproduct of trauma. Experiencing pain and inner torment, comedians transmute their experiences into humor. There are exceptions to every rule, and Will Ferrell is that exception. Ferrell grew up in Irvine, California, the spiritual heart of rock-ribbed Republican Orange County. As he would later describe it, he had "no interesting demons."

From a very early age, Ferrell knew one thing above all: that he had absolutely no interest in performance as a career. His father, a musician with Dick Dale and the Righteous Brothers, had an un-

stable career, and Will told himself that when he was an adult, he would have a steady job and purchase a house.

After his parents divorced, Ferrell lived with his mother, Kay, an English graduate student who would become a community college teacher. An Orange County upbringing instilled Ferrell's lifelong "love of suburban, lame white people," as he would later describe it. Without his even being aware of it, Ferrell was training as a suburban sociologist let loose in the homeland of "white male American jackasses"—the very same people he would devote his career to lampooning and celebrating.

Will was an accomplished soccer midfielder, and his passion for sports carried him to USC, where he cheered on the Trojan football team at the Coliseum and majored in sports information. He enrolled in a fraternity (of course), where he regularly flummoxed his brothers with ludicrous suggestions presented with an entirely straight face. And that was the thing about looking like everyone's future chiropractor: No one was ever entirely sure when you were joking.

After graduating, Ferrell moved back home with his mother and started a news internship at a local station in Orange County. One day, he made a joke while on the air, and was stunned by the rush he felt. Making other people laugh was invigorating.

Ferrell left the internship and tried stand-up comedy but was drawn to the collaborative nature of theater, and especially improv, and joined the sketch-comedy group the Groundlings in 1992. The Groundlings' style differed from that of their Chicago and New York peers. Creating memorable characters was at the heart of making audiences laugh, and every lesson the Groundlings offered their students was based in that belief.

It was easy, in those early moments with the Groundlings, to

look over at Will Ferrell and be deceived. When Jim Wise first glimpsed Ferrell in class, he took in his Art Garfunkel halo of curly hair and his suburban-dad affect and assumed that he was a nice guy, well-meaning but fatally out of his depth in the Groundlings. Fellow classmate David Jahn had a similar impression until he saw Ferrell and Roy Jenkins try out a sketch called "The Disney Barbershop Duo." Ferrell and Jenkins demonstrated their two-person version of a barbershop quartet, with Ferrell tackling multiple voices simultaneously, and Jahn reared back in surprise. "Holy shit," he thought. "The bar is raised."

Where others would dial down their performance, Ferrell was uninhibited. If a role called for him to scream and rant, flecks of spittle bursting from his mouth, he would do it, whether it was in front of a crowd of hundreds or in an empty rehearsal room.

In his spare time, Ferrell would visit classmate Maggie Baird at her apartment in Silver Lake. Baird's apartment was crammed full of cats that she and her then-boyfriend had brought with them from New York, and Ferrell was allergic. He would sit on Baird's couch as his face quietly ballooned, occasionally popping an antihistamine in the hopes of offsetting the damage.

Baird (the future mother of pop superstar Billie Eilish) would worry about Ferrell falling asleep during one of his hour-long drives home to his mother's in Orange County. Ferrell was a prankster playing tricks on an unsuspecting straight world and thought it was hilarious to drive painfully slowly, sending his fellow Southern California drivers into an incandescent rage as they leaned on their horns.

In one memorable sketch, Ferrell and Baird played geeky members of a high school marching band who liked to taunt each other about their musical routines. The whole bit was a harbinger of Ferrell's later *SNL* cheerleader routine, seeking to be true to the fixa-

tions and habits of adolescence, down to the jokes about calculus and the sotto voce efforts to attract the band teacher's attention with paeans to his posterior. In another inspired pairing, Baird played an elderly Rose Kennedy, unable to remember precisely which of her children were still alive. Ferrell was a guest forced to hopscotch from seat to seat at the dinner table, pretending to be each of Rose's children in turn.

After a visit by *Saturday Night Live*'s Lorne Michaels and Marci Klein (who came primarily to see Ferrell's castmate Chris Kattan), Ferrell was brought out to New York for an audition. He was told to prepare three pieces, and he was armed with his imitation of Chicago Cubs announcer Harry Caray, a routine about Ted Kennedy doing stand-up (which he rapidly realized was not exactly cutting-edge material), and a bit about a suburban father shouting at some people to get off the shed. (The latter would end up becoming one of the most popular sketches of the new season.)

Racking his brain for a means of standing out, Ferrell decided it would be amusing to pretend to bribe Michaels for a spot on the show. He had heard that Adam Sandler had come in for his audition and humped his own chair's leg, charming Michaels so thoroughly that he was offered a spot in the cast while still in the room. So Ferrell bought some packets of fake money and stuffed them into a leather briefcase that he brought with him to New York. On the day of the audition, he carried the briefcase, his accessories now matching his middle-management demeanor.

The plan had been to walk into the audition, pop the briefcase, show Michaels the money, and tell him: "Lorne, you can say whatever you want, but we all know what really talks. And that's cold, hard cash. Now, I'm gonna walk outta here. You can take the cash if you want. Or not." But as soon as Ferrell walked in, he could see

that the mood in the room was tense and businesslike, and he panicked.

Faced with the prospect of popping the briefcase, Ferrell choked and let it sit limply at his side. At the close of the meeting, Michaels asked producer Steve Higgins if he had anything to add, and he told Ferrell, "Nice briefcase." Ferrell was called back for a second meeting, and brought back the briefcase and the money. Michaels told him that he was hired for *Saturday Night Live,* and Ferrell put down the briefcase, not wanting to spoil his moment of triumph with a dumb joke. It had taken Will Ferrell all of three years to go from his very first Groundlings class to becoming a cast member on *Saturday Night Live.* He wound up distributing approximately $10,000 in play money to Michaels's assistant.

It was always helpful for writers to partner with performers on the show, thereby increasing the likelihood that their sketches would ever make it to air. And Ferrell and McKay—who had never worked in television before but had already improvised and written hundreds of sketches as a performer—rapidly discovered that they had a shared comedic sensibility. Their sketches began with familiar templates—the job interview, the TV parody, the late-night commercial—before veering in the oddest and most unexpected directions. Other writers on the show might have taken an entire night to painstakingly craft a sketch, but McKay and Ferrell would knock out a first draft in an hour and a half, giving themselves time to come back to their work later and revise or adjust their material.

They came up with an idea for a sketch in which Ferrell would

play Neil Diamond, sharing a slew of inappropriate and off-color stories about his acclaimed songs for an installation of *VH1 Storytellers*. Diamond's most famous songs would be inspired by a deadly hit-and-run accident and his deep hatred of immigrants.

McKay soon discovered there was no one he liked writing for at *Saturday Night Live* more than Will Ferrell. Ferrell's ferociousness, his ability to turn on a dime midsketch, his toggling between ordinary guy and blood-drenched weirdo (as in the sketch "Jimmy Tango's Fat Busters," which Ferrell swiped out from underneath Jim Carrey), meant he could brilliantly perform practically anything McKay could imagine. And more than that, Ferrell was a gifted writer as well, with the two men finding a shared comic language. Ferrell and McKay particularly loved what they called "absurd, screw-around sketches," in which loud, obnoxious braggarts were dropped into ordinary surroundings (doctor's offices, airplanes, work drinks) and proved themselves painfully oblivious to others' discomfort. In one sketch, Ferrell plays Dr. Beaman, an ob-gyn who gleefully insults parents visiting his office and then goes on to admit that he lost the couple's baby while at a BoDeans concert. In another sketch, Ferrell is a clean-cut airline pilot who gets on the PA to share his "quiet time" philosophy with his passengers: "If anyone looks at me or makes a sound, I will hit you right square in the teeth."

One of the earliest examples of McKay and Ferrell's conjoined sensibility came with "Hulk Hogan Talk Show" in December 1995. After a surprisingly detailed theme song chronicling all of Hogan's many ludicrous accomplishments, we are subjected to a comic bait-and-switch when, instead of seeing the flamboyantly maned, gleamingly muscled wrestling champion, we glimpse the pasty and

inoffensive Ferrell in an off-the-rack suit, sitting in what appears to be a golden throne with a wrestling belt displayed behind his head: "Hulk Hogan is on vacation. I'm your guest host, Phil Tobin."

Phil is interviewing a guest (Anthony Edwards) with a harrowing story of abduction by terrorists, but the interview is continually interrupted by the format of Hogan's show, and Phil must pause their conversation for a variety of wrestling-related highlights and features.

McKay's sketches had a central idea—what if the inane features of a disposable talk show preempted a serious conversation?—and let it spool out until audiences grasped the comedic stakes.

In "Old Glory Insurance," written by McKay in his first season on the show, Sam Waterston scares a roomful of seniors with fears of robot attacks: "Robots are everywhere, and they eat old people's medicine for fuel." The ludicrous idea is only enhanced by the deliberately amateurish footage of 1950s-style metallic robots clobbering silver-haired gentlemen, attacking elderly women as they rake leaves, and gobbling fistfuls of prescription pills. McKay arrived on the set for "Old Glory Insurance" and heard a "ding" in his mind. Here was "a perfect 1950s threatening robot with a perfect eighty-two-year-old woman, in perfect wardrobe," just as he had imagined it. His ideas could take flight.

Saturday Night Live rewarded some and diminished others. After just one season, Ferrell's castmate David Koechner was fired. Koechner had been frustrated by the political intrigue and passive-aggressive cloddishness of *SNL*. The show, in his mind, had too many producer middlemen with little working knowledge of comedy, but he was still shocked at the news. "David," Michaels told him, "you're already on the radar. You'll do fine."

At the same time, Adam McKay was named *Saturday Night*

Live's head writer after his first season on the show. He was twenty-eight years old and had only just started in television, and was now in charge of putting together a legendary sketch show. The work was grueling. Ninety-hour weeks were the regular order of things, and writers lived on a diet of fast food, soda, and cigarettes. By general consensus, McKay was the fastest comedic thinker in the *SNL* orbit. Writer Harper Steele found that McKay could instantly unstick her when she found herself trapped in a sketch idea that was not working.

McKay's mother was a waitress attending night school when he was a child growing up in Worcester, Massachusetts, and Malvern, Pennsylvania, and his father a bass player. As a child, he would watch Three Stooges movies with tears of laughter rolling down his face. He loved Monty Python, Public Enemy, and Larry Bird. After McKay graduated from high school, he enrolled in college, first at Penn State (where he hated the fraternity culture) and then at Temple University in Philadelphia, where he tried his hand at stand-up work. He found a modicum of success in stand-up, once opening for Chris Rock, but the form called on him to adopt an ill-fitting persona; here he was, telling girlfriend jokes, and he did not even have a girlfriend. McKay's friend Rick Roman had told him a revolution in comedy was under way in Chicago, being led by a radical named Del Close. McKay dropped out of Temple University, sold his comic book collection, purchased a 1976 Chrysler New Yorker, attached a lobster claw to its hood, and drove it to Chicago.

Close was mercurial and difficult, a comedic genius who burned bridges behind him with terrifying glee. After being fired from

legendary sketch-comedy showcase the Second City (possibly for an incident in which he threatened to place a couple's baby in a trash can), he had cofounded the ImprovOlympic along with Charna Halpern. Close always encouraged his students to take the time to search for their third thought, which would be funnier and less hackneyed than their first and second thoughts. If you were going to be dumb onstage, there was no shame in that, but Close asked them to be brilliantly dumb.

In the Movie, an improv format invented by Close, performers would treat a show as an opportunity to unspool the entirety of an imaginary film onstage, with scene changes and stage directions incorporated into the action. Close called it "scene painting," in which the performers were summoned to describe backdrops, off-stage events, camera movements, and characters' actions, smoothing the way from scene to scene.

The Movie style was empowering to McKay and his castmates because it allowed them to create shows that passed themselves off as other affairs: self-help conferences, virtual-reality demonstrations, explorations of the dank underworld of the conspiratorially minded. Close described the Family, an improv group McKay formed along with future *Scrubs* star Neil Flynn, Matt Besser, Ali Farahnakian, Miles Stroth, and Ian Roberts, as "like watching six men fall down the stairs and land on their feet." Close would eventually do the unthinkable and agree to direct one of the Family's shows himself.

McKay and Roberts, joined by Besser, Farahnakian, and Horatio Sanz, formed a sketch-comedy offshoot to the Family in 1990 they called the Upright Citizens Brigade (the name would later be shared with the comedy school and performance hub). Shows would begin with sequences set in the secret lair of the ultra-powerful

Upright Citizens Brigade, in which an array of surveillance devices allowed them to monitor the chaos they were intent on creating. The framing device was another version of the Movie, thematically pulling together a series of otherwise disconnected sketches.

Their first themed show, 1990's *Virtual Reality*, allowed the group to pull up audience members and have them join the action onstage by playing a variety of roles in their imagined VR, ranging from the president of the United States to a CEO to a babysitter. UCB shows were predicated on unsettling their audiences, on provoking unexpected responses. These were diatribes against manipulation that involved manipulating their audiences and then asking them to consider just what they had been cajoled into doing.

In one performance, the audience was led outside and handed tiki torches and plastic guns, and what had been presented as a town hall meeting to discuss putting up a stop sign transformed into an unruly protest against legendarily corrupt local congressman Dan Rostenkowski. Horatio Sanz, refusing to break character during the melee, was arrested and taken away by the police. Later, fans would come up to the other members of the troupe and commend them on just how realistic the encounter was. McKay would inform them that it actually had been the Chicago police breaking up their fake riot.

In his off hours, McKay would disappear into his bedroom in the apartment he had moved into with fellow comedian Patrick McCartney for days at a time and just write. He would eventually submit his writing to the Fox sketch-comedy series *The Ben Stiller Show*, where he received helpful feedback from Andy Dick.

"Attention," read a handbill that was distributed before a later performance of *Virtual Reality*. "On Feb. 28, 1992, Adam McKay,

age 23, will kill himself during the performance of *Virtual Reality* . . . No joke." The audience was summoned outdoors, where McKay stood on the roof of a Wicker Park building asking if they wanted to see him jump. The crowd raucously and enthusiastically encouraged him to do it, with McKay finally flinging a CPR dummy dressed in identical clothes off the building.

In one performance that has since taken on quasi-legendary status, audience members were informed that they were attendees at the Conference on the Future of Happiness, which would offer conferencegoers a one-sentence précis on the secret to happiness. Near the end of the show, the audience was summoned to the window of a ground-floor apartment, where they watched as an intruder snuck in and murdered a resident (played by Sanz).

The audience were then asked if they still wanted to hear the one-sentence description of the secret of happiness. When they inevitably said they did, the cast instead opened a box, took out pellets of dough, and pelted the audience with them. (How were the reviews? Seth Meyers would later ask McKay when he made an appearance on his show. Mixed, McKay responded.)

On another occasion, actors summoned by McKay posed as locked-out union members with a cola-fueled grievance at the Pepsi-sponsored grand opening of the Navy Pier. The police approached McKay after the rowdy protest, treating his Pepsi shirt as a marker of corporate responsibility. "How do you wanna handle this?" he was asked. McKay gulped and responded, "You know what? It's been bad enough PR, just let them go." Everyone raced to their cars and sped away before the police could change their minds or realize they had been duped.

Time and again, the audience would prove to be infinitely gullible and punished for their misplaced sense of trust. McKay and

fellow performer Scott Adsit interrupted their set on the main stage of Second City to gravely announce that President Clinton had just been assassinated. They wheeled out a TV set and proceeded to show the audience a compilation of football bloopers. McKay was purposefully looking to prompt a collision of responses, shock and horror meeting head-on with frustration and the kind of unpleasant and faintly embarrassing surprise that can only emerge from being hoodwinked into feeling a genuine, unprompted emotion.

In perhaps their most famous show, 1995's *Piñata Full of Bees*, McKay came onstage and delivered an impassioned screed against Blockbuster Video and all the ways in which the then-ubiquitous VHS-rental giant was perverting the art of cinema by editing the films they rented to customers. He asked audience members to hand over their Blockbuster cards, which he proceeded to cut in half with scissors, dropping them into an ever-growing pile on the theater stage.

In each of these cases, UCB was creating a heightened reality in which participants were finding themselves swept up in collective experiences they had not anticipated or prompted. They were looking to unsettle their audience and then unsettle them again, refusing them the comfort of a baseline against which to measure the pleasing fictions of the theater.

Saturday Night Live eventually made its way to *Piñata Full of Bees* and called McKay for a tryout. McKay worried he did not have the slickly polished sketches that would highlight his performing abilities and hedged his bets by bringing a packet of his writing to New York and handing it to Michaels immediately after his audition. His instincts were right; McKay was not offered a position in the cast but received a call. Would he be interested in becoming a writer on *Saturday Night Live*?

McKay was now summoning some of the deliberate weirdness and political provocation of Upright Citizens Brigade for a national audience. McKay wrote a sketch called "Media-Opoly," a *Schoolhouse Rock!*–esque animated musical number about corporate consolidation that deliberately bit the hand that fed it: "They own networks from CBS to CNBC, they can use them to say whatever they please." The sketch ended with a "PLEASE STAND BY" sign and a long bleeping sound, as if it had been interrupted mid-broadcast, but its airing led to a series of actual complaints from higher-ups. The sketch was pulled from the episode's rerun, but a friend of McKay's tipped him off to the plan, and he leaked the story to the media.

The deepest fit of familiar characters and underlying oddity came in the sketches that combined Ferrell's abiding interest in home-grown white-bread oddballs and McKay's taste for political satire. It was the George W. Bush sketches—many of them written by McKay—that fully made *Saturday Night Live* a success once more, returning it to the white-hot center of the comedy landscape.

In more ways than one, Ron Burgundy would be a direct descendant of George W. Bush. Both men are given to fits of extended braggadocio. Both Ron and W. mangle, and accidentally poeticize, the English language.

Perhaps most important, both Ron Burgundy and George W. Bush draw on a deep reserve of inexplicable popularity. They are ambulatory versions of the thumb on the scale for genial white men. With his square, stiff shoulders and a sports coat that looks like an ill-fitting hand-me-down, this Bush is every inch the callow heir. Ferrell could not help but make his George W. Bush, nepotism ben-

eficiary and neophyte president, distinctly likable even as he scored points off Bush's frightened-raccoon affect.

In one of the best *Saturday Night Live* Bush sketches, Ferrell is chugging beer out of a mug as he assesses his chances in the upcoming 2000 election: "Man, it's cool. I'm gonna be president. That's wicked." Ferrell is summoned to sit on his father's lap, an overgrown boy with no business in adult life. "I know you're not a bright man," Dana Carvey, returning as George H. W. Bush, tells him, encouraging him to lean his failson head on his father's shoulder.

In another sketch, father and son go hunting, and Carvey gently tries to educate Ferrell about the profound responsibilities of the presidency as Ferrell fidgets with a pair of toy antlers. Carvey lifts his gun, as if to mercy-kill his son, and then restrains his hand, reminding himself that it is illegal, and that his wife, Barbara, wouldn't like it: "Well, it's probably just four years."

The acclaimed 2000 debate sketches pitted Ferrell against Darrell Hammond, who played Al Gore as a tiresome bore, sighing and talking painfully slowly, like an elementary school teacher addressing a remedial class. In one, the debate moderator asks each candidate for a single word to sum up their candidacy. Bush famously settles on *strategery*.

Ferrell's Bush knows he is in far beyond his depth, a C student who failed to study for the final exam, and is intent on faking his way through. *Strategery* became a summation of this frat boy posing as a statesman, his foothold on the intermediate rungs of the English language decidedly unsteady, laconic Texan charisma being passed off unsuccessfully as wisdom.

In a clever post-election sketch, during the period of uncertainty before the Florida results were determined in Bush's favor by the Supreme Court, Ferrell addresses the nation with an important

announcement, looking vaguely into the camera as if in search of a Jet Ski or yacht on which he might escape this predicament of success. "I'm sure, just like me," he tells the country, "most of you have been very edgy and wetting the bed." Bush starts his acceptance speech reading from the wrong piece of paper: "Daddy, help me, I never thought I'd win this thing and I want out."

By 2001, McKay was feeling burned out after five years as *Saturday Night Live*'s head writer. He was ready to step down from the position until he was cajoled by Lorne Michaels to reconsider his decision. McKay said he would be willing to stay on at *SNL* if he was given his own title and budget and the freedom to create his own digital shorts, à la "Old Glory Insurance." He also wanted to craft his own title for the new role. Michaels agreed, and McKay began his tenure as *Saturday Night Live*'s first and only "coordinator of falconry."

In his new role, McKay produced shorts like "The Pervert," in which a cohort of grubby sexual deviants reports their disgust with one of their own for his attraction to his grocery products: "Some guys get off on showing their thing. Some guys get off on watching. Me, I get off on the Cream of Wheat chef." The black-and-white short has a down-at-heel, *Dog Day Afternoon* vibe to it, and McKay crams a surprising amount of atmosphere into a three-minute film. "The Pervert" is funny but has a sense of tone and pacing that indicated McKay was in search of more than just a belly laugh.

DURING AN *SNL* hiatus prior to becoming coordinator of falconry, McKay was brought in by Lorne Michaels, along with fellow writers Dennis McNicholas, Tom Gianas, and Steve Higgins, to write

an *Austin Powers*–like vehicle for Alec Baldwin called *The Cold Warrior*, about an American secret agent who emerges from a Soviet gulag after the Cold War has come to an end. Michaels had a production deal with Paramount, and for the briefest of moments, it appeared that the script for *The Cold Warrior* was going to get a green light for production. When it didn't, McKay approached Ferrell about writing an original screenplay together. Ferrell had contracted with Paramount to deliver a film script, which he still owed to them.

Writing a film was different than penning a *Saturday Night Live* sketch. Rather than coming up with a single premise and a comic twist, a film script required more patience. *SNL* had a certain structure that had served it well for decades, and while Ferrell liked to question the necessity of, say, the monologue, that format held firm during his tenure on the show. Writing a movie allowed all of that framework to fall away and indulge every wild thought without anyone present to tell them that this wouldn't work.

August Blowout, written by McKay and Ferrell during the late 1990s, stemmed from a small handful of disparate influences. Most obviously, it was a comic homage to *Glengarry Glen Ross*, the David Mamet play whose 1992 film adaptation had been a particular favorite of McKay's, along with the 1980 Robert Zemeckis comedy *Used Cars*. He had watched *Glengarry* seven or eight times and been particularly enamored of Alec Baldwin's "always be closing" Blake, who inspired one of the characters in their script. Ferrell and McKay had also both loved the car-dealership commercials of their 1970s youth, in which aggressive hucksters were pushing closeout deals on the latest Pontiac.

The script was also looking at Alex Cox's 1984 film *Repo Man*, in which Emilio Estevez was a newbie summoned to a world of

grubby blue-collar masculine striving. Last but not least, McKay and Ferrell were intent on re-creating a lost era of collaborative comedy, wanting to bring back the spread-the-wealth spirit of 1970s and 1980s movies like *Caddyshack*, *Stripes*, and *Animal House*, which, rather than featuring one star surrounded by straight men, had ensembles and granted funny moments to each of their characters— many of whom, not coincidentally, were veterans of *Saturday Night Live* and Second City.

Like *Anchorman* would be, *August Blowout* was set in a hothouse world of masculine competition and aggression. The script was about a man on an irrepressible, inexplicable hot streak who runs into trouble and must wrestle with what it means to not be the hotshot he has always believed himself to be. We first meet master car salesman Jeff Tanner (intended to be played by Ferrell) in the midst of a brutal Southern California traffic jam. Jeff is behind the wheel of an SUV, and as he faces the camera and speaks directly to us, he gets out of his car and climbs atop its hood.

Jeff goes on to describe himself like he is one of the products on his lot. He is "rugged, sexy, and American" and is "fully tricked out with all the features." "I come with a confident handshake, an outstanding ass, a saddle in my bedroom," Jeff says, "and except for some screwup by JCPenney, a near spotless credit report. And guess what? That's all *standard*."

The plot is set in motion by a cutthroat sales competition lifted directly from *Glengarry Glen Ross*, which Jeff plans to win. "This is a car for strong, willful men who like to off-road it," master salesman Jeff tells a young couple about an SUV, "and tame the savage land using only the rippling muscles and crackling bone that God gave him . . . and then when their musk fills the air, make love to a hard-bodied woman who wants to feel a steely beard against her

naked body . . . this is *the Ford Expedition*." When Jeff is done articulating just what owning the Expedition will do for them, his female customer looks down and is horrified to see Jeff's prominent erection. "I'm not proud of this," Jeff tells her in a moment that would echo a future *Anchorman* scene. "But when you talk about the Ford Expedition, it's unavoidable."

August Blowout, like its future successor, is enamored of the parochialism of the nondescript midsized city. It is set in Anaheim, a city of nearly 350,000 people in Orange County best known for being the home of Disneyland and—as one of the script's jokes makes clear—little else. These are stories of big fish in little ponds, and a montage sequence partway through the film plays up Anaheim's second-banana status. Jeff shuttles a new salesman around the city after a long day's sales, wanting to provide a glimpse of his favorite town: "Anaheim, she looks pretty sexy at night. . . ." The ensuing montage features Anaheim Stadium, a Disneyland character smoking a cigarette, multiple Denny's franchises, and a couch falling off the roof of a car and hitting the freeway.

Jeff is moved to sing of his oddly lustful devotion to his fair city, with the script calling in esteemed jazz musician Chuck Mangione to duet with him. "Anaheim! I want to make love to you! Feel Anaheim's lips pressed against my chest! Let's get soapy in the shower . . . and then, Anaheim, I rub my hands against your breasts!" Flexing its bona fides as a genuine Southern California product of the era, the script also references legendary local car salesman Cal Worthington and mustachioed Angels second baseman Bobby Grich. The sequence had been inspired by McKay and Ferrell's aimless drives along Anaheim's Harbor Boulevard, which they would tout to each other as the mile of car dealerships. The idea of penning an ode to Anaheim, which appeared to be an

endless row of streetlights and suburbia and little more, made them laugh.

Jeff, we rapidly observe, is a master salesman and notably deficient in every other sphere. He continues selling even while observing nature's call by bringing a cell phone and a phone book to the bathroom. But he offers his nine-year-old son, Matt, a bottle of Drakkar Noir cologne as a gift ("From now on you'll own the night") and tells him, for the month of August, "If at *any* time you need to talk to me . . . you leave a message on my voice mail. And I will get back to you in three to five business days."

Jeff tries to be a good father but is not precisely sure what that might look like. Instead of saying "I love you," Jeff is flummoxed by the finer points of emotion: "You came from me and I think you're . . . top-notch. . . . Your mom and I got naked to make you . . . and you rule. . . . You are awesome like Vince Carter."

Jeff has nowhere to go but down, and as with the protagonists of the later scripts for *Anchorman* and *Talladega Nights*, his fall is precipitous and a bit sketchy. The exquisitely polished Jeff is reduced to walking around the lot with a wrinkled shirt and a five o'clock shadow, responding to a customer who says he is planning to shop around by telling him he will start drawing up the contract paperwork. Jeff calls him a "farthead" in response.

Like in *Anchorman*, the plot hinges on a fear-inducing encounter with a wild animal. "Dammit!" Jeff complains when a cougar gets loose in the dealership. "It's eight o'clock at night in Southern California! Where the hell are we going to get some guns?" Jeff's fears are answered by a rapid-fire montage of a Walmart sign, a credit card, and an impressive array of machine guns on display—a brief taste of what would become McKay's acerbic political commentary.

(The salesmen also, in a nod to a future plot point in *Step Brothers*, purchase night-vision goggles. Boys will continue to be boys.)

In another clever bit repurposed for Ron Burgundy, Jeff, desperate to win the competition, yanks off his rumpled shirt "to reveal a perfectly pressed white shirt and tie," and begins selling cars to a blind man, to both of his bigamous coworkers' wives, to twenty passengers on a city bus, and even to a faint voice in the distance, slowly approaching the dealership. Jeff has reasserted his dominance in a dying form, like proving himself the best telephone operator of 1970 or 1985's master of the CB radio. "Boy oh boy," a fellow salesman groans. "It looks like the future's got a boner for us. Well, fuck the future. I ain't selling electric cars on the Interget. I drive and sell cars that run on dinosaur shit. I listen to AM radio and smoke two packs a day."

The joy Ferrell takes in the fossils, relics, and white-bread oddballs of Orange County carries over to this comic odyssey through the secret lives of middle-class strivers like the ones who surrounded Ferrell throughout his childhood. Perhaps for two young men who had found enormous success before the age of thirty, leaping from triumph to triumph, the thought of a cold streak—of that luck unexpectedly running out and leaving nothing but stale habits and desperation—inspired the worst fear they could imagine.

Ferrell and McKay brought their *August Blowout* script to Michaels, who enthusiastically offered to shepherd it around to the studios. Michaels brought it to Sherry Lansing at Paramount, who found it puzzling. The fact of its being attached to a first-time director and an untested star did not add to her confidence. Michaels pleaded with her to give it a second look. She agreed to a read-through of the script, which McKay and Ferrell promptly put

together, recruiting *SNL* performers like Tracy Morgan and Tim Meadows to attend, and veteran performers like Harry Dean Stanton and Gary Cole to participate.

McKay had booked it at the cavernous soundstage on which *Soul Train* was filmed, with the musical show's set still in the background as they read through the script. One of the assistants at Michaels's SNL Studios thought the reading was an enormous success and was stunned to learn that the executives were going to pass on *August Blowout*. Paramount was concerned that Will Ferrell was not capable of opening a movie as its star and decided to green-light another project. That film? *Dickie Roberts: Former Child Star*, starring David Spade. Thinking about it later, McKay thought the vast soundstage swallowed up all the laughs and made the response feel tinny and flat.

In the aftermath of that failed reading, Paramount asked McKay and Ferrell to submit to rewrites by another screenwriter. For the first rewrite, Paramount gave them the option of selecting their own script doctor—akin, perhaps, to choosing your own preferred executioner—and they named Tina Fey, another Chicago improv legend and *SNL* writer. Remarkably, Fey came back to them with a script draft that the original writers were overwhelmingly pleased by. The new version was, in their estimation, 25 percent better than it had been before, but the studio's lack of enthusiasm doomed the project. It was abundantly clear that Paramount was never going to make *August Blowout*.

Meanwhile, the script had begun to circulate around Hollywood, and McKay and Ferrell were pleasantly surprised to start hearing from people who'd had the chance to read it. Producers called McKay, asking him to meet with directors. Ben Stiller reached out, telling him that *August Blowout* was one of the funniest scripts he

had read in a long time and asking him to take on a rewrite job on his latest project. McKay got an agent, but he and Ferrell were forced to acknowledge that *August Blowout* was not going to be made. Working together had been a pleasure, and when they compared notes, McKay and Ferrell agreed that they had two choices: They could either feel sad that the script hadn't been made, or they could commence working on another one. They chose to keep writing.

Male Chauvinist Pigs

NE EVENING IN 1998, Will Ferrell was flipping channels at home when he came across something that stopped him in his tracks. It was an installment of the A&E series *Biography* about 1970s network-news pioneer Jessica Savitch, and an anchor named Mort Crim was talking about the casual sexism of the era and the cruelty with which Savitch had been treated during her ascent. "You have to remember," Crim observed, "back then I was a real male chauvinist pig." Something about the offhanded nature of the remark—male chauvinist pig, no biggie—tickled Ferrell's fancy, and he called McKay to see if he was also watching.

McKay immediately started laughing. The thought of news anchors, whom he had grown up believing to possess godlike authority, behaving like toddlers made him chuckle. "We were laughing so hard at these guys with perfect ties," McKay would later say, "admitting that they were completely freaked out by a woman coming into the news office."

Wouldn't it be funny to tell a story about benighted 1970s

newscasters, puffed full of teleprompter-fueled hot air, and to comedically address the over-the-top sexism of the era? Around that time, director Paul Thomas Anderson (*Boogie Nights*) joined the *SNL* writing staff for a week. He was a great admirer of the show and "wanted to see the mechanism of how [they did] things," remembered Ferrell.

Anderson and McKay hit it off instantly. McKay and Ferrell gave him their *August Blowout* script, and Anderson was impressed. "God, this is so funny," McKay told Anderson that he and Ferrell had an idea, and Anderson, who was venturing into producing, told McKay and Ferrell to write the script they had always dreamed of. They came out to Los Angeles to visit Anderson and pitch their script idea, and Anderson was sold. They would write a feature-length script about newscasters set in McKay's native Philadelphia, and Anderson would produce.

McKay and Ferrell flew to Philadelphia on Anderson's dime and spent two days touring the city, thinking about where they might film and about the city's Action News team, whom McKay considered living legends.

McKay and Ferrell reached out to veteran television journalists to learn more about the TV news of a bygone era. In Philadelphia, they spent a few hours talking with esteemed local-news anchor Larry Kane and were put in touch with famed New York newscaster Chuck Scarborough. They particularly loved Jack White, dean of San Diego newscasters on the city's channel 10, who gave them a private tour of his museum of magic tricks and collectibles.

Some anchors, like Scarborough, realized that *Anchorman* was not going to be entirely serious and disengaged from the project.

Others, like White, were fully supportive, arguing that not only was McKay and Ferrell's joke fundamentally true to life, but the past was even wilder than they might have known. White told McKay and Ferrell that in his earlier years, everyone in the newsroom would regularly smoke, and a few times a week, one of the filing cabinets would catch fire from people incautiously approaching flammable documents with lit cigarettes in their mouths.

Another newscaster McKay and Ferrell met told them a story where the director of their broadcast was at a bar and got so drunk that he missed the show. He asked the bartender for the telephone, reached the station, and directed the show from his barstool, calling out shots while watching the television broadcast. McKay and Ferrell talked to a friend from Pittsburgh who told them about how the number one news team in the city would have legendary boozy pool parties, and the idea kept rolling from there.

Ferrell watched footage of old newscasters, in search of inspiration for what his anchor blowhard might look and sound like. Both McKay and Ferrell began to be able to hear their protagonist's voice and channel it onto the page. McKay lay on the couch, and Ferrell sat at the computer, typing. Some days would be wasted discussing the Lakers' latest intrigues. Even when that happened, they would be secure in the knowledge that the next day would be more productive. Ferrell was, in McKay's estimation, the least neurotic person imaginable. McKay saw himself as a tad more anxious but still preferred not worrying over the details.

The first few days were spent opening an enormous file of ideas and loose notes. McKay and Ferrell explicitly referred to the first draft as "the big messy bag of ideas." It was the place to dump every stray thought they had, every image, line, or song that might make

someone laugh. Not all of them were connected to the plot, such as it was. There was no order or planning to this step. It was spit-balling at its loosest, with McKay and Ferrell suggesting cars their characters could drive, nicknames they might receive, and vague ideas for scenes.

Ferrell suggested that the protagonist might play jazz flute, and that went in. Anything that might please an audience member enough to justify the expenditure of $9 on a movie ticket was good enough to be included.

The messy bag of ideas was dozens of pages long and exuberant fun to produce. The next step was to take the ideas and write a film outline. Neither Ferrell nor McKay particularly enjoyed this part of the process, which was less amusing than coming up with the wacky ideas, but without it, it would be too easy to get lost in the thickets of the plot.

Equipped with the outline, McKay and Ferrell then began to write the script itself. The process was never competitive. It provided the joy of communicating on a special frequency that neither writer could quite tune into on his own. McKay would test out voices for all the supporting roles, and Ferrell, knowing he would be star-ring, would rehearse the lines as they wrote.

When they had something they liked, one of them would suggest they momentarily pause and type the lines into the document before they vanished into the ether. Ferrell might nudge McKay away from the desk so he could take a stab at jotting down his ideas. Even as they were typing, they were often still jousting co-medically, trading suggested lines and acting out a scene, their voices, hands, and bodies in motion. Screenwriting was like a two-man party whose banter was going to be recorded for posterity, with

each writer snatching gems from the air and stuffing them into their shared document. In retrospect, Ferrell was surprised they had never recorded their sessions, but somehow, they were always able to preserve their best jokes.

As a writer, having the film's star present in the room as you wrote granted an enormous advantage. As he and McKay wrote the script, Ferrell was able to test out each line in his character's voice, giving them a chance to hear just how it would sound when emerging from his mouth. He could demonstrate the way he might cock his head when delivering the line, granting him and McKay a privileged preview that would otherwise be unavailable until the film was cast and the actors first gathered. As a performer, writing your own script was like being granted an extra round of rehearsals before shooting began. You could master the rhythms of your performance long before a single other actor had even gotten a glimpse of the script.

For McKay and Ferrell, any initial premise would always have to be given a hard yank, a surprise swerve that carried the story far from its origins. And so the idea for a comedy about sexist anchors became an extended parody of a cult classic about plane crashes and cannibalism that they were initially calling *Action News Man*. As they were writing, McKay and Ferrell were perpetually polishing and tightening their work, and some of their effort involved saying the names of their characters out loud. Names were extremely important to them both, and they would repeat them, over and over, playing with the sounds until they were content. When they began, their puffed-up newscaster was Rod Burgundy, and the hungry upstart was Alicia Corningstone.

And now a brief word about the names in *Anchorman*. Rod Bur-

gundy eventually became Ron Burgundy, and Alicia Corningstone became Veronica Corningstone. With the variations, a pattern becomes evident: Rod/Ron's name is meant to be punchy and vaguely grandiose, and Alicia/Veronica's is meant to be redolent of long-closed Connecticut finishing schools and families with coats of arms. McKay and Ferrell are challenging our ability to accept the absurd with these names, but a moment's reflection might remind us of real-life news figures with names like Sam Champion, Storm Field, Dallas Raines, and Johnny Mountain.

"The first version of *Anchorman*," Ferrell would later say, "is basically the movie *Alive*, where the year is 1976, and we are flying to Philadelphia to celebrate the bicentennial and all the newsmen from around the country are flying in to have their big convention. Ron convinces the pilot that he knows how to fly the charter jet, and he immediately crash-lands it in the mountains, and it's just the story of them surviving and trying to get off the mountainside. They clipped a cargo plane . . . and the cargo plane crashed close to them, and it was carrying only boxes of orangutans and Chinese throwing stars. Throughout the movie we're being stalked by orangutans killing, one by one, the team off with throwing stars. Veronica Corningstone [a fellow news anchor along for the trip in this version of the script] keeps saying things like, 'Guys, I know if we just head down, we'll hit civilization,' and we keep telling her she's wrong." Characters would be in the midst of delivering monologues before being unexpectedly killed by the throwing stars, thrusting the surviving characters into panicked flight. The draft was a comedic experiment, offering McKay and Ferrell the opportunity to take a ludicrous idea as far as they possibly could.

EVEN IN ITS initial form—which was so different from the finished product—the core idea that would become *Anchorman* harkened back to one of Ferrell and McKay's most memorable *SNL* sketches. "Wake Up and Smile" began on the set of a painfully chipper TV morning show, where Oliver (Ferrell) and Diane (Nancy Walls, a fellow cast member, and wife of future *Anchorman* costar Steve Carell) trade artificial banter. "I understand you've got some cooking tips for us, Diane," Oliver says, and then repeats himself with tiny adjustments, like an actor practicing a line or a broken computer. The teleprompter is malfunctioning, and Oliver is hyperventilating, utterly lost without the guidance of what he is to say. His first independent thought, shared haltingly with his cohost, is terrifying: "I was thinking someone should get a group together with guns to sweep out those ghettos."

The show cuts to commercial, and when it returns, the set is partially ablaze. Oliver wrestles with the weatherman and emerges clutching his severed head, sinking his bloody teeth into its neck tendons. Then the teleprompter is unexpectedly fixed, and Oliver looks up, his face bloodied, clutching a man's head in his hands, a tie the only fabric covering his chest, moved to tears of horror by the return of civilization as his cohost discusses casserole recipes.

Anchorman was not itself a *Saturday Night Live* sketch, but its genesis, emerging from the minds of two comic writers whose roots lay in *SNL*, made *Anchorman* an *SNL* movie in all but name.

Ron Burgundy was the kind of clueless, puffed-up yahoo familiar from countless *SNL* sketches past. But a beloved *SNL* sketch did not always make for a wildly successful movie. (See *It's Pat*,

Coneheads, or Ferrell's own *A Night at the Roxbury* for evidence.) A sketch could easily coast on atmosphere, some mugging, and three or four solid jokes and become an all-time classic. Even the briskest feature film had to go deeper, and *Anchorman* notably differs from its *SNL*-adjacent predecessors in creating a fully rounded world, rather than merely amplifying what already worked in a four-minute sketch.

Perhaps it was beneficial that while *Anchorman* was created by two *SNL* adepts, forged in the fires of 30 Rock, it had never actually aired on the show. But there were parallels to be drawn between Ron Burgundy and past *SNL*-sketch icons. Ron was prone to purple rhetorical flourishes like Jon Lovitz's Master Thespian and Christopher Walken's Continental; was a man out of time à la Phil Hartman's Unfrozen Caveman Lawyer; and was a master of egotistical self-absorption like Dana Carvey and Kevin Nealon's weight lifters Hans and Franz.

Saturday Night Live was attracted to sketches that were themselves about television, with everything from Ferrell's *Jeopardy!* turns as Alex Trebek to Mike Myers's Linda Richman to "Wayne's World" to "Mr. Robinson's Neighborhood" to "More Cowbell" operating as a parody or send-up of familiar television templates. By centering on a crude, easily mocked variety of lowest-common-denominator television, *Anchorman* was itself an extension of the *Saturday Night Live* model of comedy.

McKay and Ferrell brought their script to Anderson. There was a plane crash and cannibalism. There was an animated sequence. There was a musical number with sharks. Anderson read it and was flummoxed. "Whoa. OK," Anderson responded. "This is kind of crazy." He admitted to them that he did not know how to give notes on the project. He did not think he was a very good producer.

Anderson stepped away from the project, and McKay and Ferrell would later joke that with their script, they had single-handedly stopped Paul Thomas Anderson's producing career dead in its tracks. It would be almost two decades before Anderson produced another director's film.

In the wake of Anderson's departure, McKay and Ferrell set up meetings with every studio financier and indie production company they could wrangle. Everywhere they shopped the film, they received the same disinterest and confusion. In one day alone, McKay and Ferrell had ten different rejections for the script. One executive and her right-hand man gave McKay and Ferrell an extended lecture on how, precisely, comedy worked. "You know," McKay mumbled, "I think there's a lot of people that would want to see this." "Well, make sure all your friends buy tickets," the right-hand man responded, "because we don't think so."

Action News Man was just too weird for producers in search of the next comedy blockbuster. It was a 12:45 *SNL* sketch in search of *Beverly Hills Cop* money, with no Eddie Murphy in sight. Over the course of two days, the writers received twenty-seven nos for their project. It was immensely dispiriting. It was the same familiar story of Hollywood aesthetic conservatism. No one wanted to sign off on anything fresh or different until it was already a success, at which point, everyone in town was demanding another version of the very thing they had already rejected.

McKay and Ferrell's manager, Jimmy Miller, reached out to Mike De Luca at DreamWorks and asked him to look over the script. De Luca was known as someone with a solid knack for producing comedy, and he assented to developing the script. He was a fan of Ferrell and had heard about McKay, and while the script was not yet in serviceable condition, he was amenable to looking at further drafts.

It was time for a rewrite of the script, and Miller suggested bringing in Judd Apatow, best known as the creator of the short-lived, critically beloved television series *Freaks and Geeks,* to assist as a producer. Apatow and McKay had met when McKay had been brought in to punch up one of Apatow's scripts. Apatow had been a comedy-obsessed teenager on Long Island who took advantage of his mother's job at a comedy club to hunt down comedians and interview them about their work. He had gone on to produce the critically acclaimed sketch-comedy series *The Ben Stiller Show,* which launched the careers of Stiller, Bob Odenkirk, Janeane Garofalo, and Andy Dick, and the brilliantly acerbic late-night satire *The Larry Sanders Show* before being given the chance to make the moving and deeply funny high school series *Freaks and Geeks.* Both *Freaks* and its collegiate successor *Undeclared* made it only one season before being canceled but helped to usher in a tender, emotionally literate brand of comedy that would prove to be hugely influential.

The first draft of the script had registered at approximately a 9.8 on the absurdist scale, by McKay's estimation. Apatow came bearing a polite but pointed message. The script was funny and fresh and could be something special. But they would have to take audiences by the hand and give them more of a story to grasp on to. Apatow's nudge was matched by DreamWorks, which was telling McKay and Ferrell that they had functionally written a Monty Python script, without having anything remotely approaching the track record of Monty Python.

McKay and Ferrell went back for another round of edits and returned with a draft where the absurdism had been turned down to approximately a 7. The cannibalism story line began to shrink, and McKay and Ferrell started to focus on the tangled relationship between their two protagonists and the notion of a no-holds-barred

battle of the sexes. Nearly all of the original draft was ultimately excised, but Ferrell saw it as working absurdist muscles that would eventually be flexed in the final film's newsroom showdown and jazz-flute sequences.

One late night, McKay and Ferrell were plotting Rod's disquisition on the historical roots of his hometown and laughing uproariously. First, they were laughing at how ludicrous their jokes were. Here they were, imagining a moment in a feature film where the protagonist would define the city's name as meaning "a whale's vagina." Then they pictured Apatow reading this draft of the script and imagined what he might make of the sequence, and started laughing all over again.

Apatow did indeed read the script, and surprised them with his response: "You guys went out there on that one, but I'm with you." He had to admit that he had laughed and was willing to back them up as a result. McKay saw Apatow's fandom as his secret weapon. Apatow admired McKay and Ferrell's *SNL* work and was unabashed in his love for comedy. When he delivered his notes, it was clear how much he respected the art of comedy. When he laughed, McKay trusted that as a genuine response to the work. He felt more like a friend than a producer, which also gave Apatow leeway to gently prod McKay and Ferrell to keep polishing their draft. Often, Apatow's script notes were variants on "I think you can do better than this."

DreamWorks liked the project but not enough to give it the green light. McKay and Ferrell clearly wanted to make it now, and their manager, Jimmy Miller, was aggressive in his attempts to close a deal, but DreamWorks executives were slow in reaching any kind of decision. Commercially successful comedies, in the late 1990s, were often high-concept or fantasy oriented, like *Austin Powers: Interna-*

tional Man of Mystery or *The Nutty Professor*, and it was a struggle for DreamWorks executives to imagine *Anchorman* as an enormous success when it notably differed from its immediate predecessors.

DreamWorks ultimately chose to let their option lapse, but an executive at New Regency named Sanford Panitch discovered the script and fell in love with it. He was a huge admirer of Ferrell, believed McKay could direct, and fought to get the film made there. McKay was friends with director David O. Russell (*Three Kings*), who read the script, also loved it, and offered his assistance. "Why doesn't anyone want to make this?" Russell wondered, and offered to serve as a producer on the film. He knew the owner of New Regency, Arnon Milchan, and would do his best to cajole him to green-light the movie.

Panitch asked McKay to speak with the head of marketing at 20th Century Fox, where New Regency had a distribution deal, to see if he could win a skeptic over. McKay called him, and it became instantly clear that the head of marketing was convinced that McKay and Ferrell had set out to make another television-journalism comedy in the vein of James L. Brooks's 1987 classic *Broadcast News* and had come up painfully short.

McKay attempted to set him straight. This was going to be a completely absurd, over-the-top comedy-comedy that was aiming to be artfully done, in the vein of *Airplane!* or *Austin Powers*. "I've got to say," the head of marketing told him, "you are a passionate young man and it has been a pleasure talking to you, but we're not going to make this movie."

New Regency nonetheless agreed to a script reading, and McKay, learning from past mistakes, booked a small conference room. John C. Reilly and Harry Dean Stanton joined Ferrell among the performers.

The actors were uniformly brilliant. Reilly channeled the loony sidekick energy of his role as Dirk Diggler's aide-de-camp in Paul Thomas Anderson's *Boogie Nights* for his turn as sports reporter/sidekick Champ Kind. The script was an obvious smash hit, and a New Regency executive named David Matalon approached McKay after the reading, still laughing. "What a way to start the day, laughing so hard," Matalon told him.

"Well, what do you think?" McKay asked him. "Can we make it?"

"No, no," Matalon bluntly replied. "We're never gonna make this movie. It's too crazy."

After the reading, New Regency let *Action News Man* slip from their grasp, and McKay turned to increasingly unappealing alternatives. Producer Robert Simonds offered to fund the project as a low-budget production. The movie was going to be filmed in Vancouver. The day that McKay was set to fly to Vancouver to begin preproduction, he got a call from the production company. The project was off. After the dashed hopes of the New Regency read-through, McKay and Ferrell felt crushed by coming so close to getting the film off the ground and ultimately coming up short.

McKay retreated to New York, to his studio apartment in what he liked to call "Notown"—a personality-free stretch of Murray Hill in Manhattan. Ferrell had another project to work on, in which he was playing an overgrown elf adrift in New York, and McKay had gotten a gig doing a script polish on the film. There was a moment where the two men were sitting together in McKay's apartment, and McKay turned to Ferrell with bemused wonder. "How are we rewriting the movie where you're a grown man playing an elf?" They had gotten their butts kicked by the experience of shopping their own script and had been forced to retreat to what they saw as lesser projects with subpar material. There had been such grand plans for

the movie they would make, and now here they were, punching up a script about reviving the spirit of Christmas.

THE THING THAT did eventually convince studios to take another look at Ferrell and McKay's script was Will Ferrell himself. Over the course of the 2001–02 season of *Saturday Night Live,* which would be Ferrell's last on the show, he filmed a supporting role in a comedy about aimless thirtysomethings who start a postcollege fraternity to add some spice to their lives. The movie was scheduled to come out in November 2002 but got pushed to February—often a graveyard for dashed cinematic hopes. Then *Old School* hit theaters and did unexpectedly robust business at the box office, grossing $75 million domestically on a $24 million budget. McKay felt an immense debt of gratitude to *Old School* director Todd Phillips for casting Ferrell and giving him such a plum role. Without it, McKay's film career might never have taken off the way it did.

The movie that unexpectedly made Will Ferrell a bona fide star now feels lopsided. It featured Vince Vaughn and Luke Wilson in the leading roles, but the breakout star was clearly Ferrell, whose Frank the Tank provided many of *Old School*'s biggest laughs. The three are different spokes on the wheel of matrimonial and connubial life, with Beanie (Vaughn) the disaffected married man, Mitch (Wilson) newly single and adrift after a traumatic breakup, and Frank (Ferrell) a former party animal crammed into an ill-fitting suit in order to experience the satisfaction of wedded bliss.

Old School is guarded, at best, in its assessment of heterosexual relationships. Frank teeters on the fulcrum between the movie's de-

piction of singleton masculine bliss and the fraught intimacies of marriage. In one early scene, Frank is in the driveway of his home, a red bandana affixed to his head, revving the engine of his cherry-red Trans Am, Whitesnake blasting on the stereo, when his wife, Marissa (Perrey Reeves), comes out, bearing a tray of iced teas. The contrast between Marissa's genteel ambitions and Frank's dirtbag tendencies, iced tea and beer, could not be stronger. One can practically picture Frank's idle daydreams about Whitesnake video vixen Tawny Kitaen dancing across the hood of his Trans Am.

Frank brags to Marissa that his Trans Am is not currently street legal. "You've come a long way since Frank the Tank, and we don't want him coming back, now, do we?" Marissa asks, her mien that of an elementary school teacher talking with a promising but difficult student. "Honey, Frank the Tank is not coming back, okay?" Frank insists, "That part of me is over. It's water under the bridge. I promise."

In the film's best scene, Frank is waylaid by some younger friends who offer him a hit from their beer funnel. He demurs, telling them of his weekend plans: "Actually, a pretty nice little Saturday. We're going to go to Home Depot. Yeah, buy some wallpaper, maybe get some flooring, stuff like that. Maybe Bed Bath & Beyond, I don't know. I don't know if we'll have enough time." But the first sip of beer at a fraternity party brings back Frank the Tank immediately, and he takes to the streets, shedding his clothing and his inhibitions. Frank is living—or reliving?—his moment of collegiate glory, and as he sprints away from the party, *Old School* cuts to Marissa and her friends in her classy SUV driving through their town, when they spot a lone man with a flabby, pasty ass running down the middle of the street.

There is something preternaturally game about Ferrell in this moment, a solitary soul who imagines himself a leader, entirely willing to appear foolish and deluded for the sake of a belly laugh: "Hey, honey! Hey! We're streaking!" We watch as Frank executes his operation to storm the college solo, his beer goggles preventing him from realizing that no one has joined him on his drunken escapade.

Ferrell shot the scene on a street where all the storefronts were closed for the evening except for a gym whose treadmills faced the street. As soon as he took off his robe, Ferrell heard someone shouting "Oh, my God!" at the sight of his bare butt.

Frank is so desperate to please his wife, so hell-bent on transforming himself into a family man, that he inevitably cracks under the strain. Ferrell's gift for blissful awkwardness shines through in the scene where he and Marissa agree to part, as he chucks his wife under her chin and tells her, "Actually, I gotta run, but if I don't talk to you, keep on—keep truckin'." It is the "keep truckin'" that really sells the entire scene, commingling Frank's genuine tenderness toward his wife with an utter inability to know how to speak forthrightly or honestly about his emotions. "Good stuff," he mutters as he walks away, his life in complete shambles.

Some months before the release of *Old School*, a writer for the internet site Ain't It Cool News named Drew McWeeny received copies of two scripts by Ferrell and McKay, sent over by a friend who thought they were funny scripts that had been unjustly overlooked. The first was *August Blowout*, and the other was still being called *Rod Burgundy: Action News Man!*

McWeeny read them both and was impressed with each. Of the two, he favored *Rod Burgundy*, which he thought created a wilder, more deeply rounded world for its characters than *August Blowout*.

McWeeny was not entirely sure of what would come of the script, but he wrote that he was sure that he wanted to see DreamWorks—or anyone—make it: "*Rod Burgundy* would not be an important film. Most likely, *Rod Burgundy* would not be a great film. But I'm willing to bet *Rod Burgundy* would be a hilarious film, and I hope we get a chance to see an unbridled, balls-to-the-wall version of it sometime soon."

With the success of *Old School*, the prospect of a feature-length comedy co-written by and starring Will Ferrell was a widely appealing prospect to numerous studios. Steven Spielberg was immensely pleased that his studio already had the rights to the next Ferrell movie and was dismayed to learn that DreamWorks had let them lapse. DreamWorks was intent on getting the project back, and a brief bidding war erupted.

One of the studios that got a second look at *Rod Burgundy* was MGM, where studio president Michael Nathanson received a phone call from manager Eric Gold asking him to read the script. MGM executive Elizabeth Cantillon also read it, and while she was concerned about the cannibalism subplot, she fell in love with the framing device, in which famous real-life newscasters sat around telling stories about Rod Burgundy (which reminded her of the showbiz-bantering frame of Woody Allen's *Broadway Danny Rose*), and the characters, and saw an opportunity to make a Will Ferrell movie for a relatively modest price.

Cantillon came in Monday morning ready to argue for the project, only to have Nathanson tell everyone in no uncertain terms that they would never be making this movie. Nathanson had lived in Philadelphia and thought the script had thoroughly failed to capture the mood of 1970s Philadelphia, or of the newscasters of the

era. Cantillon and the other MGM executives pleaded with him to change his mind, explaining that it was meant to be an exaggerated, quasi-surrealist comedy, but Nathanson turned it down.

MGM notwithstanding, other studios were excited at the prospect of producing *Rod Burgundy*. DreamWorks and Universal were both bidding on the rights, and DreamWorks came through with slightly more money, offering a $20 million budget to make the movie. *Rod Burgundy*, after years of appearing to be permanently stuck, was a go.

By the time *Old School* was released, McKay and Ferrell had already assembled a new draft of the script, which they were calling *Anchorman: Action News! With Ron Burgundy*. *Anchorman* is set in a television station sometime in the 1970s—no more plane crashes or orangutans with throwing stars. Newscaster Ron Burgundy (his name now changed from Rod after an inordinate amount of discussion between the two writers, and for reasons even McKay could no longer remember) and his colleagues—weatherman Brick Tamland, local reporter Brian Fantana, and sports reporter Champ Kind—are long-standing kings of the local ratings. Ron and his friends are rattled by the arrival of a new female reporter named Alicia Corningstone. Ron and Alicia fall in love, but he is deeply threatened when Alicia becomes his co-anchor, and love curdles into revenge. The men gang up on Alicia and seek to intimidate her into leaving the station, but it is ultimately Ron who is driven into exile from the station.

The script is buoyed by explicit nostalgia for the bygone days of television. After a rapid montage of fear-inducing news visuals, thoughts turn to "a less cynical time": "Three channels were all there was and viewers were happy. You heard me right, *three channels*." Ron Burgundy is cast as the ideal representative of this far-off era

of 1973: "Yes, in this strange time, men were men and real men were *anchormen*."

The rough outline of the later film was visible here, with numerous changes still to come. First and foremost, the script was now set in Portland, not Philadelphia or San Diego. (Picture a world in which the phrase "You stay classy, Portland" becomes part of the comedic DNA of every comedy fan under the age of forty.) Ron takes his love interest, Alicia Corningstone, to a lookout point to see the view of his city: "Drink it in. Mmm . . . Portland. She always goes down smooth." With this early substitution, we can glimpse where McKay and Ferrell are looking to aim their satirical efforts: at second-rate cities with first-rate egos, small ponds full of minnows convinced they are sharks. There were echoes of *August Blowout*'s Anaheim, but McKay and Ferrell were also intent on emphasizing the way in which local newscasters were enormous celebrities in the pre-cable era, reigning over midsized cities like feudal lords, making the opening of, say, a new Alpha Beta supermarket seem impossibly cool. Ferrell, thinking of his own Orange County childhood, was tickled by this milieu, and also found it a touch nostalgic.

In an early sequence, the News Channel 4 team celebrate another quarter at the top of the local ratings at a rival weatherman's pool party. "I think it's time to show all the fine gals of this city what a number-one-rated news team looks like," Ron enthuses, and the script notes that the quartet "all tighten their tie knots in perfect sync with each other."

Ron is wildly popular with women ("Hello, Ron Burgundy," a woman tells him at the party. "This just in: I'm not wearing any panties") but is intrigued by a mysterious stranger. He turns down the opportunity to "take a dump in the fish tank" proffered by

another anchor and approaches her with a carefully polished line: "You've got a nice little hiney on you. The second I saw your hiney, I thought, 'Boy, that is a heck of a rear!'" Alicia, of course, is Channel 4's new reporter and the first woman to appear on air at the station.

Ron has soon turned away from his pals' casual cruelty and gone all soft for Alicia: "I will grab that woman, throw her down, caress her, give her a back rub! We will go to a Cat Stevens concert together and *hold hands!*"

The others press ahead with their plans to torment Alicia. The boorish, callous Champ, a sportscaster who treats every interaction like a competition, approaches her, mock-accidentally grabs her breast, and when Alicia wheels on him, tells her, "What can I say? I like the way you're put together. You wanna go get a fillet of sole later?" "Fillet of sole" is a great detail here, and, conjoined with Champ's later threat to take a rival anchor's mother out for a seafood dinner, speaks to the pseudo-classiness of these business jocks with a preternatural hold on success. What could be classier than an elegantly plated fish, even if it comes with a side dish of clumsy grappling and single entendres?

Weather reporter Brick, simpleminded as always, gamely attempts to keep up with his colleagues while inevitably demonstrating his cluelessness. Brick offers a clumsier, less aggressive variant of his friends' techniques. He approaches Alicia last and tells her, "I thought maybe we could get together later and touch each other in the bathing suit area." When she rejects his offer, he "turns and runs away full speed."

Alicia, a twenty-eight-year-old new arrival from a station in North Carolina, is granted a brief voice-over in which she makes clear how formidable an opponent she will be for these blinkered misogynists. "Don't feel sorry for me," Alicia says as she hears her

coworkers disparaging her in Harken's office. "I'm used to this kind of situation. My real name is Rita Ganken, but Alicia Corningstone hit the ear a little better. My first on-air job was at a little station outside of Houston and they were a hell of a lot worse than these guys." The reference to Houston only increases our suspicion that Alicia is intended to be a hooded reference to Jessica Savitch, the pioneering news anchor whose first on-air job was in Houston (and about whom more later).

Later, Alicia offers a tantalizing glimpse into her determination to never cede any territory to the men around her: "As a little girl, instead of playing house I would play drill sergeant or butcher. Then in high school I learned how to dunk and could hit the three from ABA range, but the coach wouldn't let me play with the boys. . . . Then one day I read the PA announcements at school and was hooked." (None of this makes the final cut of the film, with the only remnant of Veronica's voice-over coming after her disastrous first encounter with the Channel 4 news team: "This is definitely a man's world. But while they're laughing and grab-assing, I'm chasing down leads and practicing my nonregional diction. Because the only way to win is to be the best. The very best.")

There are brief hints of Alicia as a representative of a rising feminist spirit. She goes out for drinks with some of the other women from the station, who are each pursuing goals of their own. One is attending law school at night, and another is starting a temp agency. The last attendee "had sex with the drummer from Foreigner." It was the 1970s, after all. (It would spoil a perfectly good joke to point out that Foreigner would not form until 1976.) There is a sense here of a sub rosa feminine fraternity of women out to subvert the masculine hierarchy, or at least bend it enough to make room for themselves to slip through the bars.

The script emphasizes the sexual and romantic cluelessness of Ron and his crew, with a scene in Ron's office taking a slightly different turn than it does in the film itself. Champ is the one who offers a wildly misguided take on what love might be: "She was a dental assistant, we spent three days in Barbados together. . . . And she could touch her shoulders with her feet." The oily, lascivious Brian, a man who enjoys staring at his reflection in the mirror a bit too much, takes a stab, too: "Is it like how you feel when you salute the flag . . . only you've got a boner?"

It is left to Ron to explain just what love is, and he chooses an image that speaks directly to the newsmen's most fervent and precious ideal—namely, their hair. "This morning when I woke up and saw Alicia next to me, I just laid in bed. . . . I didn't even think about getting up to style and blow-dry my hair." "Beat as the team is visibly moved," the script reads. There are limits, though, to what Ron's friends can stomach, even in tribute to love: "Ron, please tell me you did not walk out the door without blow-drying your hair." ("I'm in love, not insane!" Ron responds.)

This draft features a subplot involving the Alarm Clock, a loose crew of counterculture radicals, vaguely intent on shaking up Portland. Alarm Clock leader Paul, like his future antagonist Ron Burgundy, is a lecher with a pious face: "You ladies wanna join me, talk about the revolution, give some back rubs?"

The Alarm Clock's kidnapping of Alicia provides the justification for the script's conclusion. These characters feel somewhat more generic than the deeply considered portraits of masculine excess Ferrell and McKay draw. One character in the script is named Hot White Chick.

Just before the Alarm Clock are foiled in their plans, Paul is pressed to deliver his manifesto, at long last. Paul is a fraud mas-

querading as a deep thinker, and the only moment where he belatedly offers something resembling common sense is when he is thoroughly rejected. "Um, you know how when we drink beer or soda and then we just throw out the bottles and cans? Well, what if everyone started saving those bottles and cans so we could, you know, reuse them?" A beat passes, and then Ron responds: "You are a madman."

The names only add to the air of white-bread elegance on display here. "Champ" is sporty and playful, like something a half-assing dad might call his son on a weekend trip to the ball game (was "Slugger" already taken?). "Brick" is a heavy hint about the contents of the Channel 4 weatherman's interior life, or lack thereof. And "Burgundy," with its intimations of Gallic pride, of wine and deep-red leather, of red-sauce joints of yore, is an ideal emblem of what set decorator Jan Pascale would later describe as "failed classiness."

DreamWorks wanted the script to have Burgundy facing off against an antagonist, in the vein of Dr. Evil in *Austin Powers* (which Ferrell had appeared in as one of Dr. Evil's henchmen), and McKay and Ferrell began thinking about Patty Hearst and the Symbionese Liberation Army. To assist in their brainstorming, they brought in improv veterans Jerry Minor and Laura Krafft, whom McKay knew from his Chicago days, along with actor Kevin Corrigan (who would play a role as the lead baddie that would eventually be cut from the movie). They were brought to a nondescript office, presented with the prompt—a bank robbery—and asked to improvise a variety of scenes. Apatow, still on the project as a script adviser and all-around mentor, was suffering from a bad back and lay on the floor as they performed. The crew took notes and filmed as the performers experimented with the material, in search of usable scenes or dia-

logue. Krafft was being paid $1,000 for this quirky task and enjoyed the feeling of making McKay and Apatow laugh, although she was disappointed to learn that Amy Poehler had already been cast in the role she was playing.

Old School made Will Ferrell a familiar name; *Elf*, out for Christmas in 2003, after *Anchorman* received its green light, made him a giant star. *Elf* was an ideal fit for Ferrell because it required a certain over-the-top naïveté in its main character, a North Pole elf transported to New York City at Christmastime. It would have been only too easy to play the role of Buddy the Elf with a wink and a nod, an indication that you were aware of the treacly quality of any story that featured New Yorkers' flagging Christmas spirit as a key plot point. Ferrell went the other way entirely, leaching himself of all traces of sophistication or knowingness.

Ferrell and costar James Caan, playing his irascible father, appear to be entering this film via different doors, different eras, different methods of acting, and different ways of relating to the world, and it is the radical disjunction between the Coppola vet and the *SNL* alum that sells *Elf*. Buddy tells Walter that he dreams they "could make gingerbread houses and eat cookie dough and go ice skating and maybe even hold hands," and part of the joke is the idea of hotheaded Sonny Corleone pressed into service to hold hands with his overgrown idiot man-child of a son.

The wonder of *Elf* is that it is simultaneously a Christmas movie and a Will Ferrell movie. It is a sweet story about Learning the Lesson of Christmas, with Buddy restoring Christmas cheer by sharing Santa's book of gifts with the world via cable-news channel NY1. (One of the listed gift recipients was Ferrell's former *SNL* castmate: "Dave Koechner wants some Nike Shox.") It is also a movie with Ferrell as a radically inappropriate simpleton who

wreaks havoc everywhere he turns, dishing out insults and misin-terpreting every situation he enters. *Elf* remains as funny as it is because within the limited frame of its Christmas-movie ambitions, Ferrell is given leeway to run riot.

By the time production was complete on *Elf*, *Old School* had been released and turned into an unexpected smash hit for New Line. Instead of a Christmas movie, *Elf* was now a Will Ferrell movie. "Suddenly," executive producer Cale Boyter said, "we had a movie starring Frank the Tank wearing yellow tights." New Line wanted to pull in the *Old School* audience for another round of Ferrell's antics and was concerned about how that audience might respond to a sentimental Christmas story.

The studio took the film away from director Jon Favreau (who had been suggested for the film by Ferrell's *Old School* costar Vince Vaughn) in post-production and attempted to re-edit the film into another raunchy comedy in the vein of *Old School*. The effort was doomed from the start; there simply wasn't the footage in the can to transform *Elf* into an entirely different film from the one it had been intended to be. The studio tested the movie again with its original ending and released it to critical huzzahs (Roger Ebert expected it to be "clunky, stupid, and obvious," and was pleased to discover that the movie was actually "one of those rare Christmas comedies that has a heart, a brain, and a wicked sense of humor"). *Elf* wound up grossing a remarkable $173 million at the box office, the seventh-highest total for 2003, outpacing the latest installations of the *Terminator* and *Matrix* series. Will Ferrell was now a certi-fied movie star. How could he and McKay use that newfound power to make precisely the movie they wanted to make?

☆
———

CHAPTER 3

No Oscar Winners, Please

THE INITIAL DRAFT of *Anchorman* had laid out McKay and Ferrell's casting preferences. It had been understood all along that *Anchorman* would be a star vehicle for Ferrell, and he and McKay, in dream-casting mode, envisioned John C. Reilly as Champ, Ben Stiller as Brian, and Chris Parnell as Brick. (They also suggested Alec Baldwin as rival newscaster Frank Vitchard, Ed Harris as station manager Ed Harken, and Dan Aykroyd as his underling Garth. William H. Macy was their preference to play another news-station role, Marshall Connors, which would later be cut from the script.)

Judd Apatow suggested bringing in the casting team of Juel Bestrop and Jeanne McCarthy, along with their associate Blythe Cappello, to work on the film. Bestrop and McCarthy had become the go-to casting directors for the new wave of comedy filmmakers like Ben Stiller (*Zoolander*) and Todd Phillips (*Old School*).

Ferrell told Bestrop that they would need help with only a few roles. It would not play out exactly as they had anticipated.

Some of the casting for *Anchorman* was indeed a matter of pick-ing up the phone and asking for new recruits to their merry band. The list of actors in the original draft had been wish-casting; now that the movie was a reality, McKay and Ferrell were thinking of actors they had relationships with and might be able to cajole into joining them. Ferrell had worked with Vince Vaughn on *Old School* and wanted to cast him in the role of rival newscaster Wes Man-tooth. McKay and Ferrell thought of *Best in Show*'s Fred Willard for the role of station manager Ed Harken. *SNL* vet Chris Parnell was ultimately cast in the role of Ed's second-in-command, Garth Holliday.

Casting the four other main roles—Alicia, and Ron's three fel-low newscasters Brick Tamland, Brian Fantana, and Champ Kind—would require substantially more effort. McKay would wind up surprised by who they eventually cast. But he came to appreciate the ways in which the actual work of casting a movie was notably different from imagining casting. Performers turned out to have unexpected gifts that their previous work could only hint at.

The script had made its way around Hollywood after being given the green light for production, and McKay was surprised, and a bit flummoxed, to hear who had discovered it. A phone call came in for McKay telling him that James Spader had read the script and was fascinated by the role of Brick. "James Spader!" McKay replied. "That is insane, will he come in and read?"

Spader, being an already established movie and TV star in proj-ects like *Sex, Lies, and Videotape* and *The Practice*, said he wouldn't audition, but he and McKay arranged a meeting to talk about *An-chorman*. Spader was bursting with enthusiasm for the role of Brick, describing him as one of the funniest characters he had ever read. "I will do anything to get this role," Spader told McKay. (Every-

thing, that is, except audition, evidently.) McKay opted to pass on the tantalizing opportunity. "This is James Spader," he decided. "He is too good for this role."

The atmosphere was fun and loose. Auditions would be burned onto DVDs and sent to McKay, Ferrell, and Apatow to peruse. Once they had opted for a handful of finalists, the directors and producers would come into the office and see the actors for a second audition. McKay and Ferrell would look at fifteen or so prospects for each of the male roles remaining to be cast, and twenty for the role of Alicia.

The production team settled on three finalists for the role of Brick, including Jay Johnston, an old friend of McKay's and an alumnus of the influential sketch-comedy series *Mr. Show*, who had played Brick in the script read-throughs, and McKay's fellow Second City vet Steve Carell. (There had earlier been some talk of Tom Arnold taking the role, which would have made for a notably different film.)

In one memorable performance while McKay's Second City group was touring, Carell had been called onstage from the audience and then harangued mercilessly by McKay for his weak comedic skills until he burst into tears. Carell went on to be hired as a correspondent for *The Daily Show* in 1999, alongside fellow Second City vet Stephen Colbert, where he first became a household name, and was featured in a supporting role in the Jim Carrey–as–God comedy *Bruce Almighty* (2003).

Carell had come in for his audition in a nondescript beige suit, practically fading into the surroundings. He read a scene (later cut from the film) in which Brick enthused about eating "one of those delicious falafel hot dogs with cinnamon and bacon on top." Ferrell read Ron's lines off-camera and Carell alternated between taking

imaginary bites out of his repulsive trash-can lunch and laughing raucously at Ron's joke about the cafeteria's bad cooking.

McKay and Ferrell were deeply torn over casting the role of Brick and took two or three days to agonize over their choice. Johnston had been superb in his auditions and was already familiar with the role from his participating in some of the script readings, but Carell's consistent improvisatory wizardry was enough to win him the role. McKay remembered Carell's Second City reputation as someone who was never not funny. He had watched him for countless hours and seen him improvise, and Carell had always been sharp and fresh. McKay still wanted to get Johnston in the movie somehow, so he was cast as one of Wes Mantooth's lieutenants.

(In a bizarre turn of events, when Steve Carell left *The Office* in 2011, his replacement was none other than James Spader.)

It's easy to see why McKay and Ferrell initially thought of Ben Stiller for the role of Brian Fantana. Brian was a blowhard and a master of empty puffery, his blunt-force sexism offsetting Ron's naïve romanticism. On *The Ben Stiller Show*, Stiller played Tom Cruise in several sketches, all sunglasses and blinding teeth, in love with his own image, and it would have taken *Anchorman* down an intriguing path to cast Stiller. But the star of blockbusters like *Meet the Parents* had become too famous for a secondary role here, and McKay and Ferrell knew it was no longer a good fit for Stiller.

Paul Rudd had read the script early on and approached McKay, asking him to meet. McKay agreed, while warning him that the script was currently in limbo and unlikely to be produced. Rudd remained enthused, gushing to McKay that *Anchorman* was the funniest script he had ever encountered.

Rudd grew up in the suburbs of Kansas City, the son of British expat parents, and studied theater at the University of Kansas.

Rudd's star-making performance as Josh, the high-achieving, self-serious romantic foil to Alicia Silverstone in future classic *Clueless* (1995), had demonstrated how funny he was. It also prompted Hollywood to spend years haphazardly attempting to cram him into leading-man roles in films like 1998's *The Object of My Affection* (in which he played a gay man raising a child with his best friend, Jennifer Aniston) and 1999's *The Cider House Rules*.

When *Anchorman* found new life, Rudd came in to read. At the time, Rudd was best known for his recurring role as Phoebe's boyfriend Mike on *Friends,* but the performance that best demonstrated what he could do as Brian was in the 2001 cult classic *Wet Hot American Summer,* in which Rudd rocked jean shorts with an artfully placed red bandana in his back pocket, slobbered over Elizabeth Banks, and put on an extended, unbecoming temper tantrum after being asked to pick up after himself in the cafeteria. That combination of petulance and braggadocio, of certainty that no woman could ever turn him down, even as the evidence piled up against him, made Rudd's camp counselor Andy a precursor to Brian.

"Well, I hope he's good," McKay remembered himself muttering when Rudd came in to audition. He was, and the role came down to two finalists: Rudd and Bob Odenkirk. Odenkirk was, in some ways, the closest thing *Anchorman* could get to Stiller. He had written for and been a cast member on *The Ben Stiller Show.* Odenkirk did not—at least in this pre–*Better Call Saul* era—have the same leading-man promise as Stiller but was a remarkably gifted comedian and improv performer who had cocreated and starred in the critically acclaimed sketch series *Mr. Show with Bob and David,* which ran on HBO from 1995 to 1998.

Odenkirk had precisely the right skills McKay and Ferrell were looking for in a movie that would lean so heavily on improvisation.

They were also pleasantly surprised to discover what a gifted comic performer Rudd, already rocking a mustache for the audition, was, and saw that he was limber enough to contribute to crafting Brian's lines. He deliberately butchered the pronunciation of *je ne sais quoi*, and his lips were quivering as he shouted about its being anchor-*man*, not anchor*lady*. Ferrell later described Rudd as, "in the modern vernacular, a bit thirsty" for the role. "By the way," he remembered being told, "Paul Rudd is calling every hour and will not let this go." Both McKay and Ferrell felt that Brian Fantana had a cheesy-playboy quality that was crucial to the role, and that Rudd was better able to channel that side of the character. It was enough to win him the role by a hair.

For the character of Champ, Ferrell and McKay had fallen in love with John C. Reilly's heretofore-untapped comic abilities. Reilly was gifted at the art of bluster and the masculine bull rush, but the Oscar-nominated actor had already committed to Martin Scorsese's Howard Hughes biopic *The Aviator* (2004) and could not do *Anchorman*. It would have been intriguing to see what Reilly would have done with the role of Champ, and what the homoerotic charge between Ferrell and Reilly, so abundantly evident later in *Talladega Nights* and *Step Brothers*, would have added here, but Reilly's unavailability opened the role of Champ to the audition process.

Knowing McKay from Chicago and *SNL*, and Ferrell from their overlapping tenure in New York, David Koechner felt calm when he was called in for an audition on *Anchorman*. He knew their comedic styles, knew what they were looking for, knew how to seamlessly fold himself into the roles they envisioned.

Koechner was called in to audition for two roles: Brian Fantana and Champ Kind. He had no real preference between the two but felt he had a slightly stronger take on Champ than Brian. He brought

some wigs and sideburns he had had made for himself to the audition, and gave McKay and the producers a series of possibilities for both characters. McKay loved Koechner's boisterous energy and his improvisatory gifts. For his audition, Koechner donned a short-sleeve button-down shirt and a striped tie, and waxed enthusiastic about Alicia's butt: "I want to put that ass in a deep fryer."

Koechner and McKay had first met on an elevated train during their time in Chicago. The two men discussed Noam Chomsky and Albert Brooks during their shared train ride—a fair approximation of McKay's interests at the time, and a reflection of his future work as a comedian and filmmaker. Koechner felt an instant affinity with McKay, who shared so much of his worldview and his enthusiasms.

Comedy and acting were not viable career paths in small-town Missouri, and Koechner, who fell in love with *Saturday Night Live* as a thirteen-year-old, went to college planning to study political science. He spent his time at the University of Missouri working three jobs and reading books like Bob Woodward's John Belushi biography *Wired*. Koechner and a friend took a road trip to Chicago, catching shows at Second City and soaking in the atmosphere of studious comedic devotion. Koechner went back to Missouri and his three jobs, saving up enough money to make the move to Chicago, where he became a devotee of Del Close.

Koechner made the short list of four actors being considered for the role of Champ. McKay and Ferrell had recordings of the finalists' auditions, and when it came time for the producers and Dream-Works executives to get a look at them, they played their cards close to their vests. McKay and Ferrell knew better than to lobby for favored performers, fearing that this would lead the studio to insist on an alternate choice. Instead, they pressed play on the finalists for Champ Kind and waited to see what the verdict would

be. "Why not that guy?" someone wondered after Koechner's audition played.

Shortly after the audition, Koechner got a call from McKay and Ferrell. They were not supposed to be telling him this, they said, since everything was required to go through official channels and he would be getting a call soon from his agent. But they really wanted to call anyway so they could be the ones to tell him first that he had gotten the role.

The production team felt that the role they needed the most assistance in casting was that of Alicia Corningstone. It required someone with the comedic skills to keep up with the improv-heavy aesthetic and whose look would attract the likes of Ron Burgundy. She would also, notably, need to demonstrate the steeliness necessary to be an up-and-coming female newscaster in an openly sexist era. The studio also wanted a well-known name for the role.

More than one hundred performers came in to read for the part. Apatow suggested casting his wife, Leslie Mann, in the role. Mann would go on to far greater prominence through starring roles in Apatow's films *The 40-Year-Old Virgin*, *Knocked Up*, and *This Is 40*, in which she was a genuine find, but at the time she was best known for supporting roles in *The Cable Guy* and the Adam Sandler film *Big Daddy*. McKay felt that they were looking for someone who could embody a certain 1950s apple-pie wholesomeness that Mann was too wonderfully crude to ever fulfill.

Amy Adams was superb in her audition and possessed comic gifts that deeply impressed McKay. Adams was on the cusp of her first Oscar nomination, for *Junebug*, and had both the beauty and the comedic skills to pull off the role. McKay loved her and thought she would be an ideal addition, but his primary concern was how young Adams looked. He thought it would be a hard sell for au-

diences to believe Adams in the role of a veteran journalist when she looked like she was all of nineteen. In truth, Adams was only seven years younger than Ferrell, but the perceived age gap was wide enough to disqualify her in McKay's mind. (True to his sense of enthusiasm, McKay came right back and cast Adams opposite Ferrell in their next film, *Talladega Nights*.)

Maggie Gyllenhaal, then fresh off the success of *Secretary*, came in to read for the part of Alicia as well. Gyllenhaal had an appetite for quirk and an ability to play comedy, and she was brilliant. McKay was instantly convinced that she was one of the most talented actresses he had ever encountered. She was going to win an Oscar someday. But *Anchorman* was setting out to be this generation's *Airplane!*, and you would not cast Meryl Streep in *Airplane!*

Christina Applegate, meanwhile, was not on McKay's initial radar. In her early thirties, Applegate was already a veteran of more than thirty years in Hollywood. She had appeared on the soap opera *Days of Our Lives* as a baby, where her mother, Nancy Priddy, was a featured performer. As a teenager, she'd made appearances on sitcoms like *Charles in Charge* and *Silver Spoons*.

Applegate had spent a decade on the Fox series *Married . . . with Children* (1987–97), a crass Fox sitcom, where she had played dim bulb Kelly Bundy. In the years since *Married . . . with Children* had gone off the air, Applegate had been adopted by David Crane and Marta Kauffman, who had cast her as the lead in their short-lived series *Jesse* and had also featured her as Jennifer Aniston's flighty sister on *Friends. Married . . . with Children* was never a great show, but acting in 250 episodes of a sitcom meant that Applegate would hardly be cowed by the idea of being funny on-screen or keeping up with improv-trained performers.

Applegate looked like a blond bombshell of the sort Hollywood

had always gravitated toward. But she could nail the broadcast-news vibe that the role of Alicia called for and had just the right aura of flinty authority they were in search of. Applegate was limber, able to play any given scene completely straight or improvise. In her audition, Applegate has a little more of a Valley girl lilt to her lines, like when she refers to Ron as her "gentleman lover," but her steeliness is already present. Each insult she proffers, like when she tells Ron, "Your penis is so small I thought it was your finger," is wielded with maximal intent to wound. Alicia bounced back and forth between being funny and being self-serious, the designated straight man who also had a silly side, and Applegate proved herself ideally equipped to handle both. Applegate's tone, vibe, demeanor, and look were all channeling that ideal version of Alicia Corningstone, and McKay and Ferrell knew the role was hers.

There were other, supporting roles still left to fill. McKay (a longtime fan of Public Enemy) and Ferrell had gone out for drinks at the Stinking Rose on La Cienega Boulevard with the group's lead MC, Chuck D, asking him to to consider taking a role in their silly newscaster comedy as Alarm Clock baddie Malcolm Y. They were pleased to win him over and cast him alongside Kevin Corrigan as the group's leader Paul Hauser, Maya Rudolph as Kanshasha X, Tara Subkoff as Mouse, and Amy Poehler as a bank teller.

In the shooting script of the film, there is a scene in which Ron visits his journalism mentor, Jess Moondragon, an enthusiastic nudist with a propensity for sexual references to Mother Nature. McKay and Ferrell approached Ted Koppel to see if he might be willing to play the role. It was the fastest no they had ever received.

They also asked Martin Sheen, thinking that the presence of an esteemed actor might heighten the comedy in this sequence. They

sent the script to Sheen's agent and eventually got the *Apocalypse Now* actor on the telephone. "Adam, this is a wonderful script," Sheen told him. "It's so imaginative and absurd and, you know, I'm just at a point where I don't do anything unless it's connected to something that I believe in strongly," he said, going on to list some of the human-rights-oriented projects he had recently tackled. "But I just have to wish you the best. And I could just tell you got a lot of energy, you and your partner, Will, and just thank you so much for thinking of me." McKay hung up the phone with a room full of people crowded around, waiting to find out whether Martin Sheen would appear in *Anchorman*. "He said no," McKay told them, "but that was a wonderful no." (They wound up casting Chad Everett in the role, which was eventually cut from the movie.)

THE CAST NOW assembled, it was time to begin crafting the look and feel of the film. Every afternoon during the roughly six weeks of preproduction for *Anchorman*, cinematographer Tom Ackerman and McKay would get together in McKay's office and review the movie's list of shots. Ackerman would then spend the next morning going through the shot list, polishing and tweaking their work.

Anchorman was to take place in an institutional setting in a particularly unbecoming era for décor, and he thought there would not be much to distinguish it from a nuclear-disaster movie set in a Nebraska silo. Ackerman thought back to a bit of guidance offered by Tim Burton when he worked on *Beetlejuice*: "Well, Tom—make it weird."

Portland was now left behind. McKay and Ferrell realized that,

without tax incentives, it would be impossible to film there. The actual shoot would take place in Los Angeles, and San Diego was selected as a location for which L.A. could easily double.

From the earliest preproduction efforts, Ackerman knew the film would start with a helicopter swooping over San Diego and a sharp cut to a single white shoe stepping into the frame, posed against the skid of the helicopter. Ackerman and McKay were not thinking of Adolf Hitler, but there was a convergence between the introduction of *Anchorman* and *Triumph of the Will,* in which the Nazi dictator famously floats through the clouds before descending to earth and the huzzahs of the Nuremberg crowds. (Pity poor San Diego, only two hours south of Los Angeles and yet not appearing at all in a movie ostensibly set in San Diego. The production had budgeted one day to shoot in the actual San Diego. Ferrell flew in a helicopter over the city, and after it landed, he was shuttled to a small handful of notable destinations, like Balboa Park and the city's downtown. None of the sequences wound up making their way into the finished film.)

During preproduction, production designer Clayton Hartley and his team were expected to take the 1970s newsroom flourishes of the script and construct sets and backdrops that would transport viewers to a bygone time and place. Hartley had gathered an array of reference materials for his crew to pore over, from period photographs to furniture catalogs to clothing advertisements to back issues of *Life* and *Vogue,* in order to study the visual aesthetic of the era. Hartley also visited local newsrooms to glean what the work environment might look like. The studio would be in muted grays, blacks, and whites, while the bullpen area would be more colorful.

Hartley brought in illustrator Alex Hillkurtz, who was hired to draw large color illustrations of each of the sets. It was particularly

enjoyable for Hillkurtz to put together the drawings for Ron's apartment, which featured a shag carpet, a round bed, and an orange wood-burning stove.

Location manager Jeremy Alter was one of the very first people hired after the production received a green light. He looked at a Johnson & Johnson property in East Pasadena and the KCOP offices in Hollywood to use for their studio scene. This was a real television studio, where the film could not only shoot but set up its production offices as well, but the deal fell through.

The production wound up in the Seeley's Furniture store in Glendale, where a number of other recent films had been shot. From the exterior, the building still looked like a functioning furniture store, but the interior was cavernous, with enough space to construct the bullpen and studio sets on the lower level, along with the control room and station manager's office on the mezzanine. When the crew arrived, there were still the remnants of past films, including a riverboat set from a Coen brothers film, strewn about the store.

Alter accompanied McKay and Clayton Hartley on a scouting tour of potential locations, with Ferrell occasionally joining them as well. Their trip ranged from Palmdale, where they would shoot a brief scene of a disheveled Ron stumbling along the side of the road, to Altadena, where the funeral for Ron's dog, Baxter, was to be filmed. Ferrell quizzed Alter about the filmmaking process as they drove around Los Angeles, and Alter joshed with him not to tell anyone that this was to be for a Will Ferrell comedy, because it might scare away potential locations: "Then we're fucked!"

Set decorator Jan Pascale, who had come up working on *Mister Rogers' Neighborhood* and the films of George A. Romero in Pittsburgh, wandered the aisles of the prop houses, looking for just the right flourishes to help flesh out these characters. Pascale was tasked

with sourcing equipment for the studio set, tracking down 1970s-era Steelcase office furniture and painting desks and file cabinets orange and yellow for the period-appropriate feel. She soon became known around the set as "the period police" for her scrutiny of the décor. Pascale would flip through her collection of old Sears and JCPenney catalogs to make sure she was in the right ballpark and would regularly tell others, "Nope, that wasn't invented yet. You can't use that. Get that out of here."

Pascale worked with an equipment-rental company that had 1960s and 1970s typewriters that not only looked presentable but actually worked, so that the newsroom bullpen could look and sound like a hive of frenzied activity.

For Ron and his fellow newscasters, a single idea became fixed in Pascale's mind as emblematic of their approach: failed classiness. Ron was desperate to come across as suave and sophisticated, and it was in the gap between desire and reality that Pascale found inspiration.

Ron Burgundy was given a bragging wall of realistic-looking awards, along with framed photographs of jazz musicians and newscasters, and a side table of crystal decanters. Inspired by a tour she had taken of NBC News anchors' desks, Pascale placed mirrors, hairbrushes, razors, combs, and hairspray under the studio desks.

Pascale wanted to drop copious visual hints that News Channel 4 was a hard-drinking workplace, with Fred Willard's Ed Harken also given an unsettlingly extensive-looking bar in the corner of his office. Harken also got a slot machine and numerous other small touches intended to emphasize his underhanded, sleazy side. McKay suggested they also add whiskey glasses under the anchor desks.

Perhaps the most memorable props in the film were found in Brian Fantana's cologne cabinet, which he would raid in a failed

attempt to win over Veronica with his man musk. Pascale had been debating how the colognes should be accessed, running over her options. Should they be inside a safe? Behind a picture that could be taken down from the wall? At one prop house, Pascale came across a wall of framed book bindings. Her first thought was, "Who on earth would ever want to decorate with these?" Her second thought was that these would be perfect. It was just the right touch of mock-genteel pseudo-sophistication for Brian, whom we could hardly imagine owning a single book, to see literary snobbery as the ideal cover for his genuine interests.

On the day of her interview with Adam McKay and the film's producers for the job of costume designer on *Anchorman*, Debra McGuire brought in a photograph of herself. In the photo, she was standing in front of the gates of the University of California, Berkeley. The year was 1970, and the photo was intended as proof of her qualifications. "I could probably do this movie with my eyes closed," she told them, "because this is my era. I'm really passionate about it because it's such a formative time in my personal and creative development."

McGuire, already famous in the industry for serving as the costume designer for *Friends*, had first encountered Will Ferrell when her teenage son dragged her to a screening of *Old School*. She was unfamiliar with Ferrell but proceeded to thoroughly embarrass her son (and his friend) by laughing uproariously throughout the whole movie. Soon after, a script arrived for her called *Anchorman*. When McGuire heard who the star of the film was to be, she flipped.

McGuire and her goddaughter spent a day wandering around Los Angeles, driving from location to location to check in on several projects she was working on. As McGuire drove, her goddaughter read her the *Anchorman* script from the passenger seat. Many

scenes had songs appended in the script, and McGuire knew them all, singing or humming along with dimly remembered ditties like the Friends of Distinction's "Grazing in the Grass." The two women were laughing so hard at the script that by the end of the day, when they reached the last page, McGuire was sure of one thing: "Okay, I'm definitely doing this movie!"

McGuire and her longtime collaborator Joseph Mastrolia began by paging through back issues of *Vogue* and old Sears and JCPenney catalogs, and watching 1970s shows like *Barney Miller* (whose preference for zany ties they admired). These characters were to be Me Decade archetypes, dandies in polyester, their paisley ties as wide as their smiles, their taste for loud geometric and floral patterns speaking to a lost world of masculine peacocking.

McGuire summoned the performers to her offices at Universal Studios and asked them to look through the clothes she had selected and get accustomed to them. "What are you feeling? What is the mood?" McGuire and Mastrolia would ask them. "What colors are speaking to you right now?" Once the men had selected the kinds of pants and jackets they preferred, McGuire could begin to narrow down their wardrobe and select the individual pieces they would wear.

Seventies clothes were cut differently from their contemporary counterparts, tighter in the arms and around the waist. Mastrolia could see the clothing come to life as the performers slipped into each item. There was a certain body language that went with these clothes, one that they taught to anyone who put them on.

McGuire had rarely had this kind of time to lay out her characters' costumes so carefully, or the support of a director who so thoroughly understood her aims. She could search through fashion dead-stock pieces for inspiration, and many of the small details,

from the way a pocket was designed to the elegance of a Diane von Furstenberg wrap dress, inspired the clothing seen on the screen, which McGuire mostly designed herself.

Ron Burgundy, McGuire decided, was someone who would have his suits handmade for him. Ron wore three-piece suits, granting him, in McGuire's estimation, a certain additional armor. Brick Tamland was intended to be a kind of bargain-bin version of Ron, his three-piece suits just a tad less flattering and fitted than his anchor colleague's. Brick was hoping to put together an off-the-rack analogue to Ron's stylish look, but his suits were always a bit heavier, a bit clunkier, than Ron's.

Brian Fantana was given a vintage leather jacket uncovered in a costume house that had just the right scuzzy feel, along with jewelry and ties with designs of flowers and butterflies. Champ had a cowboy vibe, with a ten-gallon hat and Western-style pockets on his suit.

McGuire dressed Christina Applegate in hot pinks, purples, eggplants, and light blues to offset Ferrell's darker tones. Alicia Corningstone's white jumpsuit, worn the first time she meets Ron, was a shot of Lauren Bacall–style classic-Hollywood elegance straight out of *The Big Sleep*.

Applegate was unavailable to do the early fittings, but McGuire was the same size as the actress and served as her own fitting model, trying on all of Alicia's clothes and tailoring them, so that by the time Applegate arrived on set, practically all her wardrobe was complete.

Kim Greene came onto the *Anchorman* set with plans for how to transform Ferrell into Ron Burgundy. The makeup department head took a trip to the central branch of the Los Angeles Public Library downtown with a mission: to research 1970s newscasters. Greene

wanted to arrive on set with detailed knowledge of what real-life broadcasters of the era looked like. She searched for 1970s magazines and books, lugged them in towering stacks to the library copier, and put together an era-appropriate look book that could serve as a reference point.

All of Greene's plans were instantly jettisoned when the film's star walked in the door. Ferrell came in with his own mustache, which was lush and full and ever-so-slightly off.

Greene studied his mustache closely and realized that there was no hair under Ferrell's nose. At its top, the mustache formed a thin straight line, leaving a faintly dread-inducing patch of bare skin on Ferrell's philtrum. Greene struggled with how to respond. "Is that what you meant to do?" she tentatively asked him.

"No, this is it. This is Ron Burgundy," Ferrell said.

"Great, I love it," Greene responded.

She hated it. But the antipathy did not last for long. The mustache was quirky and off-putting, and Greene quickly understood that the men of *Anchorman* were meant to be exaggerated versions of what was already an exaggerated era. Ferrell saw the mustache as a tip of the cap to the Burt Reynolds–style 1970s male sex symbol, of whom Ron would see himself as a direct inheritor, a good decade before the mustache's ironic, Williamsburg-hipster return.

But the roots of Ferrell's look were in his own physical discomfort after growing a mustache. It was a sponge for his meals, soaking up soup and serving as an unwanted receptacle for all his crumbs. Moreover, Ferrell's hair was naturally curly, and his mustache hairs were curling upward and tickling the interior of his nose. Ferrell began shaving under his nose in the hopes of reducing the infernal tickling, and the clean-shaven gap kept growing and growing until it resulted in Ron's distinctive look.

Greene also had a wig designed for Ferrell to wear as Ron. It was fitted, groomed, and cut, and then adjusted to give it more of a pompadour-esque heft, like it had been blown and sprayed to within an inch of its life.

Where Ferrell's look was deliberately overmanicured, the look Greene crafted for Paul Rudd was shaggy and slightly unkempt. He had been growing out his facial hair, and Greene shaved it slowly until they were both pleased with the look. They took photos and sent them out to McKay and other interested parties. Brian Fantana's mustache drooped slightly over the edges of his lips, that extra quarter inch enough to speak to untapped depths of dirtbag depravity. Where Ron's was meant to channel subliminal cues for Walter Cronkite, Brian's was meant to hint at "roadie for Grand Funk Railroad on the '74 world tour."

Leaning on her research into newscasters like Diane Sawyer and Jessica Savitch, Greene saw Alicia as a femme fatale with an effortless ability to pull together a coordinated look. She imagined Alicia always matched her lipstick, eye shadow, and nail polish to every outfit, even if that meant Greene was redoing her makeup four or five times over the course of a day. The foundation and the cheeks stayed the same, but Greene, a talented quick-change artist, would swap out the eye shadow and lipstick for Applegate during the lighting changes between scenes. Joy Zapata, who styled Applegate's hair, envisioned her as a Veronica Lake type with a coiffed blond do inspired in equal parts by classic Hollywood and the anchorwomen of a bygone era. Zapata wanted Alicia to look good enough to make us believe that Ron would fall in love with her at first sight. Applegate also wanted Alicia to look notably softer than the actual anchorwomen of the era, seeing her as someone who fully embraced her femininity.

Meanwhile, McKay and Ferrell guided the cast through lengthy rehearsals of the script. They had two main tasks: letting the actors get acquainted with the script, and getting them accustomed to the process of improvisation. It was important to McKay to give the actors a chance to talk through their choices with the script. If they had carved out three hours on a given day to rehearse, he would devote at least an hour to letting the actors ask questions and discuss how they might play a given scene. During rehearsal, a script supervisor would be present to jot down notes on any unscripted riffs the performers might come up with, in order to have a reference point available for the eventual shooting day.

The cast's initial table read was also an opportunity to let the script breathe. Carell and Rudd were not available yet, so Jay Johnston was reading the role of Brick, and future *Veep* star Matt Walsh was serving as Brian. Johnston's Brick was more suave that Carell's would be, and Walsh enjoyed screaming ("Hey, jagoff!") more than Rudd. "Which proves yet again that even a blind man and his pet falcon can find happiness in this world we live in," Ferrell, already with his trademark Ron Burgundy mustache, clad in a T-shirt with an illustration of an otter and with his own curly head of hair on display, offered as one newscast sign-off, to raucous laughter from his fellow performers.

There was a palpable enthusiasm for the script during the read, with numerous scenes being broken up by laughter. Everyone loved hearing Koechner say "Munch munch" while he imagined himself chomping on Alicia's butt, and Ron's line read of "I'm Ron Burgundy?" sent his costars into hysterics. There were still some slight differences in the script. Brian's cologne was referred to as "Sex Panther by Prince Machiavelli." And it was Frank Vitchard, not Wes Mantooth, whom the News 4 team had a charged encounter with

over the most recent ratings. And Alicia was not yet Veronica. The name change came after the first table read—perhaps because Alicia Corningstone sounded too much like the name of actress, and erstwhile Rudd costar, Alicia Silverstone?

When it came to the shoot, McKay wanted his actors to know that he was planning on tossing ideas out for them to play around with. They would film the lines as scripted and then would try out alternative versions of the scene. Moreover, it would not only be McKay who would have this leeway to improvise. He would be calling on each of them as well and was hoping they would embrace the spirit of improvisation.

It was important to McKay that he ensure the comfort of his actors. He approached them and told them that he was planning on occasionally calling out suggestions they might try. Would they be okay with that? McKay was possessed of a powerful instinct that his Chicago and *SNL* experiences could be translated to feature filmmaking, and he set out in search of a common language that he and his cast could share.

PART 2

That Escalated Quickly

CHAPTER 4

Jogging—or Yogging

T HE SHOOT WAS about to commence. But before it could begin, the backdrop to Ron Burgundy's adventures would have to be set, and an enormous part of that work would involve considering the era of the film.

In what year of the 1970s does *Anchorman* take place? This is, on its face, a ludicrous question, as the answer is clearly all of them.

In American life, we have devoted an outsized amount of mental energy to carefully divvying up American history into decades, assigning ideas, attitudes, and ideologies to each ten-year segment. It is part and parcel of our collective desire to tidy what is inherently messy and lawless, to craft easy-to-follow narratives about the past.

Comedy in particular benefits from this misleading shorthand, allowing a movie to place itself in a historical era and roam across the landscape of the past in search of parodic material. We can laugh at the foibles and blind spots of our predecessors, their moral and emotional lapses, and feel comfortably smug about our own enlightenment and tolerance. And no decade in recent times has been the subject of quite so many titters as the 1970s.

The 1970s: dreamland of wide mustaches and longer cars, flagrant self-absorption and societal chaos. The Me Decade is the psychic landscape that *Anchorman* roams, and the time frame is carefully, deliberately chosen. The 1970s are not the conformist 1950s or the turbulent 1960s. They are perceived—wrongly—as a vast, formless space, a vacuum left behind by the failed dreams of the 1960s.

Crass, ugly, pointless, disorganized, hapless, failed, embarrassingly narcissistic, the 1970s have served as an all-purpose scapegoat for many of our national failings. The 1970s are our collective attic, and we like to occasionally wander among its detritus, if only to remind ourselves how much better our taste is than it once was.

The decade is the place we stick the worst parts of our personalities, insistent that we have left all of that—the blatant racism, the jolly sexism, the boorishness and cluelessness and deliberate crudity and callousness—in the past. We have not, but the modest progress of the past half century of American life grants storytellers permission to revisit the 1970s and give audiences a chance to celebrate their own progress. It is only too easy to lapse into perpetual pessimism over the limited scope of change in our time. Perhaps the prospect of spending ninety minutes in the cohort of Ron Burgundy and his colleagues is not only valuable entertainment but a sideways reminder that we are not who we once were and are to be lauded for the steps we have taken.

Anchorman is a kaleidoscope of overlapping perspectives on the 1970s, from its music to its cars to its fashion to its news programming. For *Anchorman*'s purposes, the 1970s efficiently symbolize twin states of being: terminal uncoolness and a stiff-necked resistance to tolerance. We are asked to observe the vapidity and ugliness of the era in all its glory, and to revel in its chartreuse-hued splendor.

The prominent placement of the news crew's rendition of the

Starland Vocal Band's "Afternoon Delight" raises the possibility that our movie takes place near the peak of the song's fame, in the summer of 1976. Gerald Ford and Jimmy Carter were facing off for the presidency in the first post-Watergate election. The country was fretfully celebrating its bicentennial, *Rocky* was a sleeper hit at the box office, and *All in the Family* was the most popular television show in America. It is possible to read *Anchorman* through this lens and see it as a reflection of the country's bicentennial blues, the nation hesitantly adjusting to the desires of outsiders wanting to be let in on the promises of freedom. (Champ's passing mention of slugger Gene Tenace might push the time frame into the spring of 1977, when he first joined the San Diego Padres.) The song is a paean to love by a sensitive but cloddish white guy, and as such is the ideal vehicle for Ron's ode to love, which feels romantic while also being nothing of the sort.

"Afternoon Delight," with its gentle guitar licks and multipart harmony, was anti-disco in orientation if not direct intent, its white-bread simplicity a notable part of its success.

Perhaps the fullest legacy of the song can be glimpsed through a series of reaction shots during Starland Vocal Band's performance of "Afternoon Delight" on their short-lived 1977 CBS variety show (featuring David Letterman as a writer and occasional performer). A handful of Black construction workers look on, befuddled, as a white crowd bops along to the music at an outdoor concert. This is music for the silent majority; none of that soul or disco tripe, thanks.

The remainder of the musical selections for *Anchorman* sticks to a similar template. Adam McKay expressed comic frustration that, in making *Boogie Nights,* his almost-producer Paul Thomas Anderson had pilfered all the best pop songs of the era.

Anchorman is enamored of a particular brand of past-its-prime,

semi-sleazy romantic number, preferably by a male artist of a certain age, and so when Ron catches his first glimpse of Veronica, it is Neil Diamond's "Cherry, Cherry" we hear, with its refrain of "She got the way to move me."

"By the beard of Zeus!" Ron blurts, overcome with emotion at the sight of this goddess. He loses her in the party crowd, and it is only when he spots Veronica again, a vision in white silk, her blond hair tumbling down over her shoulders, that the familiar strains of Bill Withers's "Use Me" kick in, with Ron letting out a growl of pleasure at finding her once more.

For the "Pleasuretown" sequence, in which Ron and Veronica traverse a fairy-tale animated landscape during their first romantic encounter, Tom Jones's "Help Yourself" provides the soundtrack. The stately horns, aligned with Jones's manly rumble of a voice, make the sequence feel like Ron's own romanticized notion of himself, and a living document of the freewheeling sexual revolution vibe: "Love is like candy on a shelf / You want to taste and help yourself."

It is less the 1970s here than the Eternal 1970s, that place located somewhere in America where the Me Decade has never ended, where bell-bottoms and earth tones are eternally cool, where sedans are the size of small boats and get eight miles to the gallon. The 1970s, in the estimation of *Anchorman*, is the place where all bad trends go to die, or better yet, to live the life eternal of rejected fashions, outmoded ideas, and junked styles. They are the bad old days, and in that understanding, it is crucial to the film's aesthetic and its political agenda that the movie tip its cap to the ludicrousness of this far-off time.

From the very first moment of *Anchorman*, we are encouraged to mythologize its protagonist. The film, after all, is subtitled *The Legend of Ron Burgundy*, and we are invited to understand *legend* in two

different ways: as the story of a remarkable, larger-than-life figure, and as a fairy-tale story, not meant to be understood literally.

"There was a time, a time before cable, when the local anchorman reigned supreme," the film's voice-over narration begins. "When people believed everything they heard on TV. This was an age when only men were allowed to read the news. And in San Diego, one anchorman was more man than all the rest." The table has been set for us, and we are returning to a bygone, quasi-mythical era of inordinate trust in institutions and unthinking masculine supremacy. "He was like a god walking amongst mere mortals. He had a voice that could make a wolverine purr," Bill Kurtis's narrator informs us, "and suits so fine they made Sinatra look like a hobo. In other words, Ron Burgundy was the balls."

Ron is not only a mere mortal reading the news for a moderately prosperous Southern California city; he is a product of the realms of the imagination, existing in the rarefied air of mythos. Perhaps as a byproduct of his training as a newscaster, Ron speaks in grandiose flourishes, his casual conversation studded with near-profundities.

Ron's explosions of mirth, surprise, or emotion often feel channeled from some imaginary past. This Ron is less a 1970s Californian than some heroic figure from the Knights of the Round Table. Expressions like "Great Odin's raven," "Knights of Columbus, that hurt," "By the beard of Zeus," and "Sweet Lincoln's mullet" all seek to align him with a heroic past of great men, now dissipated. And when he imagines his own life, it is the language of the mythical that feels most comfortable. Everything is exaggerated, puffed up, grandiose—tops of mountains and garlands of herbs and rich mahogany and glorious rainbows.

Ron, seeking cool, is terribly uncool, which makes him cool

again. Nowhere is this dichotomy clearer than in Ron's ownership of a 1970 Pontiac Catalina, in what General Motors would call "Palomino Copper" and what a non-gearhead might refer to as "Shiny Dirt." Ron cruises the freeways of San Diego in this two-door behemoth, its front shaped like an immensely wide University of Texas Longhorns logo. The interior of Ron's car, when we catch a glimpse of it, is every bit as much a testament to the monochrome powers of the color brown as its exterior.

The Catalina is a relic of a past age, when ordinary Americans still drove domestic sedans, content with their poor handling, subpar styling, and absurd gas mileage. Ron's Catalina is emblematic of his proud ineptitude. It is not a Cadillac. It is not even a top-of-the-line Pontiac. It is a second-tier car from a second-echelon line from a second-rate car company, but it is impeccable. It gleams so brightly we wonder if Ron might polish its hubcaps each time he is stopped at a red light. Ron loves this junky car and is clearly impressed with himself for owning such a sexy beast. Its design harkens back to a long-gone West of cowboys and cattle drives. The Catalina is bruised-romantic Ron's trusty steed.

Ron's car is telling in how it asks us to nostalgically relate to the vision of the past it offers. This is not the 1950s or the 1960s, and Ron is not driving an instantly recognizable cool car, a '56 Corvette or a '65 Mustang. It is an also-ran car from an also-ran decade, a harbinger of a crash to come. It is a car from the very last moment before American highways became display showrooms for Toyota and Honda. This Pontiac is a combustion-engine version of Ron himself, puffed up beyond all endurance, sure of its permanent triumph. Ron drives a future denizen of the scrapyard too in love with its own minor upgrades (that grille!) to acknowledge its own imminent obsolescence.

In his car as in so much else, Ron is gesturing to the audience about how we might take him in. Ron is a dinosaur, a relic of a long-ago past we might chuckle good-naturedly at. We can watch him at a safe remove, enjoying his quirks and flaws, secure in the knowledge of how far we have come since those long-ago days.

What is true of Ron's musical preferences and his car is true of his lifestyle as a whole. Ron is radiantly clueless, and even his efforts to adapt to the new are touchingly ill-informed. "Veronica and I are trying this new fad called, uh, jogging," Ron tells the crew at lunch. "I believe it's jogging, or yogging. It might be a soft *J*, I'm not sure. Apparently you just run for an extended period of time. It's supposed to be wild." We get a chuckle out of how benighted the 1970s were, when even something as milquetoast and dad-core as jogging was brand-new. Ron is later taken to task by Veronica for discussing their relationship on air and vainly attempts to change the topic by referencing another bygone fad: "Mmm-mm, that is good fondue."

Ron's Catalina is a lagging indicator of bygone glory days. What we see of his channel's news coverage suggests that 1970s news, like 1970s cars, is coasting on the fumes of past successes. In all that, we might glimpse the shadow influence of Bill Kurtis, who—years before he had ever heard of a movie called *Anchorman*—was a newsman articulating a critique of the ways in which local news misled and disappointed its audiences.

By the late 1960s, polls showed that almost two-thirds of Americans depended on television to receive their news. For many Americans, television news *was* the news. The late 1960s had been a golden

age of broadcast-news reporting in large part because so much of the news of that fragile and tormented era had been broadcast-ready. Gritty, in-depth, wide-angle news was immensely popular. The biggest news had been visual, grabbing distracted viewers' attention instantly: the war in Vietnam, assassinations, riots, political unrest. And the news began chasing similar highs, even when those stories' importance was artificial or unduly inflated.

"I see a fork in the road . . . and we are heading in the wrong direction in television news. There are a lot of things that dictate to us that we stay with the superficial. The direction is not toward substance in local television news, but to a more superficial coverage," Bill Kurtis, still three decades away from serving as *Anchorman*'s narrator, told Ron Powers for his 1977 book *The Newscasters*. Kurtis had made a name for himself when, as a part-time television reporter and a law student at Washburn University School of Law in Topeka, he had gone on the air during the 1966 tornado and told residents, "For God's sake, take cover." Sixteen people died in the Topeka area, and residents gave credit to Bill Kurtis for his warning, which may have saved many lives.

Kurtis moved on to Chicago, and covered the 1968 Democratic convention and the assassination of Dr. Martin Luther King Jr. Kurtis thought of himself as a local-news foreign correspondent. He reported from Belfast, Tehran, and Saigon. By the late 1970s, Kurtis had grown disillusioned with the local news, and it was all due to a new arrival often called Eyewitness News.

The Eyewitness News model eschewed newsworthy stories for visual stimulation. A robbery was good; a raging fire was better; an ongoing police chase was best. Stories, as Kurtis told Powers, that lacked dynamic visuals were a hard sell for television. This meant that many stories of urgent importance to the larger public, like

racial bias in home mortgages, were nearly impossible to report for television.

The Eyewitness News model was often conjoined with a new style of on-air rapport between newscasters referred to as Happy Talk. The format, with its "aura of exaggerated joviality and elbow-jabbing comradeship," as Powers described it, was also a Chicago invention, originating on WLS in 1968 and soon spreading around the country. Local-news teams began to be regularly referred to on air as "families," with the audience included in the joshing, light-hearted atmosphere.

On some thirty-minute broadcasts, the reporting of the weather took up an astonishing three and a half minutes of airtime. And much of the remainder of the broadcast was filled with discussion of weekend plans, dinners, and golf games. (Cue Ron's asking Brick if he is planning on hosting his celebrity golf tournament again this year. "No, no," Brick responds. "Too many people died last year, so we're not gonna do it.")

The news, in the 1970s, was redesigned to be as inviting and friendly as possible, and to report on what you—a member of the audience—wanted to hear about most. It was understood that the local news would no longer do any hard reporting, would not cover stories with policy or societal import, would not reflect hard truths back to a too-comfortable audience. Instead, audiences would watch a hastily edited nightly compilation of action sequences, puff pieces, and human-interest stories designed to flatter their preexisting beliefs, juice their adrenaline, and warm their shriveled hearts.

The anchors and newsreaders of a previous generation—men like Walter Cronkite, Edward R. Murrow, and David Brinkley—had accrued the respect of the television audience because of their earned reputation as impartial arbiters, able to speak the truth to a

vast public hungry to understand their country. The new television-news model inverted that relationship, drawing attention to the broadcasters and transforming them into minor local celebrities. *Anchorman* exists in the space carved out by Happy Talk.

Anchorman's introductory scenes place the News Channel 4 team squarely in the Happy Talk/Eyewitness News camp. A brief montage assembles the news team for the nightly intro to the broadcast. As Ron gulps a few last sips of scotch at the news desk, we hear him being introduced: "Channel 4 news, with five-time Emmy Award–winning anchor Ron Burgundy."

The camera cranes upward to a billboard featuring Ron gazing out smugly at his audience. The tagline for the billboard reads, "If Ron Burgundy Says It . . . It's the Truth!" Ron bursts through his own oversized visage, strutting purposefully toward the camera. We cut to each member of the news team doing what he does best. Champ slugs a home run in an impromptu stickball game (right in front of a sign that reads, "NO STICKBALL PLAYING"); Brick offers an awkward smile and wink while getting a haircut; Brian appears to be harmonizing with a street-corner doo-wop group before whipping off his sunglasses and revealing himself to the camera. Champ is the sports guru, Brian the urban chameleon, and Brick—well, Brick has a nice haircut and knows how to smile.

The four men stride toward us, arrayed with the beanstalks (Ferrell and Koechner) in the center and the shorter men at the sides. No one appears to know how to walk like a human being. Ron marches with an awkward gait, his arms firmly clasped at his sides, like a new recruit at boot camp. Brian is trying too hard to come off as cool, and Brick appears to be auditioning for a role as a Prussian military officer. When Powers describes "full-page newspaper ads that trumpet a news team as though it were a new kind of low-tar

cigarette . . . and principal reporters riding around in cowboy suits on white horses," we know precisely what he is referring to.

This is the news being sold as a product, with the four men awkwardly gathered in a loose half circle, clutching important-looking papers, to discuss the day's broadcast. The intent, we understand, is to sell this quartet as a serious team of news gatherers, their ears pressed firmly to the San Diegan ground, but everything is subtly off. The aura of self-satisfaction is intense enough to throw everything off-kilter, and instead we see Powers's description of these news teams as "people who grinned wryly at one another." We are given a broad hint of what to expect when we are later introduced to Ron's dog, Baxter, named after Ted Baxter (Ted Knight), the amiably buffoonish anchor of *The Mary Tyler Moore Show*—another depiction of the foolishness of local news in the 1970s. Ron is like Ted Baxter ushered to center stage in his own story, and without the soothing presence of Mary Richards to temper his stupidity.

And so we arrive at the very first story of the News Channel 4 broadcast, which manages to brilliantly summarize all these developments decried by Powers in a matter of seconds. "Good evening, I'm Ron Burgundy," Ferrell tells us, "and this is what's happening in *your* world tonight." *Your* is doing herculean work here. Ron has pared away all the complexities and ambiguities and left only the sensationalized shell of the news: "A La Jolla man *clings to life* at a university hospital after being viciously attacked by a pack of wild dogs in an abandoned pool."

The details here are superb—the abandoned pool is so good in making this ludicrous story feel palpable—but we are drawn back to Powers's observation that these post-Watergate broadcasts' job is "persuading viewers nightly that things are generally okay, that there are no deep structural flaws in the society they live in, that

laughing and drinking beer are the accepted responses to the American community in the seventies." The not-particularly-frightening drawing of a Doberman pinscher, with a caption reading, "BARK! BARK! BARK!," only adds to the sense of weightlessness. If the biggest story in *our* world this night is that a man has been bitten by a dog, we are given liberty to rest comfortably in our ignorance.

The news itself seems to consist of reports about water-skiing squirrels, with Brian and Champ casually tossing a football over Ron's head mid-broadcast, and Brick reporting on the weather in "the Middle East" while pointing to roughly South Dakota on his map. "What Brian didn't tell you," Ron reports jocularly at the end of another broadcast, "was that those were *not* real pirates." The context does not matter; in fact, the utter absence of context only makes the absurdity shine through more brightly. "Super-duper!" Ron shouts when he learns that Channel 4 is first in the ratings once more, and we are confused: Is his channel number one despite their rank amateurism, or because of it?

IN ALL THE symbolic visual language of the 1970s found in *Anchorman*, nothing occupied so vivid a space as a single patch of hair in the middle of Will Ferrell's face. A journalist would later describe how an interview with Ferrell had been hijacked by the writer's inability to look away from his mustache, which was "lush yet disciplined . . . cruel yet not haughty."

If the 1960s had been the era of the beard, whose masculine scruffiness was intended to evoke disdain for the straight world, the 1970s had seen a reduction of that preference to the real estate be-

tween the nose and the upper lip, and a swap of that deliberate squalor for a carefully cropped demonstration of manly vigor.

It was hard to look at Ron Burgundy's face and not be transported to lost realms of masculinity evoked by his lush mustache. Ron's style called back to the even carpeting of Golden State Warriors star Rick Barry, curling down toward his lower lip (Ferrell would later play a Barry-esque ABA star in his 2008 film *Semi-Pro*), and to the baroque excess, complete with upturned Gallic curlicues at the corners, of Hall of Fame pitcher Rollie Fingers. It brought up memories of legendary Olympian Mark Spitz, decked out in a golden breastplate of medals at the Munich Olympics in 1972. It could not help but evoke Burt Reynolds, possessor of perhaps the most legendary mustache of the 1970s, which spoke of easy charm and devil-may-care sensuality.

More than anyone else, though, Ron's bushy protuberance was meant to call up memories of Walter Cronkite, anchor of the CBS news from 1962 to 1981 and widely considered the most trusted man in America. Ron was ludicrous where Cronkite was serious, childish where Cronkite was mature, but the mustache was meant to remind us of the hold broadcasters like Cronkite had once held over a vast television audience. The mustache served as a symbol of masculine trustworthiness and solidity grafted onto this ludicrous man-child with barely enough self-possession to hold himself together for thirty minutes of reading the news.

These are the texts, if you will, of Ron Burgundy's mustache. But now we must press further and acknowledge our own discomfort, our creeping fear of the protuberance emerging from Ron's face. As Ferrell would note, a substantial portion of that discomfort comes from how carefully it is groomed, including that missing

quarter inch just under his nose. We look at it and silently consider the untold hours of work and maintenance required to keep it in such optimal condition. We might imagine Ron standing before his bathroom mirror in the evenings, after the cameras have been turned off, painstakingly clipping stray hairs in order to maintain its kilim-like perfection. The mustache is a visible symbol of Ron's towering self-regard and the intensity of his devotion to an idealized self-image.

But let us not stop halfway. Ron Burgundy's mustache is sexual. It is a sexual being in its own right. We might imagine it slipping away when its owner is safely asleep in order to romance some neighborhood wigs—or other mustaches. Ron's mustache calls up memories of the styling of 1970s gay culture and its codes of masculinity, and raises questions about the closeted gay man in his inner circle. Ron is, by most available evidence, firmly heterosexual, blind and deaf to the unruly emotional turmoil of his coworker and colleague Champ Kind. And yet there is something sexually fluid about Ron's mustache, the way that it asks us questions we do not know the answers to. What might it feel like to . . . kiss that mustache? "It's gross and exciting all at the same time," Christina Applegate would later note of encountering her costar's facial hair. "It's horrible. It's so disturbing, I've had nightmares about it."

Ron's mustache is slinky and disarmingly smooth. It creeps beyond the ends of his lips and toward his cheeks. If mustaches, like sports cars, are socially acceptable visual substitutes for the unmentionable, then Ron's deceptively vast mustache is yet further testament—or so he hopes—to his sexual potency.

☆

Letting the Squirrel Out of the Bag

A DAM McKAY HAD never overseen a full-sized production like this one, had never been responsible for hundreds of crew members and dozens of performers, but he was preternaturally calm. McKay never shouted, never got mad. He did not lash out or take out his first-time jitters on the cast or crew. And when anyone— whether it was Will Ferrell or a camera operator—had a suggestion or an ad-lib, he was open to hearing it.

It was important to McKay, both personally and artistically, that his sets remain oases of calm and good cheer. He did not want to be the raving maniac whose directorial whims struck fear into the hearts of his crew. He also knew that the style he was intent on crafting required his performers to feel free enough, and loose enough, to dive in. Being a jerk in comedy, McKay thought, simply did not work. He and Ferrell had learned that at *Saturday Night Live,* which was a highly competitive pressure cooker and also a fraternity of funny people who leaned on each other to succeed.

Improv required everyone to buy into the notion that failure was no big deal, that failure was in fact essential to the mission. If you

did not, at some point, try something and proceed to crash and burn with it, you probably were not trying hard enough. To yell and rant in that environment would have been ruinous to the mission of creating something fresh. A loose environment would allow all the performers to feel free to be as funny as they could be.

McKay kept reminding everyone around him that they were not, in fact, making *Apocalypse Now*. If they were trapped in the Philippine jungle, and helicopters were flying overhead, and the lead actor had just had a heart attack, and they were behind budget and behind schedule, it might have been reasonable for people to lose their temper. But they were in a converted furniture store in Glendale, and when someone began to throw a tantrum, McKay would interrupt them and say, "No, we don't do that."

It was an unspoken custom on most film sets to never offer an opinion on another actor's performance. The actor's work was fiendishly difficult, requiring them to expose themselves in a fashion that nonperformers could only relate to from their sweat-soaked nightmares, and the effort that went into even the most mediocre performance had to be respected by their fellow practitioners. But the actors on *Anchorman* had mostly been forged in the white heat of sketch and improv, where performers regularly topped, completed, or added to the work of others, and that spirit carried over to the set of this feature film.

This began in McKay's relationship to the performers. He was present not solely to oversee or to hector but to lead a graduate seminar in the creation of comedy. Every line could be improved or rendered funnier or stranger, and everyone was encouraged to contribute. This spirit of creative generosity came to include all the performers, who embraced the freedom to reimagine the film one line at a time. By the start of the shoot, the script had been through

table reads, rewrites, and punch-ups, and McKay and Ferrell were confident that the jokes were solid. Even if all they accomplished was filming the script exactly as written, they would be in good shape. But they were hoping for more.

McKay and Ferrell were seeking to re-create the improvisatory brilliance of *Saturday Night Live,* which was so rarely represented well on the big screen (*Wayne's World* and *The Blues Brothers* being the exceptions that proved the rule), while making a big-budget movie. It helped that McKay, Ferrell, Koechner, and Carell had all emerged from the world of sketch comedy.

McKay rapidly established a routine on the set. The actors would film two or three takes of a given scene, following the script to the letter. Once McKay felt confident that they had captured the essence of a scene as scripted, he would raise his voice and call out to the cast and crew: "Let's let the squirrel out of the bag." Koechner understood McKay to be declaring, "Say anything you want, and see if it sticks." McKay was opening the floor to input from himself, Ferrell, Apatow, the actors, or anyone else with a kernel of an idea for how to improve, twist, adjust, or reorient a sequence. They called these takes "alts." McKay, possessed of a naturally loud voice, did not need a megaphone or a "voice of God" microphone connected to speakers around the set. He could simply shout and make himself heard while standing behind the camera or sitting next to a monitor inside the video-village tent, which perhaps added to the informal, try-anything mood. Ferrell had already done his homework the night before shooting a scene, reading once more through the script in order to jog his memory about additional lines he might try out the next day. And the script supervisor's notes would also allow him to have a reference nearby, reminding him of what he and the cast had previously attempted during rehearsals.

Alts were a game, and performers who had been trained in improv comedy, and knew how to read a scene and grapple with its potential, were at a distinct advantage. The first few takes had been to serve the script, and even this open-mic style had to preserve the outline of the story. A line could be hilarious, but if it contradicted the remainder of the text, it would be unusable. You had to be able to read the mood of a line and substitute another idea that extended or amplified or twisted the joke. Some performers, like Fred Willard, who had worked extensively with Christopher Guest on films like *Waiting for Guffman,* were used to being handed little more than an outline and a précis of the information contained in a scene. Others, like Applegate, were more familiar with comedy that was entirely scripted. McKay's style combined scripted and unscripted approaches, demanding a confluence of skills from his performers.

The origins of the phrase "letting the squirrel out of the bag" are lost but might have something to do with a sequence early in the film. The news team gathers in the conference room the morning after an epic bender. Champ, his tie undone, his hat pushed back on his head, a square of bloody toilet paper stuck to his face, says, "I woke up this morning in some Japanese family's rec room and they would *not* stop screaming." That got a positive response, but then Koechner came up with an entirely different run (which would be used for the unrated DVD cut of the film): "I woke up this morning and I shit a squirrel. I mean it. Literally. Hell of it is, damn thing's still alive. So I got this shit-covered squirrel down there in the office. Don't know what to name it." (In another take, Champ said his night had consisted of six bottles of white wine, pissing his pants, and shooting stray dogs in Mexico.)

Holmes Osborne, a longtime friend of Koechner's, was sitting alongside Champ in the scene, playing a station executive. Koech-

ner had planned to go on with his run, talking about how he was not sure if the squirrel had shit on it or not, but was interrupted by the pleasant sound of his castmates' bursting into laughter and ruining the take. When the laughter died down, Will Ferrell turned to Osborne, the only performer who had not broken during the scene. "Oh, the *theater* actor," Ferrell said to Osborne with as much faux gravitas as he could muster. "The trained actor. He doesn't crack up. Now, that's really admirable."

Osborne was, indeed, a theater performer, who had been trained to always keep a thought in mind that held unwanted mirth away. As a secondary performer, Osborne did not want to do anything to jeopardize Koechner's performance or cause a take to be blown. But he enjoyed Ferrell's genial mockery of his theatrical technique.

To be truly brilliant at letting the squirrel out of the bag, it was helpful to listen attentively to others' work. Alts demanded heroic reserves of improvisatory creativity, which could easily inspire a narcissistic attention to your lines and no one else's, but the game worked best when actors bounced off each other's runs. After Koechner described shitting a squirrel, Steve Carell stepped forward and demonstrated how carefully he had paid attention to Champ's morning-after, bent through the broken aperture of Brick Tamland: "I'm sorry, Champ. I think I ate your chocolate squirrel." Koechner was deeply impressed that Carell had listened so closely and was able to craft his own alt to the alt. An entire night was devoted to Carell's infinite variations on this morning-after sequence, including one alt that would make the film's outtakes: "I ate a whole bunch of fiberglass insulation. It wasn't cotton candy like that guy said. My stomach's itchy."

It might have been possible for McKay and Ferrell to write the squirrel joke, given enough hours, enough caffeine, and enough

bursts of inspiration. But sometimes the best material came from turning over your highly polished script to others. McKay would tell actors that nothing could ever compare to the feeling of showing up on the day you were to film a scene, surrounded by the sets and the costumes, and letting your mind wander. The film would ultimately begin with a sequence knitted out of alts, with Ron warming up before a broadcast with a series of ludicrous vocal exercises, including "The arsonist had oddly shaped feet" and "The Human Torch was denied a bank loan" (which received the biggest laugh on the set). Ron also banters with offscreen figures, attempting to puzzle out one's name (is it Lanolin?) and picking at his teeth as he informs the no-doubt-fascinated crew that he ate ribs for lunch that day.

The opening, too, would emphasize the boozy, degraded vibe of News Channel 4, with Ron preparing for the night's broadcast by stretching to drain a glass of scotch and then sharing his enthusiasm with others: "I love scotch. I love scotch. Scotchy-scotch-scotch. Here it goes down. Down into my belly." Ron's voice takes on a singsongy quality, as if this were the theme song to his existence or the fuel that powers him through each night's news.

"The conventional wisdom is that men want to be funny to get girls, and that's true," Judd Apatow would later note. "But guys also want to be funny to make their friends laugh. Comedians, especially, enjoy each other's company." This was a multimillion-dollar project bankrolled by an enormous corporation whose director was intent on giving its key players the sensation of fucking around with their pals on a lazy, aimless afternoon. McKay, a relative newbie to the world of feature filmmaking, just assumed that this was how movies were made. David Householter, *Anchorman*'s co-producer

and unit production manager, begged to differ and kept approaching McKay to tell him, "This isn't the way it usually goes!"

McKay knew there would be moments when either the improvisatory technique or his desire to briefly confer with an actor would call him away from video village, where he positioned himself as the cameras rolled, and onto the set itself. He did not want to pause the shoot, and so he would call out, "Hold the roll," before running over to give notes. After several weeks, someone sheepishly informed McKay that he was using the phrase *hold the roll* wrong. Assistant director Matt Rebenkoff had told the crew that McKay did not know what *hold the roll*—which means "stop shooting"—meant, and to continue shooting each time he said it. "Why didn't you tell me?" McKay asked Rebenkoff. "I feel like an idiot!" Rebenkoff responded, "You just seemed so excited, I didn't want to burst your bubble."

McKay was creating an atmosphere that went against so much of the conventional wisdom of the film set. Letting actors play around as the cameras rolled was, generally, seen as the literal embodiment of setting cash on fire. Every foot of film, every minute of crew members' time, costs money, and opening the floor to let others play around on a film set was a recipe for utter chaos.

A few years prior, key grip Lloyd Moriarity had worked with James Cameron on *Titanic* and remembered Cameron (whom he greatly admired) calculating precisely what any crew delays would cost. On *Titanic*, the cost of a single minute's delay was $1,000. Even thirty minutes spent hastily planning something that should have already been designed would cost the production $30,000. *Anchorman* was not nearly so expensive a project as *Titanic*, but the principle still held. Yet McKay chose a different direction, perhaps

due to inexperience, but much more likely due to what he knew would work for this particular film. McKay knew his performers and knew that treating a set like an improv stage created opportunities for moments of unexpected brilliance.

Some scenes had a hyperabundance of possible lines from which to select, while others did not have quite enough on the page to come to life. While shooting the "Afternoon Delight" sequence, in which Ron fills in his colleagues on the meaning of love by leading a barbershop quartet version of the Starland Vocal Band hit, McKay approached Carell and told him, "We should have more lines for you, but we don't have any on the page." McKay asked him to jump in anyway: "Just say something."

McKay understood Brick as the Harpo Marx of this ensemble. Brick was less subject to the laws of physics, or the requirements of realism, than his fellow characters. He could comment on scenes or break the fourth wall without warning. McKay saw it as a magical power that was granted to Carell, but one that had to be used sparingly, for fear of spoiling the effect. After Ron waxes poetic about Veronica, Champ haltingly asks: "What's it like, Ron?" Ron takes his question to be about sex at first: "The intimate times? Outta sight, my man!" But Brian has a knottier and more shameful query in mind: "No. The other thing. Love." *Love* comes out as barely a whisper, with Brian closing the door before even saying the word.

After Brian's brief tribute to the Brazilian—or Chinese?—woman he made out with in a Kmart, Brick leaps in with his own interpretation of love as his eyes scan the room: "I love carpet." Ron nods encouragingly, and Brick continues: "I love desk." Ron—and Ferrell—catches on to what Brick is doing here and gently calls him out: "Brick, are you just looking at things in the office and saying that you love them?" Carell's delivery here is a master class in

intonation and rhythm. He stands ramrod straight in his three-piece brown suit, his eyes skittering to the side before facing forward, his voice lowering to a husky whisper: "I love lamp." When Ron asks again whether he really loves the lamp, Brick repeats his line, but this time with a tinge of sadness, as if lamp were the one who got away. It was pure brilliance, and only the improv process could have created the moment.

One day during the shoot, Koechner and Carell were sitting together during a break in the action. They were shooting one of the early showdowns between the News Channel 4 team and their rivals from Channel 9, led by Vince Vaughn's Wes Mantooth. Champ was supposed to approach Wes and threaten him, and Koechner and Carell put their heads together to discuss the sequence. The original line in the script had Champ threatening to smash Wes's face into a windshield. What else might Champ say? Koechner asked Carell. Carell thought, and then suggested, "I will smash your face into a car windshield and then take your mother, Dorothy Mantooth, out for a nice seafood dinner."

A native Midwesterner like Koechner would never have come up with the coastal specificity of the seafood dinner, and Koechner was deeply grateful to Carell for his spark of geographically nuanced creativity. Koechner could not remember if it was he or Carell who continued to build on what they had and added the kicker ". . . and never call her again!" He was tickled to picture Wes Mantooth's kindly mother sitting at home, night after night, waiting for the telephone to ring and wondering what she might have done wrong. (Wes must be held back by his colleagues: "Dorothy Mantooth is a saint!")

The key traits needed in order to capture improvisational lightning in a bottle were patience and an ability to mentally reset. For

the sequence in which Ron and Veronica sit in a car looking out at the lights of the city (shot on an overlook point near downtown San Pedro), Ferrell tried out an astounding variety of differing lines to describe San Diego. The crew kept shooting, going through four or five magazines of film as he trotted out alts—almost an hour of hectic improvisation along the lines of "San Diego, which of course in German means 'golden pancakes.'" The camera crew was getting colder and colder in the brisk evening air as the shoot went on and on. With each variation, Applegate would have to respond as if for the first time, squinting her eyes or pursing her lips and registering her uncertainty at Ron's urban knowledge.

McKay would occasionally chime in with suggestions but mostly let Ferrell operate under his own guidance, testing out different approaches to the moment before settling on the version that had appeared in the script: "I love this city. It's a fact. It's the greatest city in the history of mankind. Discovered by the Germans in 1904. They named it San *Diaago,* which of course in German means 'a whale's vagina.'"

McKay and Ferrell also tried out a series of options for the line Ron would deliver on camera that would drive away his loyal fans in a later scene. The final film kept it simple, with the teleprompter-dependent Ron accidentally telling his audience, "Go fuck yourself, San Diego," at the end of a broadcast. Veronica sits next to Ron, frozen in shock that her ploy to fix the teleprompter has actually worked. "Ron, I've got to fire you," an ashen Ed tells him, and Ron playfully responds, "Well, I've got to fire you. Bing-bom-bom." Ron points finger guns at his boss and walks away chuckling at Ed's joke. It is not until Ron is shown a video playback of the broadcast that he blanches, his eyes bulging in shock: "Great Odin's raven!" Numerous alts were trotted out for this moment, with McKay es-

pecially partial to a filthier version: "Go put a huge, purplish, veiny cock up your ass, San Diego."

The alt style was a particular challenge for the camera crew, who had to find a way to keep the camera following along with performers without knowing precisely what they might do in any given sequence. Normally, a scene might last forty-five seconds at maximum, giving crew members an opportunity to adjust, but the camera could be rolling here for minutes at a time. Camera operator Harry Garvin had pored over the script but would find himself adrift after the first few takes. Garvin began to study each performer's tics to grasp what they might be doing. He noticed that Ferrell would punctuate many scenes with the glass of scotch that was often in his hand. He might bring it up to his lips, say his line, and then drink it, or merely bring it close to his mouth. Applegate would tilt or twist her head in a certain way each time she was listening to one of Ron's monologues.

One Friday afternoon, Ferrell, Koechner, Rudd, and Carell were shooting a scene in the news station's cafeteria (the same scene Carell had auditioned with), planning their latest assault on Veronica, which Champ cruelly compared to their earlier campaign against "that limp-wristed fairy that was supposed to do the financial reports." Ron agrees that they'll "declare war on Corningstone" but is distracted by Brick's falafel–hot dog–cinnamon lunch. The news team bursts into over-the-top laughter at Brick's appalling meal, while Carell enthusiastically eats, his teeth dusted with a thick sprinkling of coffee grounds. The other actors struggled to hold it together as Brick obliviously munched.

Without explicitly announcing any competition, *Anchorman*'s performers were looking to amuse each other, and Carell was preternaturally gifted at setting off helpless laughter in his costars and

in the crew. Carell thought of himself as a spectator on *Anchorman,* which he saw as aligning with his role. Brick was mostly in the background, with fewer lines than his compatriots, and yet what Carell most wanted to get across was Brick's desire to be part of this dysfunctional but loving team.

David Koechner had been given a beige cowboy hat with a tilted brim and flared sides as an all-purpose accessory. Costume designer Debra McGuire saw Champ as the cowboy of the story—crude, boisterous, and powerful—and wanted to assign him headgear that fit the character. The thing about the hat was that it was ever-so-slightly too large. This was a flaw and also a jury-rigged solution to the problem of Steve Carell, allowing Koechner to dip his head and partially cover his face when Carell made him laugh. (It was so hard not to laugh in the presence of these performers that Koechner was sometimes reduced to thinking of difficulties his children had endured in order to avoid breaking.)

One of the earliest sequences committed to film, the party sequence at which Ron first spots Veronica, was a night shoot on location in the neighborhood of View Park, and a chance to set the tone for the team—and the whole film. The location was a house that was a true 1970s holdover, complete with shag carpeting and globe lights lining the street. (Another house scouted by location manager Jeremy Alter belonged to Ray Charles and featured a piano-shaped pool.) "Are we in a time warp or something?" camera operator Linda Gacsko wondered when she caught her first glimpse of the location.

The house party serves as the Channel 4 news team's first opportunity to introduce themselves. Brian, in a creased tan leather jacket, flashes a gun and smokes a cigarette, his arm around a sultry

blonde (Darcy Donavan) as he shares his pet names for his genitalia: "I know what you're asking yourself. The answer is yes. I have a nickname for my penis. It's called the Octagon. But I also nicknamed my testes. My left one is James Westphal and my right one is Dr. Kenneth Noisewater. You ladies play your cards right, you just might get to meet the whole gang." (In an alt for this scene, Brian shares that he has been to first base with forty-three gals and has reached home base with four lucky ladies. Rudd thought that, for all of Brian's explicit talk, he might actually be a virgin.)

Champ faces the camera and informs observers, "I'm all about having fun. You know, get a couple cocktails in me, start a fire in someone's kitchen. Maybe go to SeaWorld, take my pants off." (In a cut sequence, Champ stands on the roof and shouts, "Orgy!" at the assembled revelers. When he is greeted with dead silence, he apologizes for misreading the vibe.) Brick shows up patiently spooning mayonnaise into a toaster. "People seem to like me because I am polite, and I am rarely late. I like to eat ice cream and I really enjoy a nice pair of slacks."

Cinematographer Tom Ackerman wanted to give Applegate a bit of 1930s-style Hollywood glamour for her first appearance in the film. Ackerman had a soft spotlight fade up on Applegate, giving Veronica a faint glow. And when Ron first approaches Veronica and Applegate is seen in a close-up, the shot is intended to dazzle. Ron tells Veronica, "You have an absolutely breathtaking hiney. I mean, that thing is good. I want to be friends with it." The casually sexual, and sexist, tone was established moments earlier, when Ron was introduced by Brian to his blond friend, who pawed at her ample chest while purring in his direction, "I've got a big story for you, and it's right here." Ron, never one to not speak the words out loud,

responded, "You pointed to your boobies." Ron's willingness to turn down this sure thing in pursuit of Veronica speaks to his romantic spirit, or to his egotism.

Ron is holding a festive drink with an oversized orange wedge and a small green umbrella plunked in its center, his lush patch of chest hair, exposed by his open orange robe, an ironic counterpoint to his statement of intent: "I don't know how to put this, but I'm kind of a big deal." Ron almost chuckles at having to mention the exceedingly obvious. "I'm very important. I have many leather-bound books and my apartment smells of rich mahogany." Veronica's pause indicates she knows exactly who Ron is, even as she professes not to.

Ron instantly realizes he is overshooting his mark and asks Veronica if he can try again with her. "I want to say something. Want to put it out there. And if you like it, you can take it. If you don't, send it right back." He pauses before continuing. "I want to be on you." When Veronica turns away, Ron repeats himself half-heartedly, then takes a gloomy sip of his fruity beverage. The shoot ran so long that by the time of the last shot of the night, a two-shot of Veronica and Ron, you could just make out the brightening sky behind the trees at the edges of the frame.

As the shooting continued, costumes, hair, and makeup all contributed to a movie that was establishing its footing. Costume designer Debra McGuire found McKay terrific to work with, an easy collaborator with a flair for detail and an instinctive understanding of the significance of wardrobe to the film they wanted to make. To her surprise, of all the wardrobe items she selected, the one McKay initially rejected was the one she thought was the most obvious. When McGuire showed McKay a burgundy suit for Ron, he turned it down. McKay saw Ron as being clad in a brown suit and felt the

burgundy was too obvious a joke. "His name is Ron Burgundy," McGuire told the director. "He *has* to be in a burgundy suit."

McKay preferred the brown suit but agreed to shoot the early sequence in which Ron and the news gang burst through a sign and swagger before the camera with both suits. After viewing the dailies, McKay could only agree with the costumers' preferences. "You're right," he told McGuire and Mastrolia. "I'm really feeling it. It's Ron Burgundy. He struts with confidence in that burgundy suit."

In the mornings, Kim Greene and Joy Zapata would come in to style the stars' hair and apply their makeup. It was often necessary on other projects to be aware of the early hour, and the phalanx of concerns that performers might be carrying with them, and keep conversation to a minimum. But the atmosphere on *Anchorman* was entirely different: jovial and boisterous. One morning, Ferrell was preparing to don his wig, and Zapata was fetching some styling gel from a tub on her desk. The pump handle was stuck, and when Zapata pressed down, a blob of gel shot out sideways into Ferrell's morning bowl of oatmeal. Zapata was terribly embarrassed, but Ferrell was entirely unruffled. "Oh, it's delicious," Ferrell said, continuing to eat his breakfast. "I love gel in my oatmeal."

When the shoot paused at the end of the first week, Koechner, Rudd, and Carell went home and had identical conversations with their spouses. The new movie they were working on, they told their wives, was a dream, a hilarious script with a creative director. And the performers around them were each operating at the peak of their game. How could they possibly keep up when surrounded by such distinguished company? Everyone was better than they were— funnier, sharper, smarter.

The actors shared a three-room trailer, and when shooting

recommenced on Monday morning, they realized that each had spent the weekend roiling in the same discontent. It was a relief to discover that no one—except possibly the preternaturally self-possessed Will Ferrell—was immune to the fear of letting down a remarkably gifted ensemble.

The actors knew that something special was happening on set, facilitated by McKay, and did not want to do anything that would spoil it. Koechner thought of it as the comedy equivalent of a baseball milestone. If a pitcher was throwing a no-hitter, his teammates would intentionally shy away from him, loath to say or do anything that would spoil the moment. The actors would gather in their shared trailer in the mornings until they were called to the set. They spent a good deal of their time mooning each other, with Rudd especially prone to yanking down his pants.

The most the actors would allow themselves were anodyne comments like "This feels pretty good, huh?" No one wanted to draw attention to what was taking place. But Carell and Rudd and the other actors would gather with the crew at lunchtime to watch the dailies, bearing heaping hot-fudge sundaes as a postprandial treat as they watched the previous day's action. Dailies were usually a chore for crew members, but this was notably different. The actors would have tears in their eyes from laughing so hard. The only thing Carell was worrying about was getting fat from all the sundaes.

CHAPTER 6

Veronica

L ET US, FOR a moment, imagine another movie. It's a drama, possibly directed by Ron Howard, and starring Reese Witherspoon in the leading role. It's about a fiercely dedicated young journalist who sets out to make her mark at a news station in 1970s Southern California, only to run into a noxious array of harassers and abusers who seek to prevent her from succeeding, including a love interest who dazzles her with poetry and music before revealing how threatened he is by her very presence at the station. The film—perhaps we might call it *Veronica*?—is unflinching in its depiction of the old boys' club, but ultimately Reese is triumphant. Maybe she pumps her fist in the air in the closing freeze frame, as New York calls and summons her for the big job.

Needless to say, *Anchorman* is not that film, and yet in stray moments, when its guard slips, we can glimpse its recurring interest in pitting feminism ascendant, as represented by Christina Applegate's Veronica Corningstone, against the unthinking patriarchy of the past. *Anchorman* is, like so many of the other comedies of its era, a movie about the unending war between men and women,

and about men's rearguard action to avoid ever having to face the consequences of growing up. But it is notable that Veronica is never the bad guy here, never reduced to the kind of shrill tut-tutting to which so many female characters (including many of the characters in the comedies of the era) are condemned. Instead, she presses on, occasionally disheartened but never derailed, steely in her insistence that she deserves her place before the blinking red eye of the camera. Is *Anchorman* a feminist movie? Hell yes, it is. It is also, in its own lumbering, self-mocking way, a shadow biopic of one of the feminist legends of broadcast journalism: Jessica Savitch.

WHEN JESSICA SAVITCH was hired for her first major job, as a television reporter in Houston, her lisp was so noticeable that a coworker at WCBS in New York, where she worked as an administrative assistant, laughed at the news, assuming she must be joking. What reputable news station would hire someone so unpolished for such a prominent role?

On her arrival in Houston, a station cameraman named Bob Wolf played cruel tricks on her. Wolf insisted she bear witness to a bloated corpse floating in the Houston Ship Channel: "You know, you play pranks on a cub, and I considered her someone who hadn't paid her dues, and a female, and probably had no business in journalism anyway. I probably told her that she should be home making babies instead of doing that, because in those days, a lot of the cameramen were pretty chauvinistic."

Grizzled veterans like Wolf would do everything they could to interfere with her work when she was chasing a story. Women did

not belong in the news, and these veterans saw it as their mission to ensure that Savitch would not succeed.

In October 1971, there was a chemical explosion caused by an overturned railcar in southeast Houston. Savitch rushed to the site, sidestepped the police, and reported directly from the blast, with the mushroom cloud still visible in the distance. She was cool and composed, revealing none of the exertion that had been required simply to get close enough to report. Her story made the national broadcast that night, and television viewers around the country were wondering who the young woman with the ability to reach through the screen and compel their attention might be.

Jessica Savitch was, in every conceivable way, a product of television, only truly visible through the all-seeing eye of the cathode-ray tube. In one telling story, a group of men working in a television station whistled at the beautiful woman they spotted on tape in a mustard commercial, not realizing—or not caring—that she was actually standing right next to them. In person, Savitch was unassuming, quiet, unspectacularly pretty. But something remarkable happened when a camera zoomed in on her face. Savitch's intense jitters, her lisp, her lack of self-confidence, her neediness, all melted away when she raised her green eyes to meet the camera head-on. "When the red light came on," wrote Savitch's biographer Alanna Nash, "she became a public trust."

Viewers felt that Savitch was speaking directly to them and nobody else. She was sharing the news with them because she wanted them to be informed, and she wanted to be the one to inform them. Savitch regarded the camera as a friend, one she might speak to calmly, deliberately, and familiarly, and viewers felt that sense of intimacy. She might nervously pick at her nails before a broadcast

until blood spurted onto her news scripts, but none of that ever appeared on-screen. She was not just Jessica Savitch, rising-star reporter; she was Jessica Savitch, hope of American women.

TELEVISION NEWS HAD been, from its inception, an entirely male preserve. Walter Cronkite and Edward R. Murrow became American institutions as surrogate fathers. Americans turned on their televisions each evening to be educated and consoled by these men, who would inform us about a problem that needed to be addressed or place their hands on our collective shoulders to reassure us that all was well. "Audiences are less prepared to accept the news from a woman's voice than from a man's," observed veteran news executive Reuben Frank in 1971 when faced with the first wave of female newscasters.

Frank was articulating the silent treaty between newscasters and audiences. News anchors were arbiters of truth for a new medium. Serving as the middlemen for television's stream of visual footage, anchors were its interpreters, its explicators, and its audience representatives. They were popularly understood as the judges deciding which stories were newsworthy and which were not. The vast television audience looked at Cronkite, or Murrow, and saw a trusted messenger of truth. It was no coincidence that news anchors were almost always middle-aged white men, whose age and gender granted them a certain authority.

In 1960, writes Gail Collins in her history *When Everything Changed*, there was a "national consensus" that "women could not be . . . television news anchors." Certain professions that demanded the trust of others could only be held by men, which accounted for

why only 6 percent of American doctors in 1960 were women, or 3 percent of lawyers, or less than 1 percent of engineers. Most women wanted to be married by the age of twenty-two, Collins notes, and then never work again. That this story was never entirely reflective of the real lives of American women (even in 1960, more than 30 percent of married American women were employed), or that it was a white middle-class fantasy that left out Black and Hispanic and working-class women, did not make it any less powerful for those in its orbit.

Most women with college degrees became teachers, with salaries lower than men with liberal arts diplomas. Medical school classes often capped their female students at two per class, figuring that any more would take away much-desired seats from more deserving men. (They would have capped it at one, Collins notes, but they didn't want the women to be "lonesome.") Women needed a man's signature to rent an apartment, even if their husband was a patient at a mental hospital. Women living the dream of being housewives and "not working" were devoting fifty-five hours a week, on average, to domestic chores.

And the few women who consciously skirted those expectations, less out of financial necessity than a desire for professional achievement, worried they were betraying their femininity by doing so. As Collins describes, television reporter Marlene Sanders hired both a female housekeeper and a male college student to work in her home and watch her two sons so she could go back to work. She wondered if she was the only woman in the world making such an unorthodox arrangement. The gap between what women wanted and what they had been conditioned to want was vast. "The feminine mystique," wrote Betty Friedan, "has succeeded in burying millions of American women alive."

Then a segregationist member of Congress named Howard Smith wanted to kill the Civil Rights Act in 1964. Smith sought to water down the bill by proposing an amendment to add women as another group protected from employment discrimination. Smith would later acknowledge that he offered the amendment as a joke, a smirking argument about the ludicrousness of civil rights. (Who would we seek to protect next: ladies?) But to Smith's abiding displeasure, the amendment was passed, and discriminating against women in the workplace became illegal.

The 1960s and early 1970s saw women pushing boundaries that had previously seemed impregnable, like Jean Enersen, hired to anchor the evening news on KING 5 in Seattle. Enersen was the first woman anywhere in the United States to anchor an evening-news broadcast, soon to be followed by the likes of Jane Pauley, Judy Woodruff—and Jessica Savitch. There were baseline assumptions about women—about their femininity, about their societal and familial roles, about their sexuality—that were challenged by the sight of a woman on television. All of this would lurk in the background of Veronica's story, the iron rod propping up the film's backbone.

Even after her triumphant reporting from the chemical explosion, Savitch found herself fighting for meatier stories to report. She was furious when, instead of being assigned a piece on the aftermath of a devastating flood, she was given a story about a shoe show. Savitch was desperate to ascend the ranks and immensely frustrated by the artificial limitations imposed on her due to her gender. Savitch left Houston for a new job at Philadelphia's KYW, cornering a heretofore ignored market on stories about women and young people, with acclaimed multipart series on divorce, abortion, and single life. Savitch had legions of young female fans, and her

five-part series on rape, in which she stood in for a plainclothes officer in a derelict section of Philadelphia as she talked about how afraid she was to confront potential rapists, attracted enormous audiences, won journalism prizes, and would help change laws to ensure better care for rape victims in Pennsylvania, New Jersey, and Delaware.

Coasting off her unprecedented success, she was named a co-anchor of the KYW local news in 1974 alongside Mort Crim, who later acknowledged he told Savitch he was "not real happy about this decision."

If you've been reading very closely, you may remember the name Mort Crim as that of the veteran newscaster who had voluntarily described himself as an erstwhile male chauvinist, and whom Will Ferrell had spotted on a television documentary that planted the seed for what would become *Anchorman*. *Anchorman* has Savitch's story, and the story of all the other women who began the slow, grinding process of integrating television news, in its bloodstream, and it remembers all the male camera operators and crew members and co-anchors who stood in Savitch's way, literally and figuratively, seeking to trip her up out of an atavistic desire to prevent a woman—any woman—from finding success.

Before the first presidential debate between President Gerald Ford and Democratic challenger Jimmy Carter in 1976, being held in Philadelphia, a video glitch unexpectedly interrupted the network's broadcast. NBC needed a replacement feed to fill the time, and Savitch stepped in, ably summarizing the day's events, interviewing politicians and operatives, and bantering easily with strangers. Savitch parlayed this real-time demonstration of her skills and savvy into a job as a correspondent and part-time anchor at NBC.

There were ruffled feathers in the ranks at NBC, upset that the thirty-year-old Savitch had broken the pact that correspondents would work their way up through the ranks at the network. But hadn't the ranks always been a stronghold of the old boys' network? And was there any way for a woman to get ahead in the news in the 1970s other than demanding that her skill and savvy and fire be ignored no more?

Jessica Savitch was a hero to a rising generation of women who turned on their televisions and saw someone forthright and trustworthy and just like them on their screens. She was also a troubled young woman, struggling with a growing addiction to cocaine. She was unpredictable and lacking in self-confidence. She was in a brutal relationship with an abuser. It almost did not matter whether the real Jessica Savitch matched their expectations; what mattered is that audiences who had been conditioned to associate the reading of the news with silver-haired male anchors now had an alternative, and they were embracing it.

Savitch, like Veronica, also dated a fellow newscaster named Ron who envied her success and held her back, demanding her attention for each of his petty grievances. But Ron Kershaw, who met Savitch in Houston and followed her to Philadelphia, was controlling and violent. Savitch would regularly come into the office with black eyes that the makeup crew would valiantly struggle to cover up with concealer. Station staff would remind each other that this was something the two of them would have to work out among themselves, adopting a distinctly hands-off position to what was clearly, by contemporary standards, ongoing domestic abuse. (One cannot help but think of Champ holding back his newsroom co-workers as Veronica and Ron hurl typewriters at each other: "Let

'em work it out!") Savitch endured regular beatings from Kershaw, even attempting suicide in what was possibly an effort to escape his clutches. *Anchorman* skips the tragedy, turning down the intensity to a low simmer of buried hostility and soured feelings.

It would take years for Savitch to leave Kershaw behind, pushing her toward an increasing dependence on drugs and alcohol. But that red light was instantly soothing, the resolution to all that dogged her as soon as the light switched off. Savitch became NBC's Senate correspondent and took on a role as a weekend anchor, becoming only the second female newscaster in that role at the network. But Savitch's tumultuous personal life—she went through two brief marriages over the course of two years, with her second husband, Donald Payne, committing suicide in 1981—her struggles with addiction, and her squabbles with NBC executives damaged her professional standing. Savitch delivered brief news updates for NBC, and in October 1983, she appeared to be drunk or under the influence of drugs on the air, slurring her words during a broadcast. Savitch's career was cut tragically short. She drowned later that month, at the age of thirty-six, after a car she was riding in as a passenger plunged into a canal outside a Pennsylvania restaurant.

Savitch never had a chance to demonstrate all that she was capable of to a national television audience, and perhaps her demons would have kept her from doing so. But the baton was picked up by other trailblazing female newscasters like Lesley Stahl and Barbara Walters. Walters had already seized Savitch's dream (and Veronica Corningstone's) when she was hired as a co-anchor of ABC News in 1976, the first woman to anchor the national news, alongside Harry Reasoner. (Reasoner, horrified that he had to share his news with a woman, refused to speak to Walters when the cameras were off.)

☆

ANCHORMAN HAS MULTITUDES buried in its depths, and all this half-remembered history is compressed and reorganized to suit the film's comedic purposes. (The 1996 movie *Up Close & Personal*, with Michelle Pfeiffer and Robert Redford, with a script by Joan Didion and John Gregory Dunne, is also loosely based on Savitch's story.) Veronica is not quite Jessica Savitch but is granted some of Savitch's backstory, much of Savitch's tenacity, and an extra portion of Savitch's male tormentors. This is not a Savitch biopic, but McKay and Ferrell drop enough bread crumbs to connect viewers back to their original source material. Veronica is given Savitch's litany of frustrations at the unappetizing work she is handed, and her squabbles with station manager Ed Harken form an undercurrent of dissatisfaction that runs through the movie.

"Mr. Harken—sir—I will not have my first story at this news station be about a cat fashion show." Veronica stands in the doorway of the station manager's office, brought in by his sniveling henchman Garth. She is tall, regal in bearing, resplendent in a pink-and-brown suit, her hair falling in perfect waves atop her shoulders, a small gold chain occupying the bold V between her lapels.

There is an air of barely repressed hostility in her voice, the *sir* more the stubborn politesse of a frustrated soul than a genuine term of respect. *Cat fashion show* is practically spit at Harken, a mouthful of plosives indicating her thorough contempt for this mock journalism. (Legendary publisher and editor Robert Gottlieb once referred to the kinds of disposable books you might see for sale at the Barnes & Noble checkout counter as "ooks." Might we refer to these news stories as "ews"?)

"Miss Corningstone—ma'am," Ed responds, his own contempt for this pushy broad entirely unrestrained. "You will do the stories to which you are assigned." Willard's *ma'am* contains echoes of Mort Crim and Bob Wolf and every other unapologetic misogynist in Savitch's story. He is matching her own strained good manners, but his *ma'am* has genuine hostility behind it. We can imagine him using a far saltier word with precisely the same tone of voice. Veronica may be the first woman Ed Harken has ever had to treat like a colleague, and he is already thoroughly disgusted by the thought of it.

Veronica's mouth is puckered in anger: "I am a damned good journalist. And this cat show thing is grade-A baloney." Her voice has dropped an octave, and she slows to an unexpected halt after *damned,* perhaps demanding our attention as she insists she be treated like the journalist she is. Harken dismisses her, demanding that she file the story she has been assigned, and she storms out. The cat fashion show is a distinct echo of Savitch's shoe show, equally fluffy and soft-news, equally distasteful to genuine journalists on the ascent.

Veronica is the victim of blatant discrimination, subject to the overt hostility of male journalists intent on embarrassing and ignoring her in equal doses. Ed Harken, we can tell, is only the latest barrier placed in the path of the indomitable Veronica, and we are confident, even at this early stage, that this is a battle he is unlikely to win. In a cut sequence, we see Veronica, in a flashback, being asked by her boss at a Houston station (further shades of Savitch) to don a bikini on the air and refusing to "show off that nice little tush of [hers]."

Later, after Veronica and Ron have their first date, we hear plinky, deliberately cutesy piano music and are shown an array of

colorfully costumed felines: a police officer with a peaked black cap and a blue shirt, a leather-daddy cat, a cat horse with a cowboy figurine posed atop its back, a hippie cat, a cat bride, a pirate cat wearing the skull and crossbones, a gladiator cat named Whiskerus Maximus. Seth Rogen, playing Veronica's jovial camera operator, chuckles heartily as he puts his right eye to the lens: "I'm getting some great stuff, Miss Corningstone."

Veronica, her back turned to the camera, icily composed in a beige suit with cream piping and a black-and-gold scarf knotted around her neck, radiates disinterest in this human-interest filler. Placed in a two-shot alongside Rogen, whose shirt is pressed and beard trimmed but who still appears as if he may not have showered yet this month, Veronica looks as if the first thing she may do upon escaping the presence of these dubiously adorable cats is to thoroughly scrub herself clean of the stench of this story. "Shut up," she mutters as she shuffles her papers. "I hate cats." Is she here because this is the kind of story a lady reporter should be covering or because this is simply the schlock the local news peddles? Veronica can't tell, and is deeply frustrated.

"All right," she declares as she marches out of our frame and into the artificial frame of the news reporter. "Let's just do my sign-off and get out of here." Rogen adjusts his lens and Veronica, now seen in lower-resolution video, appears against a Pepto-Bismol–pink backdrop of balloons and banners. We can still clearly read Veronica's frustration, but her cheekbones plump as she speaks, and a tight smile is plastered on her face as she delivers her overly crafted lines: "And just for today, fashion curiosity did not kill the cat." Ron, watching the final moments of the report from his anchor's desk, chuckles genially, clearly enamored of Veronica if not with her story.

In Veronica's next encounter with the boss, Ed seems more cheerful, even as he reports that his son was "on something called 'acid' and was firing a bow and arrow into a crowd." Veronica asks for a more challenging story and is thrilled when he instantly responds, "Ask and you shall receive," slapping her own thigh and nodding with pleasure as her boss passes a folded sheet of paper across the desk. "Here's a story of a hundred-and-three-year-old woman out in Chula Vista who claims to have a recipe for the world's greatest meat loaf." ("Ooh," the obsequious Garth responds, "now, *that's* a hot lead.") Veronica's face crumples, and she slowly gathers herself in the aftermath of another setback. In some senses, Ed is less terrible than Veronica's coworkers, who harass and objectify her mercilessly. But Ed appears to not even realize the extent to which he is relegating Veronica to foolish, pointless, lowest-common-denominator stories she is too skilled to take on.

Veronica is a straight man. By her very presence, she instigates the crisis that stirs up Ron's crew. She is driven and intent on success, where Ron is mostly content with being the most beloved news anchor in the second-largest city in Southern California. Ron and the News Channel 4 team are happy in their miniature sandbox, and Veronica, with her outsized, Savitch-esque ambitions, is a dash of unexpected realism. Here, we can see, is a real person with real desires and hopes, trapped in a world of buffoons, charlatans, and schlemiels. And perhaps this is the source of the curl in Veronica's lip as she faces the camera and pretends to care about cats in costumes or considers the possibility of interviewing a great-grandmother about her legendary meat loaf.

None of which is to argue that Veronica is extraneous to *Anchorman* or that she occupies the role of designated female spoiler. Instead, Veronica is a kind of reality principle, a genuine person, a

genuine journalist, inserted into this CinemaScope playground. Veronica wants to be treated like a journalist, like a colleague, like a friend, like a human, and not like a female-shaped punching bag. Veronica wants something that the film cannot provide, for several reasons.

First and foremost, Veronica must encounter resistance because the resistance is itself the source of the film's humor. Veronica is a talented female journalist inserted into the bad old days of the 1970s to demonstrate the extremes to which others will go to prevent her from flourishing, and it is the absurdity of those extremes that is itself funny.

Also, Veronica's goal of becoming an accomplished journalist, tackling the big stories, doing good work, is a logical impossibility in *Anchorman*. Veronica is imagining a profession different from the one *Anchorman* depicts—or, perhaps, much like Savitch, she is dreaming of being rescued from the drudgery of the reporting hustle by being made an anchor. In this, the San Diego setting helps establish the arch, knowing tone. Veronica is reporting from a second-rate backwater, not even the most important city in its own region.

There are no accomplished journalists in *Anchorman*. There is no good journalism in *Anchorman*. There are only mediocrities filing mediocre stories to the improbable adulation of a mass audience. (We see newspaper headlines about Veronica uncovering a child-slavery ring and a drug ring, but it is notable that we never see evidence of that kind of reporting here.) Veronica demands outcomes that *Anchorman* cannot provide. But perhaps this, after all, is where we loop back around and return to *Anchorman* as a secret Jessica Savitch biopic. Because what was Savitch demanding of her real-life bosses and colleagues, in Houston and Philadelphia in the far-

off 1970s, but for them to expand the horizons of what might be possible within journalism, to seek out a place for a woman like Savitch that might previously have been impossible to find?

There are untouched wonders in Savitch's real story that *Anchorman* might have made use of. Would Veronica have sent fan mail to herself, giving the game away by having every letter be postmarked from the same post office? (That honestly sounds like more of a Ron thing.) Would Veronica grab a microphone made from soap and belt out Rod Stewart tunes? (If it was a good party.)

Veronica is Savitch with all the moxie and none of the demons. She is upward ambition personified, and the only real weakness she appears to possess is her desire for Ron Burgundy. (Even Veronica knows that there are "literally thousands of men" who might be preferable to Ron.) Perhaps she sees something in him that we cannot. And while Ron is hardly Ron Kershaw (beyond sharing a first name with Savitch's abusive longtime boyfriend), there is a fundamental cruelty to our Ron that feels linked to Savitch's story.

Much like Kershaw, Ron Burgundy sees success as a zero-sum game; Veronica's achievements can only take away from his own. Perhaps the cruelest of Ron's japes toward Veronica appears as a moment of truth during a brutal confrontation after Veronica's debut broadcast as an anchor.

"I told you that I wanted to be an anchor," Veronica responds to Ron's tantrum. "I told you that." She is gritting her teeth now, as if in disbelief that her "gentleman lover" could be so cruel, or so dumb. Ron is lost to all attempts at diplomacy, his fists clenched in balls of rage: "I thought you were kidding! I thought it was a joke. I even wrote it down in my diary: 'Veronica had a very funny joke today.' I laughed at it later that night!" Veronica's dreams are Ron's jokes.

Ron Howard might have filmed it differently for our imaginary Oscar competitor, but in this moment, we feel the unbridled misogynist viciousness of Ron Burgundy and all his real-life predecessors. This might be a comedy, but for a moment, we are reminded of what it must have cost groundbreaking female journalists like Jessica Savitch to demand respect.

☆

Tarp of Weapons

PONDERING THE RELATIONSHIP between the News Channel 4 team and their rivals in the early drafts of their script, McKay and Ferrell imagined them to be like the juvenile delinquents of classic movies like *Blackboard Jungle* and *The Warriors,* squabbling over turf. They pictured a violent showdown between Ron's team and a rival news team that would feel like the Jets and Sharks facing off in *West Side Story.*

DreamWorks was insistent that this scene—unwieldy as it was—be cut from the script. Meanwhile, producer and all-around scriptwriting adviser Judd Apatow had prodded the writers in another direction. "Guys," he told Ferrell and McKay, "you should just try taking a pass where you go further." He suggested they think about what might happen if the news teams really *did* get into a fight, and the plan for a no-holds-barred throwdown began to cohere, with one day designated for the shoot.

The anchor showdown sequence was to be shot on location in a downtown Los Angeles parking lot on a scorching day, in a mostly abandoned district of warehouses near the Sixth Street Bridge. It

was so hot that costume designer Debra McGuire brought multiple shirts for each actor, to give them a chance to change out of their sweat-encrusted clothes over the course of the day. Not only did the setup involve dozens of shots, many of them with significant technical challenges, but the entire shoot had to be completed with one day of first-unit work and one day of supplemental shooting by a second unit. Next to the video monitor where McKay, Apatow, and cinematographer Tom Ackerman would gather, there was an oversized paper tablet on a tripod with a list of the seventy or eighty shots they needed to capture that day.

Prop master Scott Maginnis laid out a tarp on the ground the morning of the shoot. Maginnis had assembled ordnance, ranging from the threatening to the ludicrous, including a board with a circular saw and a nail-studded baseball bat, and the performers were requested to select their weapons of choice. "It was like a playing field with all these toys," Maginnis later said. "The actors came, and they said, 'I'll take that one,' like they were really going to go into battle," remembered first assistant director Matt Rebenkoff.

David Koechner selected the brass knuckles, figuring it was an understated choice that emphasized Champ's toughness. Paul Rudd chose a crowbar, for simplicity's sake, and then went back and took a gun. Brian Fantana had already been seen wielding a gun in the film's party scene and might as well have one with him that day. In contrast with his costars, Steve Carell was assigned the trident, which Maginnis had hand-tooled in two different variants: one made from metal and one rubber version for throwing. Carell also picked out a grenade, to the chagrin of his costars: "Everyone was jealous of the hand grenade," he later told a journalist. "I mean, you have a switchblade? I can *blow you up!*"

The cast was joined by Vince Vaughn as Ron Burgundy's foil

Wes Mantooth, and by three stars making cameos for the day, each in a role as a rival newscaster: Ben Stiller, Luke Wilson, and Tim Robbins. Stiller and Wilson were friends of Ferrell's and Apatow's, who had been asked to appear as a favor. Meanwhile, Robbins had been cold-called through his agent to appear as a public-television newscaster. The *Bob Roberts* star responded with two questions: Could he wear a turtleneck? And could he have a pipe?

The entire scene was only possible because of the intense preparation and rehearsal that led up to the shoot day. McKay, Ackerman, and the camera crew rehearsed extensively with the actors, concerned about the pressure that the ambitious schedule would put on the cast and crew. If any actor missed their mark, not only would they spoil the take, they would endanger themselves and their fellow performers.

Key grip Lloyd Moriarity, responsible for overseeing the equipment on set, was afraid of the crew's relaxing too soon, not remaining adequately wary of the nearly infinite number of ways in which the shoot could go disastrously wrong. The weapons being used in the scene were primarily made of plastic or fiberglass, but it was still possible for a performer to be badly injured by mishandling one of them.

Once the actors had been prepared for the sequence, the stunt performers gathered and ran through their array of moves, coordinating the thrusts and parries in groups of two. After they had worked out their combat routines, each pair would then synchronize with the other pairs in their vicinity, their careful planning intended to avoid accidental injuries. The scene was so vast and complex that recording sync sound was nearly impossible. The lack of sound was a boon to the stunt performers. As long as they kept their mouths turned away from the lens, they could communicate

without fear of spoiling the shot. After the stunt performers were done, the camera crew, lighting team, and grips had to prepare their own steps as well, in order to ensure that they would stay out of the frame.

McKay had certain ideas locked in place about the fight. "If I'm going to see a big, crazy fight," he would later tell an interviewer, "at one point I want to see someone get killed by a trident on horseback." He was drawing from a mental list of obscure weaponry he maintained, which also included the scimitar and the bill-gisarme. (Nunchakus, he had decided, were too mainstream.)

In the scene, Ron and his colleagues are lost en route to purchasing new suits when they are unexpectedly surrounded by Wes Mantooth's crew, who pull up on their bicycles and ominously circle their rivals. Wes taunts them for the arrival of female co-anchor, Veronica Corningstone, at their station and what it might say about their masculinity: "I understand that they had to bring a female in, change your diapers, wipe the dribble away from your bubblin' lips, rub Vaseline all over your hiney and tell you that it's special and different from everyone else's." Wes speaks slowly, savoring every taunting word, as if this is a speech he has been practicing in his bathroom mirror for weeks. He pulls out a switchblade, a 1950s juvenile delinquent in a mustard-colored sports coat.

Wes is unexpectedly joined by the crews of other local-news stations, each intent on fighting it out for superiority. Luke Wilson shows up as Frank Vitchard, anchor of third-place Channel 2 News, whose one-liners are as flaccid as his ratings: "Yeah? Well, you're about to be in . . . dead place." Frank looks over at his colleagues after his weak zinger, as if to assess how thoroughly he has just humiliated himself. Robbins taps his pipe against a nail-studded bat, adding to the tweedy-but-brutal feel of his PBS anchor: "No

commercials. No mercy!" "*Cómo están, pinches,*" roars Stiller as the Spanish-language anchor. (The credits list his character as Arturo Mendes, further emphasizing the tone-deafness of casting the non-Hispanic Stiller in this role.) "Tonight's top story: The sewers run red with Burgundy's blood." Stiller flicks a whip for punctuation. Ackerman was particularly proud of the introduction of the Spanish-language crew, with his team posed on a staircase like soldiers about to enter the fray. (Others found Stiller's use of the whip offensive, a cheap stereotype crudely employed.)

"Let's go over the ground rules," Ferrell tells his fellow anchors before the fight begins. "Rule number one: no touching of the hair or face." "Of course," Stiller mutters, annoyed at his belaboring of the obvious. Wilson wields a butcher knife and threatens an off-screen figure: "I'm gonna straight-up murder your ass." Robbins, lurking in the background, grabs a machete out of midair and chops off Wilson's arm just as he is about to swing, to Wilson's surprise and displeasure: "God, I did *not* see that coming!" The best part here is Robbins puffing placidly on his pipe just after cutting off a man's arm. (In an earlier, mistimed take, included on the *Anchorman* DVD, Wilson's arm had disappeared before Robbins had begun his swing.)

McKay and the crew were thinking of classic fight sequences from other movies that they might pay homage to in this scene. Plans were already in place to have men on horseback trap Brian Fantana in an enormous net and drag him along the ground—a fond tip of the cap to *Planet of the Apes*, in which apes on horseback round up fleeing humans. (The script directions also made mention of John Ford, in order to set the atmosphere.) The crew knew that the jokes here would land best if they could ensure they found the right angle. Placing Brick in a heroic-warrior pose as he threw his

trident and murdered one of his rivals would work best if the camera was tilted up from a low angle, and there was an extended discussion regarding Sam Peckinpah's revisionist Western *The Wild Bunch*, which served as stylistic inspiration here. (Composer Alex Wurman would eventually reference *Planet of the Apes*, along with *West Side Story*, *Spartacus*, and *The Mission*, for the music in this sequence.)

Where other scenes allowed performers a great deal of flexibility to improvise, the anchor showdown was an action sequence and required more forethought and preparation. Some trickery helped make the labor a bit lighter. When Wes Mantooth arrived, his newsteam colleagues were actually Jay Johnston and two stunt performers craftily slotted into roles without any lines of dialogue ("You can't say one word?" Wes castigates them in another scene. "Even the guy who can't think says something!"). Casting stunt performers in these roles gave McKay more flexibility when it came to pulling off the action component of this sequence, rather than trying to cover up the presence of a stunt performer filling in for an actor. (Wes, who was revealed in an alt scene to be Ron's brother, was even given his own Brick, a henchman whom costume designer Debra McGuire dressed in knockoff versions of his suits.)

With all the haste of last-minute execution, the crew was worried about disappointing McKay with something shoddy. After the first take, Rebenkoff turned to McKay and asked him what he thought. "I think that was fucking awesome," the director told him, and the confidence level on the set shot up. As the day progressed, Ackerman felt a sense of growing satisfaction as one shot after another was crossed off the list mounted on the tripod.

All McKay knew was that he absolutely wanted to have a man

on fire walk through the scene. "I don't care what you do," unit production manager David Householter told stunt coordinator and second unit director Rick Avery, "you got to get the man on fire." The other performers could feel the heat radiating off the burn suit from forty feet away. The first take with the man on fire did not match what McKay had in mind for the stunt. The camera had tracked the stunt performer, while McKay preferred the man on fire to simply show up in the middle of the battle and walk through the frame. He wanted another take but did not want to risk anyone's life in order to capture a single joke. "Is there any danger to this?" he asked. "This is just a comedy." McKay was assured that there was not. The stuntman was wearing a head-to-toe fire suit and covered in gel, and the stunt crew guaranteed McKay that the stunt was entirely safe. They did a second take.

Champ was supposed to launch a fellow combatant into a windshield, but David Koechner had been reminded numerous times by Rick Avery not to touch him. The crew had placed a hydraulic springboard on the ground that would thrust him on a prearranged arc. Koechner was only to mime the gesture of lifting him and throwing him. All the while, as Koechner was gamely attempting to follow the instructions from McKay and the crew, there was a man on fire running through the shot. It was chaos, but chaos of a particular kind—like going to an action movie and having a comedy break out—that allowed the performers to shine even as the complex marks of this scene needed to be hit.

There were so many stars on the set for the day, and so much action to shoot, that McKay cobbled together three units working simultaneously. The A unit was shooting the star cameos; the B unit captured smaller shots on the fly; and the C unit handled the

stunts. "So while I would be shooting, let's say, chopping Luke's arm off," said McKay, "someone would tap me on the shoulder and go, 'We're about to set the guy on fire.'"

David Householter grabbed a camera and shot the scenes of the net dragging Brian away, the rival anchor tossed into a windshield by Champ, and the riders on horseback. All the while, Rick Avery was overseeing a stunt unit and filming their complex routines. There was so much to do and so little time that a voice would call out, "We got it! We're moving on!" and they would lurch to the next setup. By the end of the day, all the shots on the tripod were crossed off.

Journalist Drew McWeeny, who had praised the *Anchorman* script when it had seemed unlikely to ever be made, was on the set the day of the news-team showdown, invited by location manager Jeremy Alter. Producer Shauna Robertson brought him over to Ferrell and McKay. They told him that when his article had been published, neither of them had been certain that it would be worth their while to continue pursuing the project. Then his script review had come out, and it galvanized attention on their behalf. "We have no idea why you did it," they said, "but it was amazing, and it helped so much."

The next day, McKay and Ferrell gathered the crew together. Everyone was exhausted after an intense and logistically difficult day, and the director and star laid into their team: "You know, guys, we've got to work harder. That wasn't good enough," said Ferrell. McKay continued from there: "What happened yesterday was unacceptable! It was horseshit!" The crew stared blankly at the director and the star, and Ferrell blanched. This was supposed to be a funny bit to entertain the crew after an immensely difficult, highly successful day, and no one seemed to be aware that it was a

joke. "Oh, my God, this bit is just really going south," thought McKay.

Householter had to step in and reassure the crew that this was all just a joke, that they had done a superb job the day before, that all their efforts were deeply appreciated. McKay and Ferrell thought they were being funny, but too many of them had actually worked with directors and stars just like this. "We were just kidding! We were just kidding!" said Ferrell. "You guys were amazing."

The entire remainder of the day, McKay would approach crew members and apologize, telling them, "I'm so sorry. I thought it was really evident that you guys kicked ass and that was the joke." "No, man," people would tell McKay, instinctually lowering their voices. "You haven't worked with . . ." And they'd go on to name some director who really had been the nightmare tyrant McKay had been imitating.

THE *ANCHORMAN* SHOOT was always open to the unexpected and the spontaneous, with one of the film's most famous sequences emerging from between-takes banter. Perhaps no moment in *Anchorman* signifies the film's inoperable whiteness and its devotion to the unhip than when Ron, newly in love with Veronica, is asked by his colleagues to explain love to them. The door is shut for this confab. Blatant sexism is a matter of public record, but curiosity about human emotions is deeply embarrassing.

Ron asks if they really want to know what love is like, and when they insist that they do, he launches into song, in one of the most memorable sequences in *Anchorman,* and one that almost never happened.

One day during the shoot, the performers were staying sharp by taking 1970s pop hits by ABBA and the Carpenters and talk-singing them, as if they were channeling the ghost of Rex Harrison from *My Fair Lady*. During idle moments, the four actors fantasized about finding time to rehearse a 1970s song together. The idea was to have a go-to set piece for when they would appear on talk shows promoting the movie, and the actors were trying out some options for funny songs.

Camera operator Harry Garvin was listening in on the actors' banter, and he thought about a favorite 1970s hit that rivaled all comers in sheer schmaltziness. He began talk-singing the lyrics to the Starland Vocal Band's "Afternoon Delight," mimicking their efforts. The actors heard what he was doing and jumped in. The deceptively wholesome song, replete with four-part harmony straight out of the Mamas & the Papas, was really a pop treat about postprandial sex, and bringing it out of hibernation would be a nice summation of *Anchorman*'s twisted 1970s nostalgia.

Then Adam McKay heard about their plans and did them one better. This would be a perfect addition to the scene where Ron is telling his colleagues he is in love with Veronica. A few short days later, there was a plan to shoot a new sequence.

Partway through the *Anchorman* shoot, Craig Wedren was wandering the hallways of the Chateau Marmont hotel, famed hunting ground of the Hollywood demimonde, located just steps off the Sunset Strip in West Hollywood, when he ran into Paul Rudd. Wedren hugged his old friend, who was thrilled by the serendipity: "Dude, I can't believe we ran into you. We need someone exactly like you to help us with this barbershop quartet version of 'Afternoon Delight.'"

There could hardly have been a better person to assist with this

ludicrous side gig than Wedren. In the early 1990s, Wedren had come to indie-rock fame as the lead singer of Shudder to Think, a DC post-hardcore band known for Wedren's delirious falsetto. In an era defined by the hypermasculine yowls of Eddie Vedder and Chris Cornell, Shudder to Think crafted its own style of post-punk art rock. Wedren was a *singer*, not just a front man. He had also gone on to compose the music for films like *Wet Hot American Summer* (where he and Rudd had met) and *School of Rock*.

Wedren, who remembered listening to "Afternoon Delight" on the radio as a four-year-old, spent a day breaking the song down into its component segments and designing a vocal part for each of the performers. Shortly before the scene was to be shot, Wedren met up with the actors in a trailer on the set. Within thirty minutes, Wedren felt they had nailed the song. Koechner had even added a small sonic fillip to mimic the song's pedal-steel guitar, sounding like a rapidly inflating and deflating balloon. (Christina Applegate also approached Wedren, telling him she could sing as well, leaving him unsure about precisely how to respond.)

The actors were less sure of themselves. Ferrell, Carell, Rudd, and Koechner would practice singing "Afternoon Delight" while sitting in their makeup chairs. The day of the shoot, Ferrell approached McKay. "We can't do this," he told the director. "We're not ready." It was one thing to joke about forming a barbershop quartet. It was another entirely to step in front of the camera and be immortalized singing "Afternoon Delight."

Whether it was some subtle assistance provided by Wedren or the adrenaline of performance, the four actors nailed their rendition. The news team implores Ron to teach them about love, and he bursts into song: "Gonna find my baby / Gonna hold her tight / Gonna grab some afternoon delight." The conjunction of their surprisingly

polished rendition and the ludicrousness of this ode to daytime sex as a code to unlocking the mysteries of love is senseless and perfect. As soon as they were done singing and the performers wandered away awkwardly from each other, as if embarrassed by their momentary tunefulness, the crew burst into applause. (Ron reprises "Afternoon Delight" later in the film, alternating between singing and making fart noises as he flounders in a down-at-heel bar.)

The remainder of the shoot included numerous days of location shooting all around the Los Angeles area, as well as countless opportunities for the cast and crew to experiment and tinker with their approach. The movie was already exceptionally funny, but each day, there was some new nuance added to the material that only made it better.

There were no weak links in the cast, but Ferrell was a particular wizard at improvisation. It would have been understandable if he had struggled with riffing on the script, given that he had written it himself. But laboring over the words did not come at the cost of shutting himself off to bursts of inspiration, as in the sequence following the newsroom showdown, where Ron summons Brick to his office. Brick tells Ron, "I killed a guy with a trident," and Ron responds, "I've been meaning to talk to you about that. You should find yourself a safe house or a relative close by. Lay low for a while, because you're probably wanted for murder."

Koechner loved the workaday feel of the battle scene, which felt like it was intended to be one in a near-endless number of vicious local-news squabbles, and this scene maintained the deliriously humdrum approach, with Ron matter-of-fact about Brick's having just killed someone with a trident. Ron's praising his colleagues for having "kept [their] head[s] on a swivel" set the crew off in gales of laughter. (Ron has a "RON BURGUNDY IS #1 IN SAN DIEGO"

poster behind his head and holds a half-drunk bottle of beer in his hand as he talks. Even Ron's soberest tones are lubricated by alcohol.)

The looseness and improvisation extended to moments when the camera was not rolling. One day during the shoot, stunt coordinator Rick Avery invited his son-in-law, a straitlaced deputy sheriff, to the set to watch. He was a big fan of Ferrell, and Avery wanted to introduce him to the star. "Come on over here!" Ferrell called to the shy visitor, and then grabbed him and hugged him tightly. Avery's son-in-law's face turned bright red, and Koechner, sensing an opportunity, came up from behind and began mock-humping him. Improv was a way of being.

The other days of location shooting were similarly memorable, requiring attention to detail, an ability to pivot on the fly, and an appreciation of improvisational nuance.

For the sequence where Ron accidentally throws a burrito at a biker (played by Jack Black), there was some uncertainty about just how they would film the scene, which was to be shot on the Queensway Twin Bridges in Long Beach, adjacent to the Aquarium of the Pacific. After a struggle to get the motorcycle working, key grip Lloyd Moriarity suggested putting Black on a sled dolly that would travel alongside the process trailer carrying Ron's car. The crew built a faux motorcycle out of apple boxes and appended a set of handlebars on top. As soon as Black was hit by the burrito, the scene cut to a stunt performer who would skid onto the highway tarmac.

"Antony and Cleopatra!" Ron blurts, his discarded burrito decorating the roadway. "That was a terrific little spill. That's quite a raspberry." The biker angrily demands that Ron fix his motorcycle before he "stomp[s] [Ron's] goofy ass," and Ron, maddening and reasonable in equal parts, channels his inner Edwardian while

putting up his fists Marquess of Queensberry style: "If you want to throw down in fisticuffs, fine. I've got Jack Johnson and Tom O'Leary waiting for you right here." (In an alt sequence, Black refers to his motorcycle as "my little princess that I love," and Ron unthinkingly demeans his princess by referring to it as a "scooter.") Ron's calm only riles the biker more, and, furious about the loss of his beloved motorcycle, he asks him what he loves best. "I love poetry and a glass of scotch, and of course my friend Baxter here." (In a different version of the scene, Ron also says he loves America, which is very on-brand.)

Taking revenge for his motorcycle, the biker grabs Ron's dog and punts him off the bridge: "That's how I roll!" McKay was convinced that, while he had not invented it, the scene had popularized the use of the phrase, which became so ordinary that no one recognized *Anchorman*'s role in perpetuating it. ("Put that on your stupid news show!" the biker calls out as he walks away in another version of the scene.)

Seeking to avoid any PETA-related kerfuffles, the edited sequence made it abundantly clear that it was a dog-shaped stuffed animal, and not an actual dog, that was being given the boot. In one alt, a father perched beneath the bridge unexpectedly catches Baxter in his arms, with his son deciding to name his new dog Cracker. In the end, watching Baxter (or his stuffed stand-in) disappear over the lip of the bridge was punctuation enough, with Ron falling to his knees and wailing in horror at the sight of his best friend's putative death.

The scene worked, but the combination of period setting and low budget made for a stressful experience for crew members like location manager Jeremy Alter. Each day of location shooting required bringing in extras in 1970s garb and period-correct cars.

Every day was devoted to either prepping, shooting, or striking a set, and when even minor things went wrong, like not getting Jack Black's motorcycle to work, the stress mounted because of the time crunch.

The crew knew that, at some point, there would be a scene with Ron Burgundy emoting inside a telephone booth, but there was no official slot on the shot sheet for it. Instead, each day of location shooting, lingering in the background was the incongruous sight of a truck with a telephone booth perched atop its back, waiting for a spare moment to grab the scene.

During the Long Beach shoot, the phone booth finally came out and Ferrell was given an opportunity to ad-lib. "The man punted Baxter!" Ron moans, and his cries grow only more incoherent from there: "The motorcycle on the bridge! I hit him with a burrito!" Ferrell rocked the phone booth back and forth, banging against the sides and shouting that he was "in a glass case of emotion!"

Ferrell's dedication to the bit, to trying out every possible permutation of a joke, was spellbinding, and occasionally caused trouble. In San Pedro, the crew shot the sequence in which Ron, now bearded and disheveled after being fired from the station, stumbles along the sidewalk and spots his erstwhile crew. He begs Champ and Brick to return to him, with Champ overcome with grief for his best friend before reluctantly turning away. Ron lifts a quart-sized carton of milk to his lips and dribbles it all through his lush beard. "It's so damn hot," he moans, then looks down skeptically at his drink. "Milk was a bad choice."

It was a broiling-hot July day, and McKay had instructed the props department to hand Ferrell a carton of milk. Ferrell was trying to find his way out of the scene, and he was genially attempting to tell McKay and the crew that he did not want to be drinking

milk at that moment. Ferrell couldn't stand that he was being forced to drink milk in the punishing Southern California sun, but for some reason his genuine annoyance was coming out in his Ron Burgundy voice. What had been intended to be Ferrell's own light-hearted complaint instead transformed into one of Ron's funniest and most memorable lines.

The sidewalk sequence required extras to serve as passersby, and the scene was tricky to film because the extras were so captivated by Ferrell that they kept glancing at him and thereby spoiling the take.

The jazz-flute sequence (shot in a Chinatown restaurant called Little Joe's) required a smooth shift from Ron and Veronica's relatively normal not-quite-date to the absurdity of Ron's impromptu musical performance. Cinematographer Tom Ackerman wanted a romantic aura, with Ron looking dashing and Veronica practically glowing in her seat. When Ron is called up to perform by club owner Tino (Fred Armisen), and he begins playing his instrument atop patrons' tables, the scene takes on a more frantic edge, with faster-paced editing. Ron initially demurs, shaking his head and begging off, but as the spotlight wanders over to his table and the patrons applaud for him, Ron rises.

"I'm not prepared. I really am not prepared at all," Ron pleads while pulling out a flute secreted up his sleeve. (Is there a sex joke buried in there somewhere?) The gap between Ron's empty pleas of modesty and his showman's preparation is only intensified when he reaches the stage and instructs the band: "Let's take the bass line for a walk." Ron is, in his spare time, a white hepcat straight out of the era of Chet Baker and Gil Evans. "A little 'Ham and Eggs' coming at you," he tells the audience. "Hope you got your griddles."

Ron kicks over the mic stand, walks across tables, and smashes glasses in his flute-solo frenzy. In the funniest moment, Ron pops

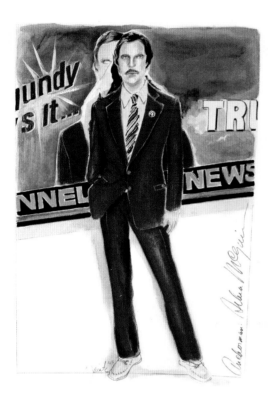

An early rendering of Ron Burgundy. Note the burgundy suit, which costume designer Debra McGuire would have to fight to convince director Adam McKay to adopt.

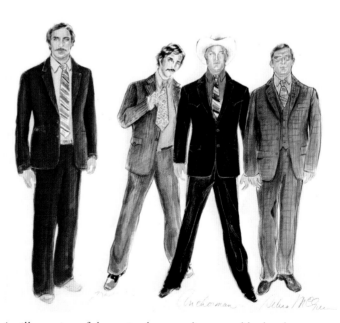

An illustration of the main characters' proposed looks, drawn during preproduction. Brian Fantana's tie is wonderfully short.

An early drawing of
Veronica Corningstone by
illustrator Susan Zarate.

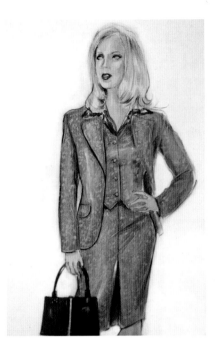

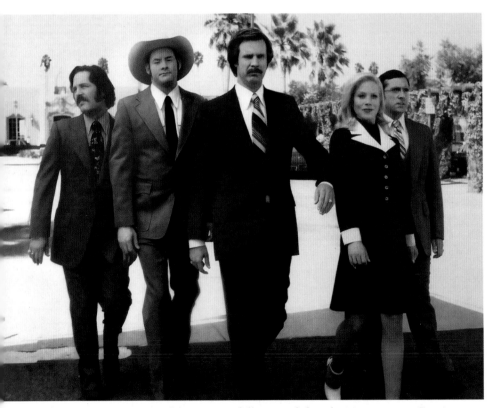

The new news team marching purposefully toward the television cameras. Ron is
gamely attempting to check Veronica out of his spotlight.

A side-by-side rendering of the paths of two characters—Jack Black's biker and Christina Applegate's Veronica Corningstone—from initial illustration to onscreen appearance.

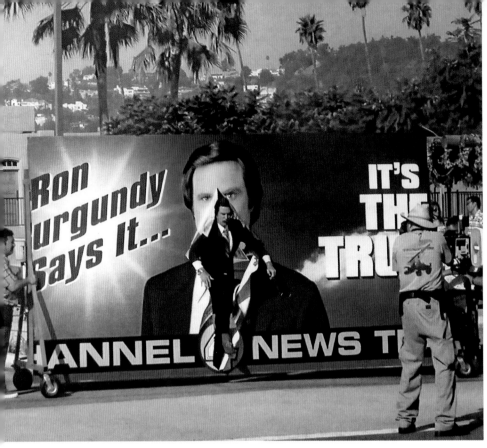

Ron Burgundy bursting through his own billboard as part of
a News Channel 4 promotion.

Christina Applegate with
Anchorman costume designer
Debra McGuire.

Tim Robbins's PBS anchor preparing for the newsroom battle. His colleague on the right appears to be wielding a baseball bat with scissors taped to the handle.

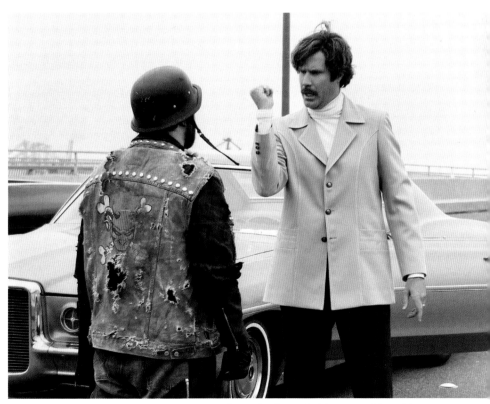

Is the right fist Jack Johnson or Tom O'Leary?

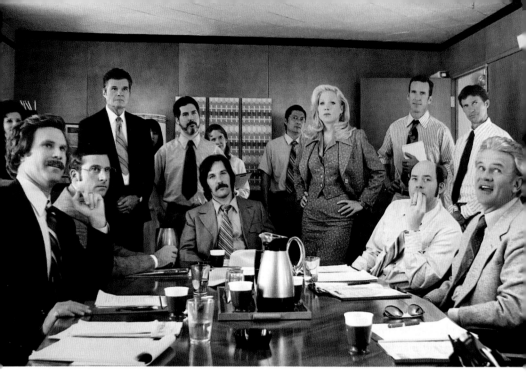

The newsroom meeting the morning after Ron and his pals' blowout party. Champ Kind may be about to tell everyone that he shit a squirrel.

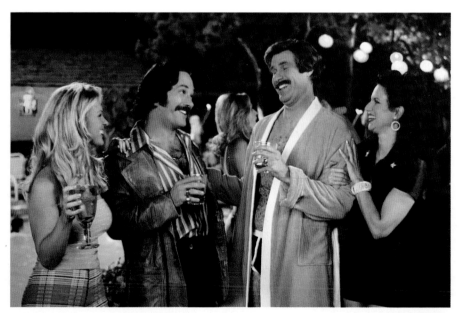

Brian and Ron at the pool party with their female friends. The piping on Ron's bathrobe matches his underwear.

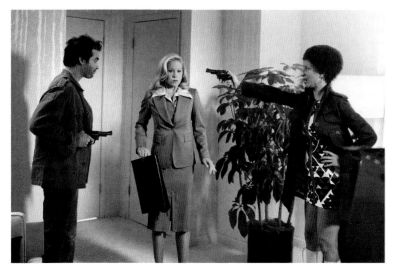

Applegate being threatened by Kevin Corrigan and Maya Rudolph, who were playing the counterculture baddies of the Alarm Clock, in a plotline that was ultimately excised from *Anchorman*.

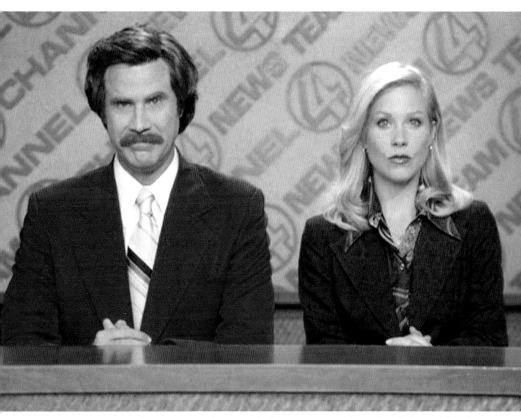

Ron and Veronica at the news desk. Ron is very pleased with himself, and Veronica is not even remotely amused.

Sex Panther by Odeon. It stings the nostrils.

Adam McKay and Will Ferrell at the after-party following the *Anchorman* premiere.

up under a bathroom stall, interrupting a patron on the toilet. Ferrell partially improvised the sequence in which he uses his flute to slurp up a patron's drink, plays the riff from Jethro Tull's "Aqualung," then lights the end of the flute on fire as a coda to his performance.

There was such an overabundance of creative vigor that even scenes that did not make the finished film were a joy to imagine and execute. It was 105 degrees the day of the sequence in which the news team rushes to the observatory to rescue Veronica from the counterculture baddies of the Alarm Clock. The scene was being directed by Apatow, who was overseeing the second unit that day in an effort to keep the film on schedule. The air-conditioning was off, the windows were rolled up, and the performers were clad in polyester suits. The heavy fabrics did not breathe at all, and they were trapped in an airless, stifling car. It got so hot that eventually all the performers removed their pants for the sequence, which would only be filmed from the waist up anyway. When they finished filming, the four actors emerged clad in jackets, ties, and underwear, to the hoots of the crew.

Even with all the heat-related shenanigans, Koechner felt he did some of his best work in this scene, in which Champ pours out his feelings for Ron. Koechner saw Champ as a complex character, not a caricature or a one-dimensional buffoon. (Others found this scene leaned on easy jokes regarding Champ's buried same-sex desires.) He was a fool, and only occasionally aware of his own limitations. Koechner also saw Champ as a closeted gay man. It was not something that had been talked much about in the preparation for the film, but it was clearly there, and Koechner was intent on bringing it out in this sequence, in which he pleads his case from the back seat: "We love you, Ron. I love you, Ron. I said I love you, Ron.

Why is everyone ignoring me? I LOVE YOU, RON. And I think we should adopt a child together in Vermont."

The remainder of the news team stares out the window, pretending not to hear, as Champ delves ever deeper into his feelings, demanding that Ron say "Champ Burgundy" and making reference to a famed 1970s Dallas Cowboys quarterback: "Maybe we could get married in a ceremony presided over by Roger Staubach. I already called him last week. I hope that's okay with you."

In the finished film, Brian, Champ, and Brick channel their affection for Ron into verbally harassing Veronica both as proof of their fealty and to ward off any potential rivals. Champ pledges to "take a run at the new girl," brushing his hand deliberately across her breast as he reaches for a pencil on Veronica's desk: "What can I say? I like the way you're put together. What do you say we go out on a date, have some chicken, maybe some sex, you know, see what happens?" (For Champ, romance and food seem to be forever intertwined.) Veronica feigns reaching for her stapler and then punches Champ in the nuts. (In an alt of this sequence, Champ winds up on his hands and knees after being punched, vomiting into a trash can.) Koechner made sure to review the scene in detail with Applegate so he did not surprise her. The two actors agreed that Koechner would keep his hands ever-so-slightly away from her chest, and that when Applegate was to punch him, she would aim for his thigh.

Of all the newsmen, it is Brian Fantana who devotes himself most thoroughly to humiliating Veronica. "I'll give this little cookie an hour before we're doing the no-pants dance," the ever-confident Brian says to Ron. "Time to musk up." Brian elbows open a hidden cabinet in his office, revealing an array of alluring bottles, including one shaped like an Adidas sneaker and another like a sports car.

As some seductive music bubbles up, Ron enthuses over Brian's stash of scents: "Wow, it never ceases to amaze me."

Ron hazards his guess for what cologne Brian is going to trot out in Veronica's honor, but London Gentleman and Blackbeard's Delight will not be making an appearance on this day. Instead, Brian opens a black box, and we hear a panther's growl as a miniature animal head pops up from its Astroturf bed. (In an earlier take, the panther head failed to pop up, and Rudd memorably improvised: "This cost me thirteen thousand dollars. It really pisses me off.") Ron wants to be supportive, but the waft of Sex Panther forces him to keep tempering his assessment of the cologne banned in nine countries: "It's quite pungent. It's a formidable scent. It stings the nostrils. In a good way. Brian, I'm going to be honest with you, that smells like pure gasoline." In his own perversely assured way, Brian is unruffled: "They've done studies, you know. Sixty percent of the time, it works every time."

Brick goes last among his colleagues, the recipient of a garbled message at the end of a long and vigorous game of telephone: "I would like to extend to you an invitation to the pants party." Veronica struggles manfully before partially deciphering his message: "Brick, are you saying that there's a party in your pants and that I'm invited?" Veronica declines the invitation, and Brick, clueless as ever, invites his male coworker Ian (Ian Roberts) to the selfsame pants party before sprinting out of the frame.

The loose feel on the *Anchorman* set extended even to the question of who might appear in front of the cameras. There were times when a performer might be needed on the spur of the moment, and a crew member would be drafted to pitch in. While filming the sequence following Brian's donning of Sex Panther, McKay turned

to Judd Apatow, sitting next to him by the monitors, and asked him to put on an echt-seventies short-sleeved dress shirt and express his horror at the odor: "It smells like a turd covered in burnt hair!" Even costume designer Debra McGuire was drafted for the sequence, asked to stride past Brian and deliver a particularly absurd line: "It smells like Bigfoot's dick!" (McGuire's daughter would later wow her college friends by pointing out her mother making a cameo in an all-time campus favorite.)

The Sex Panther scene kept being tweaked and adjusted, until McKay and Ferrell thought it would be funny for it to end with Brian's being hosed down by maintenance workers. McGuire's fellow costume designer Joseph Mastrolia felt called to step in and approached McKay with some bad news about Brian's jacket. "Guys," Mastrolia said, "this is one of those moments where cost meets creativity. We've really designated this as a one-of item. It's the perfect outfit, we've already shot him, I don't have multiples. We can't hose him down."

Mastrolia arrived to set one morning to see that the scene of Brian's being hosed down was on the day's call sheet and reiterated his concerns to McKay. Instead of demurring, McKay placed his hand on Mastrolia's shoulder and told him, "Well, we actually *can* do it because we know *you're* not gonna mess it up. We've got a maintenance uniform for you, and for me, and we're responsible if it doesn't happen on take one." It would be up to the director and costume designer to complete the scene in one take and ensure that the film's continuity was not damaged.

Mastrolia could not help but feel like a deer caught in the headlights as he donned his beige baseball cap and matching shirt with name stitched over the breast, along with brown pants and work boots, and steeled himself to ensure that he was not personally re-

sponsible for a wardrobe mishap that would not only damage the film but also be immortalized for posterity. It was impossible to forget that in a matter of months, people all over the world would see him in his maintenance garb, spraying Paul Rudd with freezing water. McKay wore protective goggles as he brushed a broom along Rudd's back, and Mastrolia (with a white protective mask covering much of his face) wielded the hose. "This is worse than the time the raccoon got in the copier," McKay said as Rudd shuddered and shivered.

McKay and Mastrolia pulled it off in one take.

The shoot wrapped on September 10, 2003, after forty days. By the end of the shoot, crew members were approaching McKay and Ferrell and thanking them for restoring their love of filmmaking. The grueling experience of working on psychologically and emotionally draining film sets had taken away some of that joy, and *Anchorman* had brought it back. "It's not like we're so great," McKay would joke to them. "It just sounds like you guys have worked with some pieces of work."

☆

CHAPTER 8

Built the Eiffel Tower
Out of Metal

MORE THAN A decade before the term *#MeToo* entered the collective lexicon, documenting an era when even sexual harassment was not yet a concept in the public eye, *Anchorman* details the corrosive effects of persistent, habitual, unwanted sexual attention, and of men hell-bent on seeking revenge on women for encroaching on their space. Ron is threatened by Veronica's success, and by her competence, and these scenes are comedic demonstrations of his bottomless cruelty and his casual contempt for women. Veronica is his rival and also a representative of an entire gender he holds in furious disdain.

Ron and his cronies are loathsome weasels in these sequences, and it is telling to see how unambiguous *Anchorman* is in condemning their behavior, even as it finds comedy in their pathetic stratagems. To be sure, this is not a film in which a full reckoning with the weight of misogyny can take place, but nonetheless, there are few more effective depictions of the conjoined ugliness and stupidity of such reckless bias than in these moments.

Even before Veronica insulted Ron's hair, the two feuding broadcasters had introduced a similar suite of themes during a clever sequence in which we watch Ron and Veronica verbally jousting over the end credits of a nightly broadcast, knowing that their audience can only see, and not hear, them. (The news credits list future stars Jon Hamm and Adam Scott, both there as tributes from their friends in comedy.) Ron never stops smiling for the cameras as he says, "You are a real hooker, and I'm gonna slap you in public." Veronica tells Ron he has "man boobs," and Ron threatens her again: "I'm gonna punch you in the ovary, that's what I'm gonna do. A straight shot. Right to the baby maker." Veronica finally rattles her erstwhile boyfriend when she tells him, "Jazz flute is for little fairy boys." Ron, who professed to enjoy this verbal warfare, is rattled: "You know what? That's uncalled for. I can't work with this woman. That's terrible."

Veronica is always given the upper hand, her specificity far superior to her male rivals' generic taunts. When Wes Mantooth asks her later in the film to "fetch [him] a sandwich," his bland jibe is topped by Veronica's offer to show him the latest ratings "where [he's] number two to a woman," adding, "Ouch. Don't lose any more hair over it."

WE WATCH AND we toggle between a delinquent's enjoyment of Ron's antics, not entirely dissimilar to those of Archie Bunker, or Homer Simpson, or Austin Powers (another relic of a bygone era washed up in a time not his own), and a kind of discontent at observing these actions. Are we supposed to be laughing at Ron? Is it okay for us to enjoy Ron and his friends being objectively terrible?

Anchorman expertly calibrates its humor by allowing us to enjoy their cloddishness while also appreciating their eventual comeuppance. McKay and Ferrell set the movie in the 1970s so that we can safely compartmentalize the action as being relegated to the distant reaches of the misogynist bad old days. We know what is coming for Ron and his cohort, even if they don't. "Times are changing," a thoughtful bartender (played by Danny Trejo) tells Ron. "Ladies can do stuff now. And you're gonna have to learn how to deal with that." Ron, clueless as ever, replies to Trejo's English-speaking bartender that he does not speak Spanish.

Anchorman is designed to encourage our enjoyment. Even when Ron is at his worst, as in the sequences in which he is taunting and humiliating Veronica, each scene is carefully calibrated to ensure that Ron remains the butt of the joke. The jokes are less about Veronica's humiliation than about how little ability Ron and his cronies have to truly humiliate.

Writing jokes for a film like *Anchorman* was to carefully tread just this side of outright offensiveness. The jokes were calibrated so that they exploded on the very characters seeking to humiliate others into submission. There are several jokes in *Anchorman*, though, that land awkwardly now, feeling repugnant and mean-spirited rather than representative of the mindset of thoughtless, rude characters. Brick refers to himself as eventually receiving a diagnosis of being "mentally retarded," using language that is blatantly offensive. Veronica's expression of disgust at the stench of Brian Fantana's Sex Panther—"It smells like a used diaper filled with Indian food"—feels like an unnecessary, bigoted swipe. Perhaps if the joke had been delivered by another character, it could be seen to reflect their own closed-mindedness, but Veronica, as the voice of reason, is never otherwise presented as being quite so foolish.

The same unthinking bias applies to the casting of Ben Stiller as the anchor of the Spanish-language news. Stiller, listed in the credits as Arturo Mendes, plays with Hispanic stereotypes in the scene, including his dress, manner of speaking, and air of barely repressed hysteria, and while Stiller is always funny, the moment lands with a thud because of the undercurrent of a non-Hispanic comedian playing an exaggerated comedic stereotype. For a comedy that had put so much thought into precisely how to calibrate its jokes, dropping Stiller in this role gave ammunition to critics who might see films of this ilk as only for and about white men.

Anchorman was intent on making a statement about misogyny, and was designed from its early stages to reflect the unthinking male supremacy of a bygone era. The jokes were crafted to illustrate the benighted attitudes of the film's characters, and to carefully, quietly advance a narrative about their casual callousness.

By contrast, *Anchorman* is also studded with jokes about sexuality that feel less carefully considered. The jokes are more unformed, with an undertone of cruelty in which we are laughing alongside the film's characters as they attack others, rather than at their bigoted attitudes. When Veronica attacks Ron by telling him that "jazz flute is for little fairy boys," she is being granted the winning argument in a rolling debate by questioning Ron's masculinity. What kind of red-blooded man, she wonders, would play the jazz flute?

Veronica is the only character in *Anchorman* who is consistently perceived as holding the winning hand in a debate, so it is particularly troubling to see her reaching for this bigoted swipe. The moment tips *Anchorman*'s hand, revealing that it is less carefully attuned to the experience of actual gays and lesbians by allowing its characters to use them as handy rhetorical devices.

This is complicated somewhat by the presence of Champ, who is

simultaneously a homophobe and a closeted gay man. The film does not have enough space (and perhaps not enough inclination) to fully pursue this theme, with Champ alternating between telling Ron off in distinctly homophobic terms ("You sound like a gay!"), telling a story (in an alt take) about harassing a gay man (driving "that limp-wristed fairy that was supposed to do the financial reports" out of their workplace), and revealing his buried same-sex longings for Ron. The scene of Champ planning his wedding, with Roger Staubach as the officiant, gestures in this direction, with Champ's colleagues' deliberate deafness a reflection of their own homophobia (they cannot even hear Champ's declaration of love) and of Champ's own colliding desires.

Champ is seeking to shield his yearnings, about which he is overwhelmingly conflicted, by policing others' sexuality, chiding his fellow men for their failings to properly inhabit their manhood. There is tragedy buried in Champ's hidden desire, and while the film does not always know what to do with this material, there is an intent here to undermine the faulty assumptions of a lost era about what it means to be a man, or who a man might be. (Who could be more manly—at least in the world of the news—than a sportscaster?)

Anchorman is well aware of the limitations imposed by good taste and audience sentiment; it is unsurprising that (in this first installation, at least) these offensive all-purpose chauvinists utter nary a negative word regarding race. Presenting these characters as racists, in addition to their toxic masculinity, would likely be a bridge too far for the audience, and the movie stays shy of the topic altogether. This is undoubtedly a wise aesthetic and political choice, but also renders the decision to use crude homophobic stereotypes more difficult to accept as anything other than ugly stereotypes only arguably salved by Champ's backstory. *Anchorman* was playing with

crudity, and introducing characters who were themselves thought-less and crude. The line between hoisting characters with their own petards and letting the voice of the film itself be cruel was narrow, and while *Anchorman* mostly stayed on the right side of the line, these moments rankled.

Ron is mostly presented as a romantic whose flights of lovelorn imagination are often indistinguishable from his misogyny. Ron loves women and is terrified of them all at once. The subtext of *Anchorman*, which it shares with *Knocked Up* and *Superbad* and many of the other films of its era, is that men are simultaneously unful-filled and wildly happy in the absence of women. The night Ron first meets Veronica, he is stunned when his dog, Baxter (whose barks he can apparently understand as speech), says he is lonely. "*I'm* lonely? I'm not lonely! I'm beloved by everyone in San Diego." Baxter is Ron's roommate and spiritual guide (he refers to him as "a miniature Buddha covered in hair"), whose canine shenanigans are outweighed by his wisdom: "You pooped in the refrigerator? And you ate the whole wheel of cheese? . . . I'm not even mad. That's amazing." Ron and Baxter even sleep in matching Channel 4 paja-mas and dental headgear, cozy partners in domestic bliss.

But being beloved is not the same as being loved. "The only way to bag a classy lady," Ron tells his colleagues, kissing his biceps, "is to give her two tickets to the gun show and see if she likes the goods." Ron is conveniently shirtless when Veronica enters his of-fice, supposedly finishing his intensive exercise regimen ("I can barely lift my right arm because I did so many. I don't know if you heard me counting. I did over a thousand") and pointing out his "ubulus muscle" and his "upper dorsimus." When Veronica takes umbrage at him sculpting his "guns" shirtless at the office, deriding it as "the feeblest pickup attempt that [she has] ever encountered,"

Ron shows his softer side by pleading for a second chance. He looks down bashfully and says, "I know what it's like to be lonely in a new city." Ron outwardly presents as a bulletproof success, but he at least bears a residual memory of solitude and sadness that he can summon on command.

Both Veronica and Ron appear to be attracted to each other against their will, or lacking conscious intent. In one of the movie's funniest standalone jokes, Ron's promises of a strictly collegial night out are undercut when the camera pulls back to a two-shot. We can see that Ron has had a raging hard-on all throughout this encounter. Veronica valiantly attempts to clue Ron in, but he remains clueless until he looks down with a jolt of surprise: "Yes, I do. I'm sorry, it's the pleats. It's actually an optical illusion. It's a pattern on the pants that's flattering in the crotchal region. I'm actually taking them back right now, taking them back to the pants store. This is awkward." Ron's panoply of ineffective or inadequate responses to this terrifically embarrassing situation builds and builds, a pileup of jokes that leads to one of the biggest laughs in the entire film. The MPAA would later insist on cuts to the scene, arguing that the camera remained too long on the image of Ron's erection. In the final cut, there is only a brief shot of Ron's crotchal region before it cuts back to his face.

Veronica is attracted to Ron as well, against her own better judgment. "He's very cute. Very cute," she mutters to herself before he approaches for their not-a-date. "No, he's not. He's not. He's hairy."

And perhaps Ron lashes out at Veronica because she has brought out a vulnerable side he does not want his friends to catch wind of. When Ron and his colleagues go to Ed's office to rail against Veronica's being hired, Ron does not quite catch the correct tone of outrage. "It is anchor*man,* not anchor*lady,*" shouts Champ, "and

that is a scientific fact!" Ron's anger is just desire with a raised voice: "It's terrible! She has beautiful eyes and her hair smells like cinnamon!" (Brick is similarly clueless: "I don't know what we're yelling about!")

Veronica is less a person for them than a body, and that body is a source of commingled fear and desire. Brick and Brian worry about whether her periods might attract bears (subtle foreshadowing of a sort) and Champ turns horniness into a fantasy of cannibalism: "I will say one thing for her, Ed. She does have a nice big ol' behind. I'd like to put some barbecue sauce on that butt and just munch munch munch." Veronica walks in as Champ lets out a wolf howl and mimes painting Veronica's butt with his barbecue brush.

Only Ron is the slightest bit embarrassed at their grotesque behavior. He tries to make up for it by awkwardly raising his voice to address her: "You can use my office and afterwards maybe we can go to lunch." But as soon as Veronica leaves, we hear Champ carrying on with his comic monologue at her expense. Later, when Ron weakly tries to stop his friends from attacking Veronica, Brian calls him a "schoolboy bitch" and Champ gets to the heart of the matter, conflating misogyny and homophobia into a single toxic stew: "You sound like a gay!" Everyone chuckles, and Ron is pressured into acquiescing: "Let the games begin!"

Ron is a hapless romantic whose wayward dreams of flowers and rainbows easily curdle to nihilism and anger at the slightest touch. When Ron is pressed by his news-team colleagues to ditch Veronica, he launches into spontaneous poetry about their future together. "I know that one day, Veronica and I are gonna get married on top of a mountain," he tells them firmly, barely able to hold his emotions in check. "And there's going to be flutes playing and trombones and flowers and garlands of fresh herbs. And we will dance

till the sun rises. And then our children will form a family band. And we will tour the countryside, and you won't be invited!"

During Ron and Veronica's night out at Tino's (where they sit at a table whose sign reads, "Permanently Reserved for Mr. Ron Burgundy"), Ron shares with Veronica the ambition "that lives deep within [his] loins, like a flaming golden hawk," and Veronica responds in kind: "Believe it or not, we share the same dream. I, too, want to be a network anchor." Tellingly, Ron leans in and changes the subject: "God, you are so beautiful." (In a scene, Ron chuckles at her career goals and says, "And I'd like to be king of Australia!") Ron is incapable of processing Veronica's revelation, or simply disinterested, and wins her over with his romantic ardor, which once again takes on a quasi-mythic tenor. The two leave Tino's and return to his apartment in a romantic mood: "I'm storming your castle on my steed, m'lady." It is not quite enough for Ron and Veronica to be attracted to each other; their love must exist in a magical fairy land of wonder—at least for Ron.

Ron's romantic ardor lasts long enough for him to spill the beans on his and Veronica's relationship, first to his coworkers ("Veronica Corningstone and I had sex and now we are in love!") and then to the people of San Diego: "That, of course, was our newest reporter, Veronica Corningstone—she's really great. I'd also like to share with you that we are currently dating, and that she is quite a handful in the bedroom." In an alt of this scene, Ron goes on to describe her as "quite a creative little partner in the bedroom," mentioning her use of a Hula-Hoop, lasso, and ice-cream scooper as part of their sexual shenanigans. Ron is trampling Veronica's explicitly stated requirement for privacy, privileging his grandiose romantic sentiments above all else: "I wanted to shout it from on top of a mountain. But I didn't have a mountain, I had a newsroom and a

camera. Look, I report the news, that's what I do. And today's top story in Ron Burgundy's world read something like this: I love Veronica Corningstone."

We are also prodded to note how Ron and the news team handle Veronica's presence at the anchor's desk when Ron goes missing before a broadcast, paralyzed with grief after Baxter's loss. They firmly believe Veronica's triumph is their calamity and act accordingly. (In an unused take, Brian wants to cancel the night's news in Ron's absence: "Put on a rerun, Joe.") Veronica has already demonstrated her toughness by confronting Ed and Garth with her demand to anchor the night's news. "Mr. Harken, this city needs its news. And you are gonna deprive them of that because I have breasts? Exquisite breasts?" She goes on to put it even more bluntly, reminding them once again of her sexual desirability even as she insists on being taken seriously as a journalist: "I am good at three things: fighting, screwing, and reading the news. Now, I've already done one of those today, so what's the other one gonna be?" (Ed bashfully suggests "screwing," and gets slapped in response.)

Veronica is about to read the news in Ron's absence, and the men do not like it. Brick is frozen in fear, and Champ and Brian launch into an extended, belabored attempt at intimidation as she grounds herself for the cameras, whispering *power* to herself. Champ cocks an eyebrow at her, then leans over menacingly, wielding his catchphrase: "One slip, and you're gone. Whammy!" Brian, seated next to Champ while smoking a cigarette, holds up an open lighter, as if he were about to set her ablaze. Champ and Brian are simultaneously intimidating and ludicrous, their intensity undermined by the ashtray stuffed full of cigarette butts in front of Brian. Whatever it is they are trying to do, Brian is also clearly a nervous wreck at the thought of Veronica reading the news. (An alternate

version of the scene shows Brian sticking the cigarettes in his nose, causing Applegate to break.)

Veronica is visibly anxious as she kicks off her introduction, her mouth forming silent words between the ones that are audible, but by the time she states her name for the cameras, she has calmed herself down.

Brian and Champ have hardly given up on their efforts to spook her. Brian leans in and opens and closes his mouth again and again as Veronica reads the news, like a baby in search of the next bite of Gerber, and Champ silently screams, his ten-gallon hat trembling with the intensity of his effort.

Brian, now in oversized, misshapen tighty-whities, mirthlessly thrusts his junk in Veronica's direction, and Champ stands in front of him like a master of ceremonies at a flea-bitten circus, waving his arms in front of Brian as if to present his manhood for her approval and amazement.

But Veronica is now locked in and even begins to ad-lib her response to the most recent story: "I used to date a guy named Hoppy down in Alabama. He was quite a jumper, too." We see the women at the station chuckling appreciatively at her joke, a small cheering circle to offset the larger male retinue. Veronica's voice notably softens as she comes to her final line, where she throws in one further ad-lib: a sign-off of her own to match Ron's. "I'm Veronica Corningstone," she tells her viewers, "and thanks for stopping by, San Diego." Champ looks askance at her, and Brian ashes his cigarette, aware that they have failed to stop her.

"All clear," an offscreen voice announces, and Veronica, celebrating an unalloyed triumph, whispers, "Yes," in celebration, pumps her fist, then pauses and pumps it again. (This is a moment when one fist pump will not be enough.) Veronica's voice is positively

trembling with emotion here. Ed approaches to congratulate her on a job well done. Even Brick is seen lurking in the background, smiling vaguely, as if he might be excited about Veronica's debut or possibly contemplating some postwork jelly beans.

At the apex of Veronica's triumph, Ron bursts into the studio. Veronica, relieved to see him, approaches, delighted to share her good fortune with him: "Ron, darling. I'm so glad you're all right. I have something so magnificent to tell you. Listen—" Ron, who has now straightened up and is visible to the camera, is covered in dirt, his hair hanging limp on his forehead and curled over his ears. "We can do the news now," he tells Veronica, interrupting her, and then turns to face the crew: "It's all right, everyone."

Veronica is in the very last moments of viewing Ron as her boyfriend and not her rival, and strokes his hand in a vain effort to calm him: "Listen, sweetheart, we were so worried about you, and we waited as long as we could, but, darling, I did the news, and I nailed it. I nailed it!" Veronica is glowing with pleasure, pumping her fist as she recounts her triumph, and then shuddering and pumping her fist a second time. There is a near-sexual feel to Veronica's bodily response here, her voice giving off an orgasmic undercurrent. Ron rapidly shakes his head, as if to free his mind from the horrific cacophony filling his ears. He raises his fist in the air, as if prepared to fight off this development, and looks around to see if anyone is chuckling at this obvious prank: "Wait, Veronica, please tell me this is some kind of sick, tasteless joke."

And now things get *genuinely* embarrassing, as Veronica makes one last appeal to head off Ron. "Why can't you just be proud of me," she asks him, "as a peer, and as my gentleman lover?" Veronica looks around and drops her voice when she calls him her "gentleman lover," as if knowing she is going too far and saying something

that will permanently scar everyone within earshot. ("Oh jeez," Ed mutters.) Ron is now fully hyperventilating, setting off an unstoppable toddler-style temper tantrum. "I can't believe you did this to me. You read my news!" The news is Ron's and no one else's, and in his mind it is a horrific abuse of his trust to have commandeered it. (In an alt take, Ron insists on reading the night's news before an empty newsroom, bereft even of cameras.)

The feuding couple are once again bickering against a backdrop of male onlookers, but the framing feels different now. This is Veronica's life: arguing for herself in front of an unmoving screen of impassive men unable or unwilling to listen to her. Veronica, only now fully understanding who she has gotten herself involved with, sounds rueful: "You have broken my heart, Mr. Burgundy." She repeats herself, part of a pattern of repetitions in this sequence, in which we understand that characters are expressing the deepest, most private facets of their personae by seeming to be unable to resist saying the same thing time and again.

RON AND HIS crew are misogynists with flutes, sex pests with faux-book-lined walls, their ugly impulses sheathed in cocoons of almost-classiness. The movie's language also toggles between pseudoclassical erudition and down-and-dirty coarseness, with its protagonist switching at will between thinking of himself as a romantic and a scholar and presenting himself as a no-holds-barred male chauvinist. *Anchorman* is a fake bookshelf stocked with odoriferous scents, its air of fake scholarship poisoned by the deliberate mustiness of its characters' profound defensiveness.

When Ron feels cornered, he turns once more to the gap between

the sexes for comfort, seeking to band with the boys in order to fend off the threatening charms of women. Veronica is attempting to eject Ron's tape, seeking to displace his moment of unearned glory with her Protestant work ethic, which has gotten her named co-anchor.

Ron and Champ prank-call Veronica from an empty office in an effort to get back at her. Champ stares out from behind some cheap-looking off-white vertical blinds, his face a mixture of anticipation and dread. "Hello, Veronica, this is Mike . . . Rithgen from the network," Ron starts. "You've just been promoted and you're going to need to move to Moscow. Why don't you just start cleaning up your desk, and we'll see you in the morning. We'll pick you up in a van."

Ron proves himself ill-equipped for the fabulist's first task: making up a believable fake name for himself. He strikes out at offering a plausible story, getting bogged down with irrelevant details: Why the van? Veronica, unsurprisingly, is hardly fooled: "What did you say your name was?" Ron cannot remember as far back as fifteen seconds ago, and his name comes out even more garbled this time: Is it Rutnithin now? Ron tells her again to start cleaning out her desk, and Champ begins to chuckle to himself, overcome by mirth at the thought of Veronica in the Soviet Union: "She might want to get a coat."

Ron and Champ enjoy the prospect of male bonding through cruelty, reminding Veronica that she is unwanted. The humor, though, primarily stems from how crude and unsophisticated they are. Ron repeats Champ's suggestion, and we cut back to Veronica's perspective, hearing just how clearly audible Champ's chuckles are over the telephone. She looks over to her right and tells him, "I can see you." Then, as if to emphasize her point, she lowers the tele-

phone receiver away from her mouth and shouts across the room, "I can see you." Ron is rattled: "Shoot, she knew it was me."

Veronica's phone rings again. Ron and Champ have not shifted their position at all. Champ is still clutching the blinds with barely repressed glee. Ron is adopting another voice, a bit more robotic and adenoidal than his network executive. "This is your doctor. I have your pregnancy report here, and guess what. You—you got knocked up. So you should probably get out of news." Women's bodies did not belong in the news, did not belong in men's spaces altogether, and when Ron sought to imagine ways in which Veronica might be sidelined, he came back to the problem of her body. Women's bodies were for babies, and to babies they would return.

Perhaps it is telling that Veronica accuses Ron of being a baby himself, because is he not imagining himself undermining Veronica's career through his own ongoing temper tantrum? In telling Veronica she is pregnant, he is impregnating her with himself—not his baby, but Ron himself, an overgrown toddler who never learned how to share his toys with others.

When Veronica asks who is calling, Ron whiffs: "This is Dr. Chim. Dr. Chim Richalds." In addition to failing to come up with a serviceable first or last name, Ron also appears to introduce himself with both his title and his first name, like some overcompensating pediatrician. He also repeats his last name twice, struggling to settle on a single pronunciation of his own name. "I'm a professional doctor. You saw me. You don't remember. You should move, you should get out of the business."

The film cuts back and forth between Ron and Champ in their dingy boys'-club hideaway and Veronica at her desk. Veronica is straight-backed, poised, and confident, elegant in gray pinstripes; Ron and Champ are both hunched over, cackling, two overgrown,

mustachioed little boys for whom having a crush and playing a prank are one and the same.

Perhaps it is unsurprising that the very men who do not seem to possess much in the way of an interior life or an active intellect are also the ones who want to insist that only men are capable of handling more complex matters. Ron bribes the station announcer to change the voice-over before the nightly broadcast, introducing "five-time Emmy Award–winning anchor Ron Burgundy and Tits McGee." Ron's poker face starts to give way as soon as he hears the voice-over begin, and by the time he hears the punch line, his eyes are squeezed shut in mirth, an irrepressible smile spreading across his face. Veronica's head is tilted at an angle; she looks like a disappointed parent dealing with a toddler's temper tantrum. "Good evening, San Diego, I'm Veronica Corningstone," she says to the camera. "Tits McGee is on vacation." (The intonation Applegate gives to "Tits McGee" is priceless.)

Veronica is remarkably unruffled by the surprise attack, hardly pausing before defusing the bomb. Ron is an insult comic with a ready-made audience of boyish, boorish bozos happy to laugh at anything as long as it is a crude takedown of a woman. We can contextualize Ron's insults because he is so unremittingly mediocre at scoring points off Veronica, and because Veronica is so gifted at turning back the insults directed at her. Ron, as we soon learn, reads anything he sees on the teleprompter, and as soon as Veronica properly introduces herself, Ron stumbles over the very barrier he has placed in her way: "And I'm Tits—I'm Ron Burgundy."

Ron's incompetence is his saving grace for the audience. If he was a more effective harasser, we would have to take his cruelty more seriously than we do. As it is, Ron is capable of conceiving of efforts to torment Veronica but fails to put them into action in a

manner that would truly undermine her. We are laughing at Ron, not with him; our sympathies are with Veronica, even as our comedic sentiments are with Ron. We are cleverly positioned to laugh at Ron for his shambling efforts to disrupt Veronica, and relieved by Veronica's sangfroid in fending off Ron's thrusts.

All the same, an uglier possibility lurks. Is there a segment of *Anchorman*'s audience that ignores all the guardrails and circuit breakers that McKay and Ferrell have inserted into their story and embraces Ron Burgundy unambiguously as a role model?

In a *New Yorker* essay from 2013, Emily Nussbaum introduces the idea of the television "bad fan": "All shows have them. They're the 'Sopranos' buffs who wanted a show made up of nothing but whackings (and who posted eagerly about how they fast-forwarded past anything else). . . . They're the ones who get furious whenever anyone tries to harsh Don Draper's mellow." "I will say it," Nussbaum goes on. "Some fans are watching wrong."

The "bad fan," in Nussbaum's estimation, is someone who ignores the express instructions of a show about how to understand its characters and strips away the packaging to be left with only the hijinks and none of the commentary.

Ron Burgundy was not a criminal like Walter White or Tony Soprano, but his story similarly allowed viewers to indulge in a forbidden fantasy: What might happen if we were to remove all the fetters that prevent us from speaking our minds at all times? Hopefully, most of us would not be as callous or cruel as Ron, even in our worst moments, but there is still a frisson of pleasure to be had in the thought of expressing ourselves without an iota of concern for others' feelings, if only for a moment. What would it feel like to loosen our tongues and breathe the free air of unfettered, vicious speech?

Anchorman, unsurprisingly, lent itself easily to memes. For some, Ron was turned into a mascot for the extreme right, in which free speech mostly meant getting to say ugly shit over and over again with no consequences whatsoever. Ron had been repurposed by the edgelords of the internet as an all-purpose spokesman for anti-media trolling, free-floating misogyny, and general pro-Trump sentiment, sprinkling a wondrously enjoyable movie with the taste of ashes.

When *Anchorman* came out in 2004, it was perhaps easier to collectively convince ourselves that we were in a kinder, gentler era in which blatant misogyny and hatefulness were no longer acceptable adult behavior. From the perspective of the current moment, following four years of President Donald Trump and the Supreme Court's overturning of *Roe v. Wade*, it feels too easy to attack the political and cultural delusions of 2004, too much like shooting fish in a postracial barrel. *Of course* we had not put racism and sexism behind us. *Of course* we would soon be prey to a con man with an unerring instinct for the biases and delusions of his most fervent supporters. But perhaps, in revisiting *Anchorman* with the heavier hearts of today, we might acknowledge that the clearly laid-out path McKay and Ferrell offered for studying Ron Burgundy may not be the one all its viewers took, and that there may be darker reasons, too, for the collective embrace of its most beloved character.

☆
———

Wake Up

BRENT WHITE STEPPED out of the theater into the balmy air of Westwood Village. The streets were filled with UCLA students clumped in packs and bunches, headed out to smoke narghiles at the hookah bars on Broxton Avenue or to partake of the absurdly cheap chocolate-chip ice-cream sandwiches at Diddy Riese. White—the editor of *Anchorman*—spotted the Dream-Works executives gathered by the theater door and sidled up next to them, eager to eavesdrop on their verdict.

Big-budget comedies had to pass through the funnel of preview screenings, in which the studio would seek to re-create the real-world experience of seeing the movie with an audience at a theater, complete with noisy chewers, cell phone fiddlers, and that guy who insists on recapping the entire movie to his seatmate, scene by scene. Jeffrey Katzenberg, Walter Parkes, and many of the Dream-Works executives were in attendance that day. Happily, it was instantly clear that the movie was killing with the audience.

All the DreamWorks executives were approaching McKay, shaking his hand and telling him that it was one of the funniest films

they had ever seen. But then the cards began coming in. The cards offered a numerical approximation of the audience response, and while they were hardly scientific, they generally gave a good estimate of how people responded to your movie. A score over 60 was solid. A score in the 70s or 80s would likely be cause for celebration. Below 60 meant you had problems that still needed to be ironed out. The score compiler approached McKay and the gathered execs with some sobering news: Their movie had received a 50. The people responsible for shepherding this new comedy looked at each other in shock and confusion. Here was this movie that had just visibly landed with the audience, so why had it scored so poorly?

The mood among the executives, White rapidly noticed to his surprise and dismay as he listened in, was grim. Terry Press, DreamWorks's head of marketing, came over to McKay in the troubled minutes after the screening with a message: "You idiot, you killed the dog."

"Yeah, but it's a joke," McKay responded.

Press was unmoved: "You killed the dog."

After the failed screening, Apatow summoned the troops and asked them to think through what fixing the film might look like. White, the editor of the film, had developed a habit for preview screenings that helped him to assess his latest cut. Before a preview, he would place a microphone at the front of the theater and record the audience. Back in the editing room, White would sync up the audience recording and have a real-time response track for the film. Where the laughter swelled, White knew he had a scene that worked. Where the laughter dipped, White knew it might be worthwhile to reassess whether the scene was connecting with audiences.

White pulled up the cut on his Avid editing machine back at the

DreamWorks lot, knowing that the laugh track held a story that it would be his job to decipher and comprehend. And as *Anchorman* played once more, White took note of something he had not previously noticed: The film was working too hard. The movie was a comic thriller, with Ron Burgundy and the news team as the unexpected heroes. But it had to continually oscillate between two sets of characters, and the secondary Alarm Clock story line was ultimately not as compelling or as funny as what was taking place in the newsroom. They needed to make some serious cuts.

WHEN CONSIDERING A Will Ferrell comedy, one's thoughts were unlikely to turn to Sundance, the spiritual home of the American independent-film movement, but Brent White's long journey to *Anchorman* had begun in Park City, Utah. White, a BYU graduate, had been on his first trip to Sundance in 1987 when he realized that all the best conversations seemed to be taking place in editing rooms. As alluring as the set might be, he thought, it was the editing room where movies were made.

White began shadowing the legendary editor Dede Allen, who had worked on movies like *The Hustler, Bonnie and Clyde,* and *Dog Day Afternoon.* Working alongside Allen on films like *The Milagro Beanfield War* (1988) was a revelatory education in the work of an editor. The editing manuals demanded a rigid attention to angles and background details, but Allen's motto argued that "matching is for sissies." It was the performance that was always king.

On a return visit to Park City a decade later, a friend pulled out a VHS tape and popped it into the VCR, and White quickly real-

ized he had never seen anything quite like it before. White asked his friends if they could put in a good word with director Jake Kasdan, who had lent the screener and was working on the show.

For the next week, the offices of an NBC pilot series called *Freaks and Geeks* were overwhelmed with suggestions that they hire Brent White for an editing job that wasn't even available. Eventually, White was called in for a cursory getting-to-know-you meeting, and in the time between scheduling the meeting and the meeting itself, one of the show's editors left for another job. White was hired.

White had struck up a close working relationship with *Freaks and Geeks* creator Judd Apatow during the acclaimed show's lone season in 1999–2000, coming back to work on his equally short-lived college show *Undeclared*. When *Anchorman* received a green light, Apatow encouraged Adam McKay to hire White as the film's editor. DreamWorks was concerned about bringing in an editor whose most prominent credit came on a short-lived television show, especially given that McKay was himself a first-time director, but Apatow and McKay insisted, and eventually the studio relented.

"To screen is to change," Dede Allen always told White, and coming into his own as a film and television editor helped him to understand the truth of that aphorism. Editing was a practice of dueling enthusiasms. Constructive feedback sharpened each successive iteration of a cut until, at the very end of the process, a movie emerged. Drama had to be constructed in a particular order; the crime could not be solved before the killer unsheathed his weapon. Comedy was looser, granting more leeway to editors like White to play with scenes and try them in a variety of arrangements.

The footage from *Anchorman* would come in out of order, and White would find himself adjusting his efforts depending on which

tranche of film was in his possession. For one sequence, White first received the footage of Ron Burgundy shouting, "I'm in a glass case of emotion!" and only got a look at Brian Fantana on the other end of the call some weeks later. Rudd's responses to Ferrell's wildly overwrought outbursts were the ideal seasoning to the sequence. (One take, not used in the final film, has Brian asking Ron, "Are you raped?") Once White had them in hand, he could include more of Ferrell's antics, because the office sequences would allow him to cut away from Ron and then cut back.

When the shoot was complete, White constructed a cut of the film, putting together the version of the movie that appealed most to him. Then he showed his cut to McKay, who would work his way through the material, trimming away unwanted scenes and trying out different permutations of the film. Then the producers would offer their input, each contributing their own idealized version of the movie. Each version would overlap atop its predecessors, with only White keeping track of the palimpsest of ghost films that went into the construction of this movie.

For White, it was never a hassle or an imposition; it was an archaeological expedition, a dig in which incredible discoveries were uncovered with each spadeful of dirt. Each pass at the film revealed new facets to the work, new ways to tell the story in the best possible fashion. It was White's job to gather these small miracles, produced through the sweat equity of the editing room, and assemble them into the best possible cut of the film.

On *Anchorman*, White was parked in their three-room editing suite in the post-production trailers on the DreamWorks lot, across the hall from Steven Spielberg's editor Michael Kahn.

When placed around the same monitor as McKay, Ferrell, and Apatow, the dryly humorous White seemed downright serious, a

monk of comedy. But perhaps no one was as well equipped to sense precisely which laugh was needed at any given moment in a film, or how long a beat was needed, or how many jokes could be piled atop each other in any scene before it was too much.

If he was looking for a button to a scene, Brick Tamland was especially suited to provide a funny non sequitur with which to exit a sequence. *Anchorman* would live or die based on its sense of comedic rhythm, and Carell in particular could give White a full stop or a half stop to a given scene, or extend out the feel of a moment. White felt similarly about Fred Willard's improvised, one-sided phone conversations with unseen school administrators about his teenage son's antics with German pornography and LSD-fueled archery.

White had designed a modular editing style to match his modular mindset. He had carefully filed away takes using a system he had crafted, so that clicking on any line of the film's script would immediately call up all the possible choices. Working in any given sequence, White could imagine its precise relationship with the film's other scenes and how any joke might affect all the other moments in the film. If a new joke were slotted in, how might it affect all the other scenes in the cut? And if a joke were removed, what else would need to be excised in order not to leave behind any orphaned punch lines? For White, editing a film was a process of granular attention to the details of a scene—which line was funnier? which facial expression was punchier?—within a larger frame of ever-shifting scenes.

The essential question was how long a given run could be continued before it collapsed under its own weight. How many jokes could be strung into a single scene before the audience wearied of it? The early stages of the editing process were often about crafting

loose versions of what had taken place on set, so McKay and Apatow could see what each iteration of the scene might look like and assess how it stacked up to other takes. But McKay was shooting with multiple cameras, which meant that for every take, there were often two and sometimes three cameras filming. This flexibility gave White the option of expanding or contracting a given scene, stringing together a run or compressing one. By being able to cut away from a take and insert a different angle, White could slot in bits of multiple takes in a single scene. He could also shorten a baggy take by cutting away the middle of a scene. The editing process would take roughly one million feet of film, shot over the course of a forty-day shoot, and slim it down to about fifteen thousand feet.

McKay believed they had gotten superb performances from the likes of Kevin Corrigan and Chuck D in the roles of the Alarm Clock henchmen. But the scenes had always felt like an extra limb to the movie, more a studio requirement than an essential component of the film, and while it broke McKay's heart to jettison it, the Alarm Clock plotline had long felt somewhat unnecessary to him.

Removing the Alarm Clock plot gave *Anchorman* more time to spend with Ron and the news team. Without it, though, the movie had no ending. The plot had initially culminated in a nefarious plot by the Alarm Clock to seize the television airwaves that would ultimately be thwarted by Ron and his team. If there was no Alarm Clock, the film would require an entirely new conclusion. *Anchorman*'s cast and crew would be summoned back for a reshoot.

McKay and Ferrell had long been amused by animals who wreaked havoc on their surroundings, like the cougar lost inside the car dealership in *August Blowout*. They crafted a new ending for *Anchorman* in which Veronica gets trapped in the bear pit at the San Diego Zoo, and Ron must emerge from his exile to save her.

Most important, *Anchorman* brought Baxter back from the dead in order to negotiate with the angry grizzly and save his master's life. DreamWorks signed off, kicking in $4 million to fund the reshoot.

Tim Robbins, reprising his PBS-anchor role, sidles up to Veronica to tell her, "At public television, we're really down with the whole women's-lib thing," before knocking her into the bear enclosure. Ron returns from his slide into oblivion, debating whether to report the story or save Veronica. He eventually leaps down into the bear pit, much to his chagrin: "I immediately regret this decision. These bears are massive. They looked a lot smaller from up there." Veronica is moved by Ron's foolhardy courage and chooses him against all her better instincts: "Oh, Ron, there are literally thousands of men that I should be with instead, but I am seventy-two percent sure that I love you." (Champ cheers for them while also muttering, "Stop it.")

There was going to be an actual bear on the set the day of the shoot in Griffith Park, and the crew were warned to keep their distance. They were not to make any sudden gestures, out of fear of distressing the bear. There were wires put up to give the bear the impression that the pit was electrified, but they were merely for show.

The bear's handler had arranged a gesture that would indicate that it was time for the bear to surge forward. But this information had never been shared with the performers, and when Applegate was calling out to Ferrell for help, she raised her arms in the air, imitating the bear's signal.

The bear unexpectedly lunged in Applegate's direction, its claws extended. The bear's handler leapt in, grabbing Applegate around the waist and throwing her out of the way. Applegate was yanked out a side door and away from the bear. When makeup department

head Kim Greene, who had been watching the scene from above the bear enclosure, dashed down, Applegate was shaking uncontrollably. McKay shut down the set for the day, giving Applegate an opportunity to recover from her encounter and for calm to be restored.

The reshoot was also a rewrite, with many new jokes delivered off-camera. McKay would call sound editor Mark Mangini regularly and ask him to come over to their offices with his sound recorder. Dissatisfied with the sound during one session, Mangini convinced McKay and Ferrell to decamp to the parking lot. Ferrell and McKay sat in the front seat of Ferrell's rental car, and Mangini held his microphone up from the back seat.

Bill Kurtis had been contacted by the film's producers asking if he might be interested in serving as *Anchorman*'s narrator. Unsure of himself, the longtime Chicago newscaster reached out to his friend Harold Ramis (director of *Groundhog Day*) in search of advice: "Am I going to throw my career away on this?"

"If it's gonna be a hit," Ramis responded, "then you won't."

Kurtis tentatively agreed to an audition, with McKay and the film's producers listening as he read through the script from a studio. They liked the timbre of Kurtis's voice, and flew him out to Los Angeles to record the narration and to shoot some on-screen material (which did not make the final film), including a scene of him interviewing Veronica Corningstone. McKay and Ferrell had enormous fun hearing their absurd lines emerging from the mouth of this legitimately credentialed anchorman. The only request Kurtis had was that they not insist on his saying the word *penis*, which was in the script he received. *Balls,* he decided, was okay.

Each day, once the shoot was done, McKay would arrive at the editing suite and head into White's room. The two men would

close the door, and the other editors would hear the faint sound of laughter emerging from within. White loved the experience of trying out different subtitles for Baxter's barked "dialogue" as he faces down the bear threatening Veronica and Ron. Here was editing in real time; each new pass at Baxter's dialogue was an alt of its own, providing a different kind of laugh for the scene. "In my travels I met one of your kind," Baxter winds up telling the grizzly. "His name was Katow-jo. We became friends."

"Fare thee well, Baxter," the grizzly bids his new canine friend. "You shall always be friend of the bears."

While White was editing the picture, Mangini and the sound team were working alongside him. Mangini and his team spent an inordinate amount of time on the scene in which Jack Black's biker punts Baxter off a bridge. Mangini built a series of sounds for the aftermath of the scene, with Baxter whimpering and crying all the way down, and a belated splash that seemed to indicate a bridge at least a thousand feet high. The post-production team roared with laughter at the result, but after some time, concerns about the perception of animal cruelty grew, and the sound mix was excised.

During the laborious effort to build the film's sound mix, Mangini spotted a moment where Ron bent over, and decided to sneak in a fart noise. It was not a comically exaggerated toot; more of a realistic-sounding attempt to sneak one out. Mangini had planned to tell McKay that, of course, the fart noise was just for their amusement, but when the scene played, the mix room fell apart with laughter. Mangini decided he wasn't going to admit to anything. If this fart sound was getting this kind of rapturous reception, it should stay in the final mix for the movie.

Mangini's reverie was interrupted by the sound of Adam Mc-

Kay's voice: "Stop, Mark, play that again." Mangini played the sequence again. "Take out the fart," said McKay.

"I don't understand," Mangini responded. "You guys just choked, you laughed so hard when you heard that."

McKay's response remained burned in Mangini's brain almost two decades later. "Mark," McKay told him, "a fart is a solemn comedy weapon." The fart came out.

McKay set the tone for the Tino's sequence, where Ron played jazz flute, by informing composer Alex Wurman that he wanted the flute solo to be "burning." Wurman heard the instructions and thought of a friend and collaborator named Katisse Buckingham, who had played flute on Dr. Dre's classic album *The Chronic* and could provide Ron with his musical identity.

Wurman did not know what he wanted Buckingham to play, exactly, so he grabbed a piece of sheet-music paper and wrote in a series of squiggly lines in place of notes, to indicate where he wanted Buckingham to come in. Wurman had Buckingham in one room, being filmed by a video camera, while McKay and White were together with Wurman in his studio, watching as Buckingham played. Buckingham got the go-ahead, played for about ten seconds, and paused.

The silence suggested to Buckingham, who could not see Wurman or the producers, that he had not captured the vibe they were going for. In actuality, they were laughing hysterically. The picture was already synced up for McKay and White to look at, so Buckingham's solo instantly appeared to be emerging from the flute of Ron Burgundy as he played. It was one thing to conceive of Ron Burgundy as an accomplished flautist; it was another entirely to actually hear him play.

Wurman asked Buckingham to carry on and make a gurgling sound with his flute, to imitate the sound the instrument might make when Ron was slurping up a patron's drink. Buckingham hit his note extra-hard to get a distorted tone for the moment Ron lights his flute on fire. They also asked Buckingham to continue playing while saying "Stay classy" into his flute—a bit that did not make it into the film itself. The whole experience was wonderful for Buckingham, and a little odd. He had been an aspiring actor as a teenager and had briefly dated Christina Applegate when he was sixteen. Now here he was, an adult playing the flute for the actor wooing his ex-girlfriend in a movie.

Kristen Sych, working with animator Graham Morris, was brought in to draw a fantastical animated landscape dubbed Pleasuretown to decorate Ron and Veronica's first sexual encounter. The two lovers, who had first been filmed rocking up and down on a teeter-totter pushed by a crew of teamsters, rode flying unicorns through an animated landscape of laughing pandas in fezzes and Cupids firing arrows. "Look, the most glorious rainbow ever!" Ron says. "Do me on it!" commands Veronica, and they slide down the rainbow all the way back to Ron's bedroom (where we can spot an array of Emmys on his dresser), and reality.

Sych and Morris created a series of recurring cycles of drawings of trees and flowers and animals, like an NC-17 *Jungle Book,* and then replicated it all the way to the horizon. For a brief sequence like this, it gave the impression of a vast animated landscape, executed with relatively minimal effort. In one bit that was ultimately excised from the sequence, Ron and Veronica fall into the capacious arms of the Love Panda, who paws at Veronica when Ron's back is turned and must be put in his place with a slap: "Back off, Love Panda."

As the editing process continued, Apatow grew frustrated with DreamWorks for its perceived interference in the film. Perhaps marked by his negative experiences on *Freaks and Geeks* and *Undeclared*, Apatow was suspicious of DreamWorks's intentions, especially after a young executive barreled into the editing suite while White and DreamWorks production exec Mark Graziano were working on the mix stage, demanding to see the latest cut of the film so he could implement some changes. The exec was quickly removed, but it made Apatow feel unappreciated.

Apatow's remarkable gift was his unblinking enthusiasm for the work of comedy. Even at the very end, after the shoot and reshoot, after the testing, and the color correction, and the sound mix, McKay looked over at Apatow, sitting at the back of the soundstage, and was struck by how both of them were still laughing like goons at the movie. McKay was overcome by the sensation of gratitude for the fact that he had been able to make this movie the way he wanted.

When it came time to put together the film's outtakes for a credit sequence, McKay and Ferrell had a ludicrous but inspired thought: Instead of picking through their own material, why not lift the outtakes wholesale from the 1977 comic action film *Smokey and the Bandit*? Audiences would expect Will Ferrell and Paul Rudd; instead, they would get Sally Field and Burt Reynolds's Burgundy-esque mustache.

Other than the 1970s link, there was no real connection between *Anchorman* and *Smokey and the Bandit*, but it made them laugh to think of this gentle prank being played on a nation of moviegoers. Then some DreamWorks execs came in for a screening of the latest cut, and when the outtakes rolled, there was an uncomfortable, ever-deepening silence. The *Smokey and the Bandit* tribute was almost completely cut, replaced by a more traditional

set of outtakes from *Anchorman* itself. If you looked closely at the finished film's outtakes, there was still a glimpse of Burt Reynolds flubbing a line (the clip was actually from the 1980 sequel, *Smokey and the Bandit II*) and Sally Field gently correcting him, likely puzzling everyone who noticed it.

Armed with the new ending, *Anchorman* went back out for further audience testing and received a 74. Even with the improved test scores, McKay was still concerned. He was hearing reports of another movie called *Without a Paddle*, which was out for testing at the same time as *Anchorman*, that was scoring in the 90s. Audiences seemed to be loving *Anchorman*, so what was wrong? An employee from the audience-testing company set his mind at rest, telling McKay, "Don't sweat it. Your movie's actually where it should be. This movie's hilarious."

Trimming the Alarm Clock subplot had undoubtedly helped the score, but McKay chalked up the enormous change to something else. When people asked, McKay would tell them that he knew exactly what it cost to kill a dog in a movie. The answer, he would say, was twenty-four points.

IT IS ALWAYS terribly sad, although perhaps a sadness restricted to the cohort of editors and their staff, to think of all the brilliant bits of comedy that will never see the light of day. These are the hilarious moments in time captured by the motion-picture cameras that do not fit the larger arc of the story or are superseded by scenes that claimed their places instead. White always wanted to find a way to serve those instances of grace to audiences and knew that it was often fruitless. Beyond a brief post-credits blooper reel or a small

handful of deleted scenes for a DVD release, there would be no glory for these brilliant orphans.

The debate had raged for decades, with fans and scholars adopting their own perspectives on the essential question of filmmaking: Where was a movie made? Was it a product of the conjoined labors of the cast and crew, with the final result a reflection of that collective effort? Or was it formed in the editing room, constructed out of the fragments assembled during the shoot? There is, of course, no definitive correct answer to the question. Each film is its own puzzle to complete, its own struggle to assemble. But if there had ever been any doubt about the sheer power of the editing process to craft something profoundly surprising, something that was greater than the sum of its parts, that debate was settled by a film called *Wake Up, Ron Burgundy.*

You may say that there is no such film, that there were only two films ever to feature the character of Ron Burgundy, and that they were given the far more workaday titles of *Anchorman* and *Anchorman 2.* And yet, hidden away in the pocket between original film and sequel, sequestered in a DVD release, came this little-known Ron Burgundy adventure, occupying the liminal space between director's cut and remake.

When *Anchorman* was finally locked, White gathered all the excised Alarm Clock scenes together and realized he had approximately forty minutes of footage for a deleted-scenes DVD feature. More than that, the entire plotline had a defined arc, with a beginning, middle, and end. It was practically a feature film in its own right, but White thought that the scenes, free of any context, would likely come off as underwhelming.

Instead, he and McKay had a stroke of genius, born out of the improvisational, freeform style embraced on set. Why not add in

material that had not made the film itself and treat it as a previously untold story in the ongoing adventures of Ron Burgundy?

Anchorman easily had enough spare footage and deleted scenes to encompass an entirely new film, and White set himself the task of assembling an alternate movie out of leavings from the cutting-room floor. There were threadbare bits that would have to be plumped up, and the return of the Alarm Clock plotline meant less time for the romantic story line between Ron and Veronica in this alternate version.

The challenge would be in crafting bridges that could connect the disparate pieces White was left to work with. The solution came in the form of *Anchorman*'s narrator Bill Kurtis. Kurtis was brought back to deliver an opening voice-over establishing Ron as the monarch of San Diego, and he pops in occasionally over the course of *Wake Up, Ron Burgundy* to fill in gaps left by the haphazard footage they were working with. But McKay and White kept a sequence where Kurtis's stentorian oration is interrupted by a ringing telephone, with Kurtis taking out his frustration on an unseen other: "Damn it, Sharon, I'm recording narration!"

The plot of *Wake Up, Ron Burgundy* is a photo negative of *Anchorman*, composed of all the elements that were rejected or slimmed down from the theatrical release. Preview audiences had been turned off by the extended sequence of Ron's hitting rock bottom after losing his job, so the remainder of the scene, including a bearded Ron crying in the shower while clutching an oversized teddy bear, made its way into the B-side edit. *Wake Up* was a master class in editing, asking White to get his film from point A to point D without being able to generate any new footage or to draw on a script that provided answers for the narrative arc of the story.

Wake Up, Ron Burgundy does not contain a single take that over-

laps with *Anchorman*. The two films are simultaneously identical and entirely different. If you watched *Wake Up* with your phone in your hand, one eye on your Instagram feed, it would be easy to emerge with the sense that you had just watched *Anchorman*. The main characters, the setting, the mood, the sensibility—all are identical to *Anchorman*. And yet in actuality, no part of *Wake Up, Ron Burgundy* precisely resembles the original film.

This film is still about Ron and his News Channel 4 compadres but encompasses an entirely new plotline, including performers who did not appear in *Anchorman*. The mood and style are much the same as in *Anchorman*, and yet watching it feels like entering a waking dream or a particularly vivid fantasy. Everything is mostly as we remember it, but enough is fresh to make us uncertain of our footing.

There are also the performances cut from *Anchorman*, which include Maya Rudolph and Chuck D as the Alarm Clock baddies, Amy Poehler as a bank teller, Justin Long as Fred Willard's miscreant son (only heard in *Anchorman* as a disembodied voice), and Stephen Root as one of the station's fill-in anchors. Apatow favorite Loudon Wainwright III, who starred as the layabout dad in the short-lived college series *Undeclared*, pops in here as a nosy fellow diner interrogating Ron about his sex life.

We begin with Kurtis's voice-over pompously walking us through the origin of storytelling, eventually coming, with a wink and a nod to McKay and White's experience, to those stories "lost to us because they don't test well with recruited audiences, or because a movie is too long." Ron steps out of a helicopter (the same one seen near the start of *Anchorman*) as Kurtis tells us that "this is the chaff from the wheat," the pudding on offer at the all-you-can-eat lobster dinner. Forewarned is forearmed, and we first see Ron strutting

down the street, slapping a woman's butt (she looks angry until she spots Ron and tells him to call her), catching an American flag before it drops to the ground, and being handed a drink. Ron is a Neanderthal, a patriot, and a playboy, and San Diego is his oyster. (Getting the shot, filmed in Long Beach, required coordination with the FAA and paying off a nearby Kinko's to close for the day, out of fears that the helicopter rotors might blow out the store's glass windows and injure customers.)

The plot is set in motion by the news crew's collision with the Alarm Clock. "Y'all better wake up," one of the robbers (played with absurdist verve by Rudolph) shouts, "because the Alarm Clock's ringing. Ding-a-ling-a-ding-ding-dong!" The Alarm Clock is ostensibly led by a disheveled, pseudointellectual activist named Paul (Kevin Corrigan), who is struggling to explain his philosophical qualms with the ruling order of 1970s Southern California. Casting his gaze desperately around a room for inspiration after a heist, he eventually latches on to the "propaganda box" of television. The Alarm Clock is on a collision course with Ron Burgundy, planning to commandeer the airwaves for a broadcast of their murky manifesto.

Ron and the news crew are hardly intrepid reporters. Brick tells the audience to make sure to roll the windows up when they leave pets in the car, so the heat doesn't penetrate. Brian delivers a report on the evils of breastfeeding: "Let's leave those ho-hos to us big kids, moms." Ron attempts to launch an investigative-journalism feature when he sees how successful his rival Veronica has become and demonstrates his woeful incompetence as a reporter. Ron rings an elderly man's doorbell and threatens him, under the mistaken impression that he is a terrorist mastermind: "Why don't you shut your mouth, you filthy piece of trash?"

In perhaps the funniest sequence in *Wake Up, Ron Burgundy,* Ron finally tracks down Paul for an interview. He asks Paul point-blank whether he has robbed any banks, and is instantly ready to call the interview to a halt as soon as Paul denies the allegation: "All right, guys, let's bring the van around." Ron continues apologizing to Paul after each question, while Brian passes along more and more incriminating information: a photo of Paul in the bank, an identical voice match between Paul and the masked ringleader. In one superb Burgundy-esque cutaway, we see Ron munching on a ham-and-cheese sandwich mid-interview.

Wake Up, Ron Burgundy also functions as an alternate history of Ron Burgundy and his sidekicks, granting us access to portions of their backstory, and their psyches, that did not make it into *Anchorman.* In one brilliant scene excised from the final cut of *Anchorman,* the news team is lost in the forest en route to saving Veronica. Some dim corner of Brick's brain abruptly clicks to life, and he is jolted back to his heretofore unmentioned time as the commanding officer of the men's unit in Vietnam. Brick is suddenly a coiled spring of ferocious intensity, speaking in a whispered growl straight out of Christian Bale's fantasies. "Stand down, Corporal Burgundy!" Brick snarls, grabbing Ron by the lapels. "I'll take point. Champ, right flank. Gator dirty teacup. We will fan out to a cobra double-helix formation. If we encounter any hostiles, silent throat-cuts only." None of Carell's castmates had any advance warning of where he was going to take Brick here, and while the take is completed without interruption, a close look reveals the ghost of a smile on Rudd's face, and Koechner dips his head, using his hat as impromptu anti-laughter protective gear.

Numerous glimpses of 7-Eleven and Burger King signs in the distance are not enough to convince Ron and his colleagues that

they are not hopelessly lost, and talk turns to cannibalism as a means of survival (a last remnant of the cannibalism plotline from the first draft of the script). Everyone agrees that Brian is to be eaten, and Champ approaches menacingly: "I'm going to eat your face off your bones, Fantana." (Brick cheerfully offers to be eaten as well, to no avail.)

McKay and White deploy an array of split screens and a soundtrack of fuzz-pedal horns for the Blaxploitation-esque conclusion, with Champ Kind thoroughly kicking Chuck D's ass and Ron diving in front of Veronica to protect her from a gun. "Mr. Burgundy, you took a bullet for me," coos Veronica. "And I would *not* do that again!" Ron moans.

White and McKay asked DreamWorks for more funding to spruce up *Wake Up, Ron Burgundy* with visual effects and music, but given the hazy commercial prospects of this cut beyond appearing on a future DVD release, the studio turned them down. The result (available on some versions of the *Anchorman* DVD, as well as streaming on numerous platforms) is not a good movie, precisely, but neither is it intended to be one. It is, ultimately, less a feature film than a compelling hodgepodge of equal parts cast-off brilliance and mediocrity. It is an intriguing anomaly, a fascinating one-off, a test case devoted to the glories of editing.

PART 3

I Miss Your Musk

☆

I'm Ron Burgundy (Part 1)

ANCHORMAN CAME OUT on July 9, 2004, and reviews ran the gamut from outright disgust to surprised huzzahs. Many of the reviewers sought to peg *Anchorman* as a product of, and story about, television, an extension of the *Saturday Night Live* brand in all but name. Brian Lowry of *Variety* was mostly positive about those results: "Although at times pic feels like an extended 'Saturday Night Live' sketch from the show's invariably flabby last half-hour, collaborators Will Ferrell and Adam McKay generate enough inspired lunacy to sail past the arid stretches and provide a welcome splash of breezy, at times jaw-droppingly bizarre summer fun."

Other reviewers saw *Anchorman* as a failed attempt at covering ground that television itself had already covered better. David Sterritt of *The Christian Science Monitor* saw *Anchorman* as a sitcom-inspired fizzle: "Imagine a movie where every character is more self-centered than Ted Baxter in 'The Mary Tyler Moore Show' of old, add a caboodle of idiotic jokes, and you have some idea of this ugly, unfunny farce."

There was an awareness that *Anchorman* was bouncing off something genuine that enriched its humor. Roger Ebert appreciated *Anchorman* for its sense of realism: "Sometimes the key to satire is to stay fairly close to the source. 'Anchorman,' like 'This Is Spinal Tap,' works best when it's only a degree or two removed from the excesses of the real thing." *Salon*'s Stephanie Zacharek argued that *Anchorman* "has a pleasing, noodly elasticity about it—the picture knows what its limits are and proceeds to boogie unself-consciously far outside them." But no one was as charmed by the movie as the *Washington Post*'s Stephen Hunter, who stretched to find adequate grounds for comparison: "Over the past century, film geniuses have erected many a cathedral of style, solemn structures of tradition and cohesion, the highest projection of the imagination: Swedish Realism, German Expressionism, Spanish Poetic Realism, Italian Neorealism, Danish Dogmatism. To this hallowed list does Will Ferrell's 'Anchorman' petition for admission. Its contribution: San Diego Neo-Infantilism." Hunter goes on to argue that "the movie, which is extremely funny, might be said to represent a triumph of tone over sense. It's a skit, but so ingeniously constructed and convincingly executed that it manages to sustain its energy far beyond sketch length." He sums up the experience of watching *Anchorman* like this: "You will laugh. Then you will laugh some more. Then you will laugh still again."

Anchorman did quite well, making $85 million at the domestic box office after its release in July 2004. (It was a lesser success overseas, making only $5 million more around the world, including a grand total of $3,688 in Lebanon.) *Anchorman* was the twenty-seventh-highest-grossing American film of 2004, just behind *Mean Girls*, but did not truly become a phenomenon until its DVD and cable premieres. *Anchorman* became a sleeper success on DVD and

a fixture of weekend-afternoon cable viewings. (The film's DVD commentary consisted of Ferrell and McKay aimlessly noodling, debating whether they would be allowed to say things like "fuck a walrus" and "unshaven whale's vagina" as part of their discussion. McKay also pitches Ferrell on a film called *An Eskimo in New York City,* in which Ferrell would play an Eskimo who comes to New York, becomes a newscaster, and starts a fraternity with his friends.)

Not everyone loved *Anchorman.* One of Ferrell's college friends went to see it in the theaters on a double date with another couple. Approximately fifteen minutes into the movie, the other couple got up from their seats. "Sorry," they said. "We're gonna leave." They walked out.

Time passed, and Ron Burgundy grew in stature. Ron Burgundy is, of course, a fictional character. He exists solely within the bounds of two feature-length films, along with the apocrypha of alternate versions, promotional efforts, and fictional memoirs (about which, more later). And yet, Ron Burgundy overspills the bounds of any of these works, or of the stories that contain him. He is a character who has become an archetype, an instantly recognizable holy buffoon. Whether we love Ron, despise him, or are uninterested in him, we might acknowledge that he is the rare character to take on a meaning and significance beyond the story in which we find him. Alongside the likes of Neo, Black Panther, Tony Soprano, Carrie Bradshaw, and Harry Potter, Ron Burgundy is an emblem, a demonstration of the ways in which stories can return us to ourselves bigger, bolder, and more charismatic than we might ever otherwise be.

In college, I had the privilege of studying with Harold Bloom, who would likely be horrified to see some of his ideas pilfered on behalf of a movie whose funniest moments revolve around unwanted

erections and prank phone calls. But Bloom argued that William Shakespeare's work had played a significant role in the creation of the modern personality, and we can see how Bloom's celebration of Shakespearean characters like Hamlet and Falstaff might apply as well to—gulp—Ron Burgundy.

"Setting mere morality aside," Bloom writes in *Shakespeare: The Invention of the Human*, "Falstaff and Hamlet palpably are superior to everyone else whom they, and we, encounter in their plays. This superiority is cognitive, linguistic, and imaginative, but most vitally it is a matter of personality. . . . Heroic vitalists are not larger than life; they are life's largeness." We might recognize Ron Burgundy in Bloom's description of "life's largeness." Ron is so full of life that we are easily capable of imagining his presence continuing beyond the final frames of the film and carrying over into other, untold adventures.

"The illusion of being a real person—if you want to call it 'illusion'—attends Falstaff as it does Hamlet," continues Bloom. "Yet somehow Shakespeare conveys to us that these two charismatics are *in* their plays, but not *of* them; Hamlet is a person, and Claudius and Ophelia are fictions—or Falstaff is a person, while Hal and Hotspur are fictions." Ron Burgundy is entirely ludicrous, and yet the incredible richness of his persona—suave yet uncouth, blustering yet deeply sensitive, the silver-tongued dolt—provides him with a similar relationship to the story from which he springs. We may root for Veronica Corningstone, who is far more realistic a character, to triumph over the crude Ron, but Ron nonetheless dominates by virtue of the sheer size of his personality.

Created to embody a lost world of masculine caddishness and stupidity, Ron proved to be a figure others did not weary of. Like a vanishingly small subset of movie characters past and present, he

had taken on a life of his own beyond the bounds of celluloid, celebrated and venerated as if he were flesh and blood.

It started early. When *Anchorman* first came out, Ferrell climbed back into the burgundy suit and appeared, together with famed newsman and *Anchorman* narrator Bill Kurtis, at an event at the Paley Center for Media. Ron, telling Kurtis he was feeling extremely nervous, settled himself down with a drink from the bottle of scotch placed prominently on the table between them. He compared himself to past greats immortalized in biopics, with the first name that came to mind that of Evel Knievel. Ron shared with the audience that he felt deeply impressed by the documentary footage they'd assembled of his life, which he described as being gathered between late 1969 and 1977, although he wasn't sure how the filmmakers had captured even half of what they had.

Ron's only quibble: "They toned down a lot of my sexual exploits." Prompted by Kurtis, Ron went on to recount his approximately eleven "homosexual experiences," encouraged by the intense male camaraderie of the 1970s newsrooms in which he worked. Ron told the audience he had a relationship with local sportscaster Warner Wolf: "I lived with him for eleven months up in Vermont." But it was not, Ron wanted the audience to know, a "homosexual relationship." It was just "two guys talking about building model ships and sports and walking in nature without their clothes. I mean that's pretty much it."

Ferrell filmed a series of celebrity interviews (including with Burt Reynolds, who had snuck his way into the *Anchorman* outtakes via *Smokey and the Bandit II*) as Ron Burgundy for the 2004 MTV Movie Awards, with the scripts written by the star along with Adam McKay. He found himself initially unable to form a cogent question for actress Rebecca Romijn, only settling into the interview once he

was reclining in a bubble bath alongside her (shades of Margot Robbie in McKay's later film *The Big Short*), giving her a sensual massage and sharing a postcoital sandwich.

In another interview, Ron interviews Jim Caviezel of *The Passion of the Christ* and confuses him with his most famous role: "So tell me, Yahweh, why did you decide to start acting?" Caviezel tries to correct him, but Ron refuses to budge: "I'm sorry, I wasn't listening. Did Babe Ruth make it into heaven?" The actor tries to remind him of his name, but Ron sees through his disguise: "'Jim Caviezel.' JC! I gotta tell you, not the best fake name, my lord." Caviezel stalks off, supposedly offended by Ron's line of questioning, and proceeds to casually walk on water across the backyard pool.

Another script, written but not filmed for MTV, had Ron interviewing Ludacris and going on a global journey of discovery set to the tune of R.E.M.'s "Shiny Happy People" after Ludacris realizes something embarrassing about Ron: "You've never talked to a Black person before, have you?" "Does Clarence Thomas count?" Ron asks. (He does not.)

The first time Adam McKay noticed something unusual was taking place with his directorial debut came the following Halloween. McKay's wife, Shira Piven, and his daughters were driving to meet him in order to take their children trick-or-treating. Piven called McKay from the car: "Honey, listen to this." She yelled out the window, "Who are you?" and held up her phone so her husband could hear. "I'm Ron Burgundy!" a voice called out. "This is the craziest thing," Piven told him. "I'm driving around and I've seen four or five people dressed as Ron Burgundy." "Are you kidding me?" McKay responded, thunderstruck.

A few months later, McKay attended a play at Tim Robbins's

theater in Santa Monica. After the performance, he and Piven made their way to a nearby bar to have a beer. As they were talking, McKay heard a voice nearby say, "Sixty percent of the time, it works every time." McKay assumed it was a friend looking to get his attention by quoting Brian Fantana and swiveled in the voice's direction. "Oh, hey!" he said.

Two people looked over at him quizzically. "Can I help you?"

"Oh, I thought you were talking to me," McKay responded.

"No, we weren't talking to you," said the people, who clearly did not recognize the man who had written the very lines they were quoting to each other. McKay realized that he'd just happened to overhear strangers quoting lines from *Anchorman* to each other. What did it mean when your movie was such a titanic success that you just happened to be eavesdropping on people sharing their love for it?

McKay would start getting calls from friends who had heard the movie being quoted on ESPN. McKay and Ferrell would receive a photograph of a troop transport carrier in Iraq, taken at the height of the Iraq War. It featured the face of Ron Burgundy adorning its side, with the caption "Stay classy, Baghdad" written on it. McKay eventually had to turn off a Google alert for the film because there were just too many instances of *Anchorman*'s being referenced.

One day, Will Ferrell was walking around Beverly Hills, running some errands, when someone stopped him, calling out his name. "Harold Greene!" Ferrell responded, instantly recognizing one of the newscasters of his youth, who had read the news in both Los Angeles and San Diego. Greene was curious about *Anchorman*. "I gotta ask you a question," the mustachioed Greene said. "That's me, right?"

"Oh, no," Ferrell responded. "I mean, I totally remember watching you and I know you had a mustache. But no, that's just kind of a mix of all of you guys."

"There's an old saying in the news game," Greene retorted. "Yeah right." And he walked away. Ferrell chuckled to himself, flattered that Greene believed he was watching a stealth biopic of himself.

Ron Burgundy was more than merely a movie character; he was a roving correspondent of American life, brought out on the road by Will Ferrell and his colleagues to entertain live audiences and to expand the legend, one show at a time. In 2008, as part of the promotional effort for Ferrell and McKay's new website, Funny or Die, Ferrell toured an array of colleges in the Northeast and Midwest with a handful of other comedians, including Nick Swardson, Demetri Martin, and Zach Galifianakis. McKay was along for the ride as well, serving as the tour announcer and presenting the video compilation of Ferrell's work (which somehow also included the likes of *Platoon* and *Unforgiven*) that began the festivities.

Each stop on the tour took on its own personality. At Kansas State, where the tour kicked off, Ron saluted all the troops attending from nearby Fort Riley before making a lewd gesture and referring to his penis as the original "Big Red One." At Ohio State, Ferrell came onstage in a University of Michigan sweatshirt before ripping it off, stomping on it, and revealing a Buckeyes jersey underneath. When they played Penn State, Ferrell-as-Ron took to the stage to interview Nittany Lions football stars Derrick Williams and Sean Lee, asking them if disgraced former head coach Joe Paterno had ever attempted to bite them. Each time Ron Burgundy came out, it was like the headliner of the show had arrived, and the crowd roared with pleasure. They knew his patterns of speech, his

tics, and his gestures, and were thrilled at being in the presence of this beloved character.

In a performance at Radio City Music Hall in New York, which capped the tour, Ferrell emerged as Ron Burgundy to interview another broadcast-news eminence: former NBC anchor Tom Brokaw. Ron was in the mood to reminisce about the grand old days of the news, asking Brokaw, "I don't know if you remember that broadcasters' convention that you and I were at in Lake Tahoe, Nevada, and we got into a BB gun war with Roger Mudd and Morley Safer. And then you convinced me to get on a snowmobile and ride into a casino with Diane Sawyer. Do you remember she took her top off?" "A lot of people," Brokaw responded, "thought it was one of your more dignified moments." Ron had some tough questions for Brokaw, not least among them this query: Would the NBC anchor be willing to smoke a vial of crack in order to save the president's life?

In its own ramshackle fashion, the Funny or Die tour was harkening back to the heyday of the Marx Brothers, who would tour the country's vaudeville stages with a new script, tweaking and polishing jokes until they were ready to appear in front of cameras. This tour was the inverse, extending out the universe of a beloved film so that its protagonist could appear in the flesh, to the delight and approbation of a nation of college kids who happily invited *Anchorman* into a treasured place in their dorm rooms. Ron Burgundy had gone unscripted and, like the characters of Buster Keaton's *Sherlock Jr.* or Woody Allen's *The Purple Rose of Cairo*, in which fiction crossed wires with fact, had stepped down from the screen and into a version of real life.

Ron's understated enthusiasm and his penchant for elegant non

sequiturs made for perfect response GIFs. The four newsmen leaping into the air in unison outside the news station was an ideal "Hooray!"; "That escalated quickly" was all-purpose social media commentary; Ron's squinty-eyed, breathless "What did you say?" was a textbook expression of disbelief; Brian Fantana's "Sixty percent of the time, it works every time" struck just the right tone of clueless confidence endemic to the twenty-first-century internet. Champ's saying "I miss your musk" to Ron served less as come-on than all-purpose expression of friendship. Social media hungered for brief, pithy, funny statements, and what could provide those better than *Anchorman*, which was itself a series of hilarious non sequiturs that could easily be excised from their original place and repurposed?

CHAPTER 11

Pancake Breakfasts

NE STRAY MOMENT from *Anchorman* was enough to gesture toward an entire world of hidden emotion regarding male friendship and the ways in which it is threatened by romance. The four newsmen are sitting in front of the news desk eating their lunches shortly after Ron first falls for Veronica, and we hear Brian with some housekeeping announcements for the crew: "So the team pancake breakfast is tomorrow morning at nine, instead of eight." Ron, picking a remnant of his sandwich out of his teeth, is stirred into a response, some loose bauble of forgotten information breaking free: "I almost forgot. I won't be able to make it, fellas." We have already discussed his and Veronica's plans for jogging (or yogging), but for now, let us take note of the response to this hos-before-bros declaration.

Brick goes first. Holding a banana, his mouth frozen in mid-chew, he responds like a child who has just been told that Daddy is going to live in a new apartment across town, but that he and Mommy still love each other: "So Ron's not coming?"

Champ turns away from Brick to face Ron, clearly addressing

his response to the wrongdoer, his brisk tone brooking no dissent: "No, Ron's coming. It's the pancake breakfast. We do it every month." Champ is nodding as he says this, as if to prod Ron into acquiescence.

"I realize that," Ron says, still chewing. "But sometimes you just gotta look at yourself in the mirror and say, 'When in Rome.'"

"The bottom line is," Champ retorts, "you've been spending a lot of time with this lady, Ron." There is a harder edge to Champ's voice now, an air of menace to his appeal. *Lady* is not a friendly word in Champ's vocabulary.

With all the talk of pancakes, the sandwiches, the bananas, and the slurped drinks, the scene is a helpful reminder that the men of *Anchorman* are creatures of appetite. They are constantly eating and drinking in their scenes, consuming everything from burritos to milk to beer to chicken wings.

Champ then branches off into an unexpected revelation of his own emotional and erotic yearning for Ron, each sentence tumbling heedlessly into the next: "You're a member of the Channel 4 news team. We need you. Hell, I need you. I'm a mess without ya. I miss you so damn much. I miss being with you. I miss being near you. I miss your laugh. I miss your scent. I miss your musk. When this all gets sorted out, I think you and me should get an apartment together!" Ron clears his throat and looks away. Brian, who has been pursing his lips and blowing at the straw in his drink, overwhelmed by secondhand embarrassment, chimes in: "Take it easy, Champ. Why don't you stop talking for a while?" Ron agrees: "Maybe sit the next couple plays out, you know what I mean?"

Champ has worked himself up into a near-frenzy at the thought of losing Ron, and this little speech is a small masterpiece of buried emotion. When Champ tells Ron he misses his laugh, he be-

gins giggling uncontrollably himself, pummeling Ron with small, friendly punches in an effort to maintain physical contact. Champ takes a deep whiff of Ron when he laments missing his scent.

There is something uncontrolled and reckless about Champ's insistence on being heard here. He blows through all the small hints that neither Ron nor Brian wants to hear what he is saying: the heads turned away, the small sighs, the eyes cast downward. And by the time Champ gets to his big pitch for Ron's affections, his voice has gotten dramatically louder and more impassioned. Champ has at last sensed the yellow lights everywhere urging him to slow down and presses through regardless.

As Koechner understood his character, Champ was a closeted gay man in a world that feared and loathed gayness. But this scene is also an exaggerated version of the yearning buried inside male companionship. The monthly pancake breakfast is the ideal symbol of their bond—the place where they drown their feelings in maple syrup, where they express their love for each other in tall glasses of orange juice and side orders of crispy bacon. Pancake breakfasts are unfancy and also delicious. You may come home with a shirt drenched in stray dollops of grease and sticky imprints of butter, but you also emerge with a full belly and a lazy smile from all the jokes you can no longer remember. *Anchorman* was the harbinger of many cinematic pancake breakfasts to come.

AT THE END of a long night, two young men crawl into their sleeping bags, laid out side by side on the bedroom floor. Before drifting off to sleep, one leans on an elbow and turns to face the other, ready for a bit of pillow talk. "You saved me! I owe you so much," says the

recumbent one, scrawny and prepubescent looking. "I love you! I love you, man."

The other young man, beefier but equally uncomfortable in his own skin, awkwardly takes in a breath, grunting momentarily in discomfort before discovering that he, too, feels the same way: "I love you. I love you. I'm not—even embarrassed to say it, I just, I love you." He has heard himself say the words, let them ring out in the room, and then found the strength to repeat them, for they are as true as anything he has ever said.

"Why don't we say that every day?" his friend responds. "Why can't we say that more often?"

"I just want to go on the rooftops and scream, 'I love my best friend, Evan.'"

The camera switches to an overhead shot, looking at the two young men, as the beefy one playfully bops the other's nose, and then gathers him in for a hug: "Come here." He awkwardly slaps him on the back before pressing his nose to his friend's shoulder. He whispers "I love you" once more into his friend's ear, and his friend responds in kind.

This moment of emotional abandon and same-sex romance is not from a critically acclaimed Sundance drama but comes near the conclusion of the Seth Rogen and Evan Goldberg–scripted teen comedy *Superbad* (2007), in which Evan (Michael Cera) and Seth (Jonah Hill) reach an emotional breakthrough just before taking the first steps toward severing those bonds. That tension—between romance and friendship, the love of your friends and the demands of heterosexuality—is at the heart of the movies that would surround *Anchorman* and speaks to the comedic concerns of what would eventually come to be dubbed the Frat Pack.

The next morning, Seth and Evan (note the overlap with the names of the film's writers) run into their respective crushes at the mall in the film's final scene. The two boys split up to form new couples, but not without a long, awkward farewell, in which they shake hands like middle-aged businessmen at a sales conference in Tempe. Seth and his new girlfriend head down the mall escalator, and the two boys trade glances, each taking in a last glimpse of a lost paradise.

Superbad (directed by Greg Mottola and produced by Judd Apatow) was not the first of the movies created by the loose collective of actors, directors, and writers that would come to be referred to as the Frat Pack, fairly or not, but its closing sequence is perhaps the sharpest distillation of the guiding ethos of their films. Unlike most of the other films produced during this restlessly creative burst of comedic filmmaking, *Superbad* drifted backward in time, away from young men in their responsibility-free twenties and thirties to adolescents on the cusp of college and the first fraying of the homosocial bonds that formed much of the emotional nuance of their lives. For this, at their heart, was what the Frat Pack's movies were ultimately about—adult men behaving like teenagers, seeking avenues of escape from the constricting embrace of adulthood and the women who carried maturity with them. Seth and Evan bid a fond farewell to childhood, and with it, all the glorious male bonding that accompanied it. Romance—and sex—beckon, and yet the feeling is one of melancholy, of a beautiful moment that has come to an unceremonious end.

Whatever the genre, whatever the format, the crux of these movies was the fractious, squabbling, self-conscious, quasi-ashamed, blissful reality of male friendship. Men were discouraged from

embracing their feelings, or even acknowledging them, and these comedies were an exaggerated response to the societal limitations on male love.

Frat Pack movies were more than a little terrified of women and of all that women signified, including maturity, responsibility, sexual expression, fatherhood, and the putting away of all matters adolescent at long last. The men in these films retreated into the cocoon of masculine friendship as a way of skirting these demands, of embracing irresponsibility as a way of life. The love of men came with no demands, no requirement to change.

Jokes, Freud tells us, are pathways into the unconscious, and these jokes about masculine camaraderie were reflections of what these characters valued most and what they feared having stripped away from them. The protagonists of these films were virgins, stoners, teenagers, in a committed relationship with their bros. Frat Pack movies had limited space for women, because they were themselves intended as safe spaces for men, documenting how they behaved when left to their own devices. There was much nervous joking about what all of this might mean; witness the "You know how I know you're gay" routines in *The 40-Year-Old Virgin*, the mock sex between James Franco's and Seth Rogen's characters in *Pineapple Express*, or Rudd's awkward wrestling with the conventions of making a male friend in *I Love You, Man*.

Frat Pack movies spent an inordinate amount of time talking about sex: how to get it, where to get it, what to do when you got it. But the movies themselves were surprisingly chaste, with little nudity and even less actual sex. All the talk was a protective amulet wielded by these frightened boy-men, a spell cast in the hopes of keeping their friends close and real women—terrifyingly real

women—far away. They were not misogynistic, exactly; they did not hate women so much as they feared them.

These were stories about men in love, more often than not about camaraderie between men that shaded into genuine emotion. They were about the glue that brought men together, sometimes in defiance of the requirement of women that they grow the fuck up, and sometimes as an expression of their fear of women's maturity. These movies were cocoons for Peter Pans, safe spaces for men who preferred to retreat to their man-caves. They were about the reluctant fading of the eternal summer of adolescence and the buried emotions of men who just missed their friends.

These movies were often founded on the bedrock of nostalgia for a vanished past, be it the familiar 1970s nostalgia of 2004's *Starsky & Hutch* (in which we also heard "Afternoon Delight," for the aftermath of a scene where its two stars visited Will Ferrell in prison) and 2008's *Semi-Pro* or the vague Rat Pack envy of 1996's *Swingers*, which predated the Frat Pack films but anticipated many of their themes and concerns. In these imagined pasts, the movies wondered, did men have it better? Was there more space for them to express themselves?

The movies of this era were about men who were still boys and boys who aspired to be men, without quite knowing how. The cult hit *Swingers*, written by and starring Jon Favreau, was the embodiment of conjoined male cluelessness and entitlement. Having left his ex behind in New York, Angeleno transplant Mike (Favreau) mopes as his pickup-artist friend Trent (Vince Vaughn, shockingly thin and sculpted here) wheedles and cajoles him to get back into the mix. "There's nothing wrong with letting the girls know that you're money and that you want to party," Trent tells him. In the

film's most memorable scene, Mike comes home after a late night out with Trent, a woman's number in hand, and instead of waiting until the next day to call, proceeds to act out the entirety of a relationship, from first bloom to fiery end, over the course of a half-dozen increasingly funny and horrifying answering-machine messages.

It was telling that one of the first smash successes to emerge from this loose cohort of stars and directors who would regularly collaborate over the decade to come was a film whose story leapt directly from the precarious shoals of adolescence to adulthood with no stops in between, and whose protagonist sought to right a grievous romantic hurt from his teenage years as a means of healing a fractured soul. A single swift cut tells much of the story of the Farrelly brothers' *There's Something About Mary* (1998), carrying us from past to present in an unbroken line. Ted (Ben Stiller), a gawky, metal-mouthed teenager, finds himself escorting the effervescent Mary (Cameron Diaz) to the prom. During a visit to the bathroom, he is unjustly suspected of spying on Mary as she changes, and in a disastrous effort to flee, he succeeds in closing his zipper on top of his "frank and beans." *Mary* jumps directly from Ted in the ambulance to an adult Ted recounting the story of his failed courtship of Mary to a bored therapist (played by future Frat Pack supporting-cast MVP Richard Jenkins).

Ted is Stiller in his most charming mode, capable of wooing the beautiful Mary, but a millimeter beneath the polished surface lurks a desperate adolescent. *There's Something About Mary* is a gross-out comedy in which Ted endures numerous trials and humiliations—having a dog bite his crotch, getting a fishhook caught in his mouth, having Mary mistake the semen hanging from his ear for hair gel—in the hopes of finding love. Men in *There's Something About*

Mary are all delusional stalkers of a kind, with Ted only the most heartfelt and least icky of the bunch.

What does it even mean to be a man anymore? Buddy comedy *Starsky & Hutch*, with Ben Stiller playing the by-the-books Jewish cop and Owen Wilson the laid-back, amoral WASP from the fondly remembered 1970s TV series, has no idea what the answer might be but knows enough to acknowledge that something has changed between the 1970s and now. Starsky emotionally apologizes to Hutch after ratting him out to their superiors and then instantly backtracks: "No, I'm not crying. You're crying. . . . I don't cry. I work out." Not crying but working out; such was the conundrum of the men of this era's comedies, who knew they had to be more emotionally astute than their forebears but were deathly afraid of what revealing too much of themselves might look like or what it might mean for their own senses of self.

The hard-R raunch comedy *Wedding Crashers* (2005) had Owen Wilson and Vince Vaughn as interlopers who wheedle their way into a dazzling array of nuptial celebrations. John (Wilson) is the fake-sensitive lover with an array of sad backstories involving the French Foreign Legion and Mount Everest; Jeremy (Vaughn) is the drunk uncle with a twinkle in his eye.

Wedding Crashers is a romance whose only emotional heat comes from the relationship between Wilson and Vaughn. Jeremy wants to flee a postnuptial weekend and John wants to stay, and they settle their brief outbreak of hostilities while sitting at separate breakfast tables. "Can I tell you something without you getting angry?" John essays in Wilson's patented aw-shucks delivery. "I love you. Yeah, you, big guy."

Jeremy never ceases chewing while offering his own answer: "I love you, too."

The underrated *I Love You, Man* (2009) took this moment as the building block for an entire film in which the purported heterosexual romance between Paul Rudd and Rashida Jones is given definitive second billing to the bromance between Rudd's upwardly mobile but friendless yuppie Peter and Jason Segel's philosophical stoner Sydney. Peter goes on a series of disastrous "man-dates" with men who assume he is looking for romance or sex before stumbling on Sydney, who likes to hit up residential open houses for the free food and who proves to be the kind of adventurous free spirit the buttoned-up Peter desperately needs. *I Love You, Man* reserves its most romantic moment for Peter and Sydney, with Sydney's acknowledging that he at last watched the Johnny Depp romance *Chocolat* ("just delightful") and the two men's celebrating their love before a crowd of onlookers.

Mary documented why Ted had failed to launch—it was the frank *and* the beans—but many of its successors simply began from the unstated premise that their male protagonists were boys in the guise of men, their lurching stabs in the direction of emotional fulfillment the source of their frustration, and ultimately their growth. *The 40-Year-Old Virgin* (2005), Judd Apatow's feature-film directorial debut, laid out its fundamental conundrum in its title. *Anchorman* alum Steve Carell played Andy, an unassuming electronics-store employee with an apartment full of unopened toys; a carefully regimented life of video games, comic books, and action figures; and elaborate weekend plans that consist of hours of preparing egg salad for sandwiches he never even consumes. The uneaten egg salad is itself a potent symbol of Andy's life. He walks to the bathroom in the morning with an erection so enormous that he must contort his midsection to ensure his urine hits porcelain.

"I respect women," Andy tells Paul Rudd's lovelorn David. "I

love women. I respect them so much that I completely stay away from them." Having avoided or missed out on sex, Andy is a worthy emissary for the movie's simultaneous fascination with, and repulsion toward, sex, and, by extension, women.

Andy is surrounded by wannabe alpha-male coworkers Rudd, Seth Rogen, and Romany Malco, who are intent on educating him in the ways of women as he haltingly approaches Catherine Keener's appealing, indubitably adult Trish. *The 40-Year-Old Virgin* is amused by these three unwise men, letting us luxuriate in their banter while also acknowledging their fundamental haplessness regarding women.

Apatow's second film, *Knocked Up* (2007), is perhaps the greatest of the films to emerge from the Frat Pack other than *Anchorman* and builds on *The 40-Year-Old Virgin*'s deep interest in the conflict between the aimless banter of twenty- and thirtysomething middleclass white guys and the emotional needs of women. Seth Rogen's Ben Stone and his pot-smoking, work-shirking compatriots have devoted themselves to a questionable new business, in which they are compiling a complete list of every actress's nude scenes. (The existence of another website that already provides this service, of which they are entirely unaware, comprises a key plot point in the film.) After he meets rising entertainment reporter Alison (Katherine Heigl) at a club, he gets Alison pregnant. Ben attempts to patch together a reasonable facsimile of maturity without being entirely sure what that might look like.

Alison's sister Debbie (Apatow's wife, Leslie Mann) and saddad brother-in-law Pete (Rudd) are like the grown-up versions of Ben and Alison, working their way through midlife discontent. "Marriage is like that show *Everybody Loves Raymond*, but it's not funny," Pete tells Ben. "All the problems are the same, but instead

of all the funny, pithy dialogue, everybody's just really pissed off and tense. Marriage is like an unfunny, tense version of *Everybody Loves Raymond*. But it doesn't last twenty-two minutes. It lasts forever."

Ben reluctantly, haltingly begins the process of separating himself from his immature friends, only to latch on to Pete as a somewhat questionable role model. Pete and Ben go on a Vegas road trip together, and Pete tries—and fails—to summon the ghost of *Swingers*: "You're so money, and you don't even know how much money you have." Ultimately, Ben must grow up by being a genuine partner to Alison as she gives birth, and by telling Pete off: "You know why she rejected me? Because you're such a shitty husband, she thinks I'm going to turn into a shitty husband."

This film was a huge hit, grossing $148 million at the domestic box office, far outpacing *Anchorman,* and Rogen was now the breakout star of the second wave of Frat Pack movies, taking his place alongside Ferrell, the breakout star of the first wave. He was the pot-smoking Everyman for a new era, an adult who spoke and acted like an addled adolescent, even when saddled with adult responsibility.

Pineapple Express (2008), directed by former indie stalwart David Gordon Green and produced by Apatow, is a comic thriller set in a world seemingly composed entirely of twelve-year-olds in adult bodies. Characters call "time out" and "time in" while fighting with each other; refer to the legal doctrine known as "bros before hos"; and debate "who started it" with a crew of nefarious, but also incompetent, henchmen led by Craig Robinson.

Dale (Rogen) and Saul (James Franco) are running for their lives but are distracted by their burgeoning friendship, whose charms overcome any of their fears. "Don't dip the pen in company ink?"

Saul muses. "I'm totally glad I dipped in your ink, bro." At the film's end, the unkillable Red (Danny McBride) emerges from a blazing inferno, covered in soot and dirt, into a three-way hug with Saul and Dale. "I know this sounds weird," he later asks, "but can we be best friends?" The three boys discuss the details of getting a three-way heart charm necklace to document their eternal bond.

This Is the End (2013) and *The Interview* (2014) (undoubtedly the only Seth Rogen movie that has ever required the president of the United States to comment on its existence) were an apocalyptic thriller and a North Korean–set spy caper, respectively, in which the primary focus was the fraught homoerotic bond between Rogen and his best friend James Franco.

Even when it was well past time to grow up, these comedies were still drenched in the sticky syrup of regret over lost youth. The belated sequel *This Is 40* (2012) picked up where *Knocked Up* left off, homing in on the midlife struggles of Pete and Debbie, who are each rattled by the impending arrival of midlife. Unlike the women in the bulk of the Frat Pack filmography, Mann is allowed to be funny—speculating about how she might poison her husband's cupcakes or threatening a preteen boy who has been bothering her daughter online—in a fashion not regularly accorded to female leads in comedies of the era.

This Is 40 received mixed reviews upon its release, and is unquestionably too long, but holds up surprisingly well as a portrait of the upper-middle-class West L.A. blues. Sneaking desserts whenever his wife's back is turned, farting in bed and blaming it on the mattress springs, squandering the family's money on a quixotic effort to promote a new album by legendary rocker Graham Parker, Pete drives Debbie gently batty.

Pete, like *The 40-Year-Old Virgin*'s Andy, is a bike rider in a

world of SUV drivers, but Apatow's insight is that being gentle does not make Pete kind. Pete is sneaky and withholding and stubborn. "No one is ever looking out for me!" Pete wails after being hit with a car door, and then pummeled by an obnoxious Range Rover driver, and the complaint stands for the inner turmoil of nice guys—or are they "nice guys"?—pummeled by life and looking for recognition.

In an infamous 2007 rant in *Vanity Fair,* the wildly overrated contrarian and Iraq War cheerleader Christopher Hitchens decided to explain to all of us, once and for all, just why it is that "women aren't funny." In his essay, Hitchens argued that men sought to be funny to impress women, and that women had no necessity to impress men, having their beauty at their disposal already. The only funny women in stand-up were "hefty or dykey or Jewish."

Hitchens goes on—and on—about women's child-rearing responsibilities and the ways in which it causes their already-limited humorous capabilities to shrivel. Women are serious, and by consequence humorless: "Women also fall more heavily for dreams, for supposedly significant dates like birthdays and anniversaries, for romantic love, crystals and stones, lockets and relics, and other things that men know are fit mainly for mockery and limericks."

The point is not merely to lambaste Hitchens but to point to an unconscious belief in the culture that Hitchens surfaces, and by arguing on its behalf, accidentally assists in demolishing. Why *were* the Frat Pack films so disinterested in the contributions of women? Why were female characters so rarely allowed much opportunity to

be funny themselves, relegated instead to roles as the symbols and guardians of humorless maturity?

(Wait, *birthdays* are "fit mainly for mockery"? Okay, I am done—for now.)

In order to dismiss Hitchens's essay to the far fringes of proudly misogynist drivel where it deserves to be permanently relegated, we must call up only a brief handful of minutes from the boundary-shattering 2011 film *Bridesmaids,* produced by Apatow and directed by Apatow's *Freaks and Geeks* collaborator Paul Feig from a script by Kristen Wiig and Annie Mumolo, which is not only funnier than Hitchens could ever dream of being but also funny while being proudly, unabashedly filthy. *Bridesmaids* ends this cycle of films with a camera-negative version: an unapologetically crude film about female friendship.

The beautiful thing about the bridal-shop sequence in *Bridesmaids* is that it is grounded in a distinct brand of socially observant, relationship-driven humor about women that its predecessors could never have managed, in no small part because they so rarely even feature more than one woman in any given scene. If the Frat Pack films are about love masquerading as camaraderie, *Bridesmaids* is about petty jealousy masquerading as politesse. Annie (Kristen Wiig) is summoned to a couture bridal shop to purchase bridesmaids' dresses for the impending wedding of her best friend, Lillian (Maya Rudolph), after a meat-intensive lunch at a Brazilian restaurant. They are joined by, among others, Rose Byrne's Helen, who has procured their entrance into this hushed, all-white temple of commercialism and femininity.

Annie is frustrated by Helen's presence, by her know-it-all attitude to weddings, by her having wrangled a famous French designer

to create Lillian's wedding dress, by her pushing the women to purchase an $800 bridesmaid dress Annie cannot afford. There is so much pent-up frustration, in fact, that it might be easy to miss the signs that this scene is planning to veer in another direction entirely.

Melissa McCarthy, playing the fun-loving but decidedly not demure Megan, accidentally releases an unidentified, horrifying sound on entering the store. "This is some classy shit here," she says, her last word interrupted by the eruption of what sounds like a deep burp emerging from the roiling coils of her lower stomach. "I want to apologize," she says, more to the room of white dresses than to any person in particular. "I'm not even confident of which end that came out of."

Lillian comes out in a wedding dress, and an ashen-faced Megan enthuses that it is "so pretty it makes [her] stomach hurt." Megan dry-heaves, sounding like she might also be farting at the same time, and suddenly everyone is blanching and preparing to hurl. "Everybody has the flu," Annie tells Helen, a denialist until the bitter end, even as Helen asks her whether she ate any of the "gray kind of lamb" or "weird chicken" that was served at lunch.

The scene builds and builds. Rita (Wendi McLendon-Covey) dashes to the bathroom, vomiting first on top of the toilet and then inside it. Megan cannot pull Rita away from the toilet and settles herself atop the sink, shouting at everyone, "Look away!" Annie insists that she is hungry, not sick, and she grimly snacks on almonds procured by Helen as sweat drips from her hair.

The prim Becca (Ellie Kemper) comes in and vomits directly onto Rita's head. Lillian runs out of the store in her bridal gown, in desperate need of a bathroom: "It's happening, it's happening." She almost makes it across the street before settling into a defeated posture on the asphalt: "It's happening."

"Oh, you're really doing it, aren't ya?" Annie says to herself, as impressed as she is horrified by what she has wrought. "You're shitting in the street."

Wiig would later express some discontent with this sequence, feeling that she was pushed to include a more masculine, gross-out kind of comedy out of keeping with her desires for *Bridesmaids*. But part of what makes this moment so hilariously awful is its grounding in the tense relationship dynamics between these women.

Bridesmaids is about shitting inside wedding dresses, but it is also deeply astute about the ways in which women compete with each other and the ways in which they release their hostility. It is telling that *Bridesmaids* is a film about a wedding in which the groom is a pleasant nullity with only a handful of lines. Annie is not jealous of or threatened by Lillian's impending marriage, or by her fiancé, but she is deeply troubled by the notion of being replaced by the upwardly mobile fembot her best friend has chosen to embrace.

As another movie about the attractions and perils of friendship, *Bridesmaids* was a natural outgrowth of the Frat Pack cycle of films, with Wiig, Rudolph, McCarthy, and Byrne as analogues to the bro cohort of the Channel 4 news team or *The 40-Year-Old Virgin*. But *Bridesmaids* was also, by its very existence, a gentle retort to those films' treatment of women. They were not misogynistic or cruel, mostly. They were not entirely dismissive of women. But they did not trust women to be funny and sought to employ female characters as reality principles or purveyors of personal transformation. Women were markers on the meandering path to maturity.

Bridesmaids was an enormous hit, grossing $169 million at the domestic box office in 2011 (which far outpaced the original domestic haul for *Anchorman*) and serving as an all-purpose fuck-you to all the Hitchens-esque misogynists of the world insistent that

women could never be funny. But in the aftermath of *Bridesmaids,* film comedy began to irreversibly shrink as a genre, eclipsed by television and squeezed by the relentless Marvelization of the film industry. With increasingly less space for films that were not capable of dominating the international market, there were fewer and fewer big-budget (or even moderate-budget) feature comedies being made by studios. *Anchorman* had ushered in a rich (if flawed) era of film comedy, and while comic stars like Ferrell, McCarthy, and Kevin Hart endured, it was indubitably clear that the cinematic footprint of comedy had shrunk dramatically since 2004. Were *Anchorman* and *Bridesmaids* two of the last of the great American film comedies? Quite possibly.

Mission Accomplished

I N THE PUBLIC eye, Will Ferrell is best known for two roles,
each of which tapped into the performer's abiding interest in
genial buffoons, equal parts clownish and ogreish, intent on pre-
serving our goodwill even as they bullied, insulted, and humiliated
others. Ron Burgundy and George W. Bush were mirror images of
each other, and playing the five-time Emmy-winning anchorman
allowed Ferrell to channel something harsher and more outraged
in his ongoing impersonation of the forty-third president. It would
be critically delinquent to summarize Ferrell as the poet laureate
of delusional marshmallows without taking stock of the political
stinger hidden in the tail of his amiable delinquents, with none more
representative than his second go-round as Bush.

You're Welcome America (2009), which was written by Ferrell and
premiered on HBO shortly after the inauguration of Barack Obama,
is a howl of rage disguised as a fond farewell. *You're Welcome Amer-
ica* is also a necessary correction. The *Saturday Night Live* sketches
portrayed this deeply mediocre and destructive president as a genial

fool, and *You're Welcome America,* a filmed record of Ferrell's Broadway show of the same name, preserves the fundamental outlines of a familiar character while toughening its case against him. The show had its opening night of previews on the day of Barack Obama's inauguration, and Ferrell saw the subject matter as "still visceral for the New York crowd. . . . There were moments when they would just yell things out at me, because they wanted to have a conversation with him." The result was like *Anchorman* turned inside out, an accusatory finger pointed at Ferrell's array of genial villains and the ashes left behind in their wake.

You're Welcome America's deliberately ironic title offers a peek into its frame of reference. Having left the Oval Office at long last, this George W. Bush has learned nothing from his experience. Ferrell's Bush enters the theater lowered to the stage by a hovering helicopter, his tongue lolling out of his mouth, a swagger to his step, stalking the stage like a retired jock reliving his greatest gridiron exploits. He introduces himself as "George W. Bush, former president of the United States," and when a wave of cheers echoes through the hall, clearly directed at the word *former,* Bush is flattered: "Thank you, that's very sweet of you." McKay, who assisted Ferrell with *You're Welcome America,* thought the word *cathartic* was overused but ideal for describing the feeling of putting on the show after the dark eight years that had preceded it.

Bush's misunderstanding establishes a routine that is underscored and reiterated throughout *You're Welcome America.* Even as Bush pays tribute to his eight glorious years in office, he cannot help but reveal the ways in which he left us collectively angrier, poorer, and less powerful than we were before he became president. He is forever stuck in time in his flight suit (in which he appears partway through the show), gloating about declaring "Mission Ac-

complished" in Iraq. That it was not accomplished—that everywhere Bush turns, he turns up evidence of his failures—is the rich vein of irony this show insistently taps.

We laugh at Ron Burgundy for being a relic, a holdover of a bygone era whose crudity is emblematic—the film argues—of a time long past. Ferrell's George W. Bush is similarly ludicrous, perfectly content to remain the same dim-witted, self-absorbed, chronically distracted simpleton he has always been, and no amount of world-historical blowback or psychic trauma can divert him from his path.

Ferrell's one-man show is an exuberant comic recap of a horror film, with Bush gleefully reintroducing his allies/co-conspirators as beloved compadres in the business of defrauding America. Former vice president Dick Cheney (soon to be the subject of McKay's 2018 biopic *Vice*) is "so charismatic he could shoot a man in the face with a shotgun and have that guy apologize to *him*." Seeing Hispanic former attorney general Alberto Gonzales, Bush makes lowrider noises and pretends to bounce his imaginary car on hydraulics. Condoleezza Rice is a temptress in a tight-fitting red dress who comes onstage and breaks into a stiff but sensual dance for the president.

And now for the deep textual proof that Ron Burgundy and George W. Bush are, if not precisely the same person, alternate versions of the same fundamental archetype. Bush addresses the years in which he was supposedly serving in the Air National Guard in Texas and admits he was living in Vermont with a man named Dave Rothschild. "Dave and I would go on long walks in the woods, write poetry to each other," Bush reminisces. "I'd express my fear of going to the Vietnam War. Dave would validate those fears."

Bush's Vermont interlude cannot help but remind those of us

listening closely of Ron Burgundy's extratextual adventures in Vermont with fellow newscaster Warner Wolf, talking about model ships and walking around nude in the woods. Ferrell has granted his two most beloved characters near-identical Vermont interludes, although Bush's comes with an additional (no pun intended) twist. His time with Dave Rothschild was never sexual, Bush claims, but they did "give each other Western-grip hand jobs." Bush next demonstrates—at length—the Western grip, wiggling his thumb graphically.

Were Ron and W. in Vermont at the same time? Only Ferrell knows, but his lending both men near-identical versions of the same backstory grants credence to the notion that Ron Burgundy and George W. Bush are blood brothers. We sense, in both of Ferrell's depictions, that each uses masculinity as a shield with which to cover a vast sense of spiritual inferiority.

As *You're Welcome* proceeds, it expertly toggles between treating Bush as a cartoon character—President Frat—and searching for hidden nodes of emotion. The phone rings onstage, and it is former FEMA administrator Michael Brown, infamous for his botched response to Hurricane Katrina in 2005. Bush is reminded of his telling him, "Brownie, you're doing a heck of a job," as the cameras rolled, and gets a good-hearted chuckle out of it. "It's so funny, because you were not doing a heck of a job," he says to Brown. "You were doing the opposite of a heck of a job." There is a deep, piercing anger buried in the ex-president's throwaway lines here: "You hit the nail on the head, Brownie. Americans do have short attention spans. No, it's great, because you can just half-ass shit and it doesn't matter."

Unexpectedly, about two-thirds of the way through the performance, the camera creeps closer to Ferrell, settling in for a close-up

of his face as he ponders the fallout of his decisions regarding the war in Iraq. Ferrell-as-Bush looks momentarily ruffled, his trademark swagger misplaced as he considers the horrific consequences of his fateful choice. At first, he is defensive: "In the choice between freedom and tyranny, we must always choose freedom."

But then something strange happens, and we tap into the deepest place in this immensely shallow and incurious man, a man who in real life would spend the years after his presidency painting the portraits of men and women grievously injured in the wars he sent them to fight: "Do I cry about it? Yeah, without a doubt. I cry a lot. I feel for the families who've lost loved ones. I cry for the parents who've lost a son or daughter. I cry for the kids who never get to know their mom or dad. I also feel for the hundreds of thousands of Iraqi civilians who've lost their lives. A lot of this crying is done alone. 'Cause I'm the one who made the call and I must live with that. So at this moment in time, I'd like to honor all those who've died as a result of this war with a moment of silence."

It is a stunning moment, an unexpected moment of grace in which this callow heir to the throne is forced to confront the reality of his legacy. *You're Welcome America* has a little bell that plinks when Ferrell speaks lines spoken by the real Bush, and this scene is haunted by its silence. No bell rings, because George W. Bush never spoke these words in the real world. And the moment feels revelatory, because the intentional theatricality of the moment—the way in which Ferrell's Bush suddenly seems possessed of an interior life, weighed down by traumas he can hardly bear to identify—reminds the audience, who just endured eight years of Bush's presidency, how much they hungered for him to speak to that sense of uncertainty and hurt, and how he never did.

★

You're Welcome America deepened a shallow joke—Bush as callow frat boy—that was a solid decade past its sell-by date, and in so doing, demonstrated that both Ferrell and McKay were on parallel tracks in discovering political nuance in their work. Contrary to the voices that would declare McKay's Oscar-winning financial-meltdown film *The Big Short* (2015) the start of an entirely new career path, evidence of his political concerns and ideological affiliations was scattered across the director's earlier, more explicitly comedic work with Ferrell and shows a clear affinity, all the way from *Anchorman* to *Don't Look Up* (2021).

The showboating world of NASCAR has little to do, at first glance, with 1970s newscasting, but McKay and Ferrell's first post-*Anchorman* collaboration is set in another bastion of insular masculinity and instinctual hostility to change. The men are race car drivers and not newscasters, and the threat is European sophistication and not feminism, but *Talladega Nights: The Ballad of Ricky Bobby* (2006) is the story of another sore winner stripped bare by failure and forced to recalibrate in the face of disappointment.

McKay and Ferrell had a recurring interest in a certain brand of hypercompetitive, headstrong, emotionally dim man ensconced in a comfortable rut. "I wake up in the morning and I piss excellence," the hulking, sideburned NASCAR driver Ricky Bobby (Ferrell) tells an interviewer early on in *Talladega Nights*. "I'm just a big hairy American winning machine." McKay and Ferrell were carrying forward their interest in big hairy American winning machines, superbly calibrated machines of braggadocio and masculine bluster that they found simultaneously funny and maximally horrifying.

Talladega Nights is top-heavy, with most of what's best in the

movie taking place within the first hour. Ricky Bobby hungers for his absentee father (Gary Cole) and takes in the single lesson he ever transmitted, during a drunken school visit, as gospel: "If you ain't first, you're last." Ricky and his best friend Cal Naughton Jr. (John C. Reilly, entering the McKay orbit after being unable to appear in *Anchorman*) become NASCAR crew members, and when their driver poops out midrace, Ricky steps forward as a replacement.

Talladega Nights re-creates some of the inseparable, quasi-erotic bond between Ron and Champ in its pairing of Ricky and Cal. "I love you!" Cal shouts over the roar of the engine before Ricky Bobby's virgin ride.

"What?" Ricky responds.

"Nothing! You're my best friend!"

Ricky Bobby is touched, and also more than a little harried, it being the middle of a race and all: "I gotta get going."

Reilly has powerful sidekick energy, and *Talladega Nights* and its successor *Step Brothers* each coast on the intense link between Reilly and Ferrell. Where Steve Carell and Paul Rudd gave off the impression of existing in their own highly differentiated orbits in *Anchorman*, Reilly roped himself to Ferrell, like a shadow or a doppelgänger, a slightly scrawnier, character-actor variant of Ferrell's misplaced egotism.

Ricky Bobby (note the shared initials with Ron Burgundy) is a doltish braggart who comes to believe that his success is a matter of divine intervention. He has a beautiful blond wife (Leslie Bibb), two sons named Walker and Texas Ranger, and an array of branding opportunities. He does commercials for oversized hunting knives and Maypax, "the official tampon of NASCAR," and an ad entirely in Japanese for prune-flavored candy.

In *Talladega Nights'* funniest scene, Ricky Bobby delivers an

absurdly drawn-out grace before a family meal, in which lackadaisical Christian fervor mingles with American hypercapitalism in a toxic stew of self-justification: "Dear lord baby Jesus, or as our brothers to the south call you, 'Hey-zoos,' we thank you so much for this bountiful harvest of Domino's, KFC, and the always delicious Taco Bell." Cal offers his own testament to his lord and savior as well: "I like to think of Jesus, like, with giant eagle's wings, and singing lead vocals for Lynyrd Skynyrd with like an angel band, and I'm in the front row, and I'm hammered drunk." (The wide variety of alts for the sequence included comparing Jesus to a mischievous badger, a muscular trapeze artist, a figure skater doing interpretive dances, and a dirty old bum.) Ferrell would come back to these Jesus jokes in *You're Welcome America,* where Bush pays tribute to his preferred, "almost Swiss-looking" Jesus.

Life is blissfully all-American until the arrival of French Formula 1 driver Jean Girard (Sacha Baron Cohen), who turns up at a redneck bar in a slim-fitting black suit, smoking a cigarette, joined by his husband (Andy Richter), and interrupting the rock music on the jukebox to play some Charlie Parker. ("We keep it on there for profiling purposes," says the bartender. "We've also got the Pet Shop Boys and Seal.") Jean is Gallically dismissive of their gauche Americanness: "What have you given the world apart from George Bush, Cheerios, and the ThighMaster?" Jean lays claim to democracy, existentialism, and the ménage à trois as French inventions, and even Cal is impressed, by the latter if nothing else. ("We created the missionary position," shouts David Koechner, making a cameo as a crew member. "You're welcome!")

Jean is a high-octane machine precision-designed to aggravate Ricky Bobby's flag-waving chauvinism. Auto racing is the preserve of macho men, and Jean refuses to play the role. "Like the fright-

ened baby chipmunk, you are scared by anything that is different," he tells Ricky as he pins his arm to the pool table, and we cannot help but feel like it is not just Ricky Bobby who is being addressed here. Jean tells Ricky that he will let him go as soon as he says, "I love crepes." (It is well worth the cost of a streaming platform's monthly fee to hear Cohen say "crepes" as it is to see Reilly lean in and insist that Ferrell stay strong: "These colors don't run.")

In their first race, Ricky Bobby does his utmost to pass the wily Frenchman: "Hey, it's me! America!" McKay would later describe Ricky Bobby as a George W. Bush figure, with Bush's pathological cluelessness, copious intellectual deficiencies, and lack of curiosity surgically removed and transplanted into a NASCAR driver. Ferrell would also describe himself as tending to "go in and out of Bush sometimes when [he was] playing Ricky Bobby," getting a kick out of the notion of the president smooching a Frenchman. In this parable of the Iraq War, Ricky Bobby insists on attacking an opponent he does not understand, is badly wounded, refuses to change course or adopt a fresh plan, and winds up in a quagmire entirely of his own devising. *Talladega Nights* builds a case against Ricky Bobby for his frustrating inability to change course, to slam on the metaphorical brakes and try something new. He is someone who has grown so used to winning that he steers headfirst into a disastrous defeat. Hey, it's me, America.

Talladega Nights was a raunchy comedy with labor-intensive action set pieces, and races that involved giant crowds. The race sequences were nice, but McKay thought the best parts of the film were just Ferrell and Reilly's bantering together while standing around their race car. McKay and Ferrell were worn out by the end of the shoot and dreaming of a simpler next project. What if their new film took place entirely in a single house? As they were in the

editing room cutting *Talladega Nights*, which wound up grossing $148 million and becoming McKay and Ferrell's most successful film at the box office (*Anchorman* had made $85 million, by comparison; much of *Talladega*'s increased box-office take was likely due to *Anchorman*'s word-of-mouth success on DVD), McKay turned to Ferrell and Reilly and said, "I just picture you guys in bunk beds." Editor Brent White knew there was no script yet, nothing beyond this single image. His first thought was, "I have to see this movie."

They talked further and came up with the idea of remarried single parents whose adult children still live at home with them. The project was green-lit on the basis of a pitch alone. Reilly (who received a story credit on the film), Ferrell, and McKay repaired to a guesthouse on Ferrell's property to write the script for the movie. The threesome began to put together their big messy bag of ideas. Reilly remembered getting in trouble for touching his brother's precious drum kit as a child. Someone suggested the bunk beds' collapsing. McKay offered a story from childhood where a twelve-year-old had threatened an adult.

McKay had two remarkable improvisers in Ferrell and Reilly, and in casting the new film, he sought out collaborators who could keep up. "Before you take this role," McKay would tell actors, "I'm gonna have you improvise. I'm gonna throw ideas at you. We're gonna mess around." Mary Steenburgen, only fourteen years older than Ferrell, had worked alongside him in *Elf*, and Ferrell approached her, asking if she would be insulted to be asked to play his mother in a movie. McKay got a special kick out of asking the prim-looking Steenburgen, who radiated motherly warmth onscreen, to deliver crude lines. "Holy crap," Steenburgen asked her costar Richard Jenkins about the improv style, "how does one do this?" Adam Scott, who played Ferrell's smarmy brother Derek,

compared the improv process to "learning how to do the shot put at the Olympics in front of a stadium filled with people and cameras and judges."

Ferrell and Reilly returned as Brennan and Dale, two middle-aged layabouts whose failure to launch has been cushioned by overprotective parents. *Step Brothers* (2008) is brilliant in its transformation of its forty-year-old protagonists into hypercompetitive children wrestling for their parents' love, fighting for superiority in a kiddie pool of middle-aged water-treading. *Anchorman* and *Talladega Nights* are about successes who spin out; *Step Brothers* is about failures who imagine themselves triumphant.

In a perfectly apposite shot, Steenburgen's Nancy is in the driver's seat of her car, and Brennan is in the rear, a forever child still throwing a tantrum from the back seat. Dale, meanwhile, argues to his father that the presence of a woman in their household will destroy their long-established masculine routines: "We like to shit with the door open, we talk about pussy, we go on riverboat gambling trips." (None of these are true.)

The two boy-men are instructed that they will be sharing a room, and the image of Ferrell and Reilly lying side by side in their child-sized beds is a comic triumph in its own right. As A. O. Scott of *The New York Times* noted, with the two stars' "big soft bodies, they really do look weirdly 8 years old, even as adults."

In one of *Step Brothers'* most effervescent moments, Dale and Brennan realize that they are not rivals at all. Dale challenges his newfound blood brother to respond to his questions without hesitation. They find, to their conjoined delight and shock, that they are in unthinking agreement about everything from their favorite dinosaur (velociraptor, natch) to the best non-pornographic magazine to masturbate to (*Good Housekeeping*) to the one man they would

sleep with if they were, you know, required to (John Stamos). Dale nods his head and lifts his eyebrows at each successive matching answer, as if to ask Brennan to note exactly what is taking place here. "Did we just become best friends?" wonders Brennan.

These men are just stubbled, glandular, pear-shaped boys, and *Step Brothers'* primary joke is forever refreshed by its infinite variations. The two boys burst into their parents' bedroom that evening. Brennan's rhetorical throat-clearing ("We think it would be prudent—") is overrun by the impatient Dale, who gets to the point: "Can we turn our beds into bunk beds?" Brennan is so excited at the prospect—"It would give us so much extra space in our room to do activities"—that his voice audibly cracks on *activities*.

We hear the crackle of power tools in the background as their parents lie in bed (Dale insists he is only brushing his teeth), and return to the boys, brimming with enthusiasm at the prospect of their jury-rigged bunk beds, slapped together with some nails and two-by-fours. The two beds collapse on top of each other, and Brennan disappears, shrouded completely by their broken dreams. "The bunk beds were a terrible idea," Dale shouts as he runs to his parents' room. "Why did you let us do that?"

Step Brothers pushes us to see Dale and Brennan as desperate cases, pathetic failures whose inability to cope with the workaday world is the source of their humor and the bars of their prison.

Brennan is unsure of the most basic aspects of adulthood: "Do I carry my high school diploma around with me? . . . What happens if there's inclement weather? What do you wear? Can you wash your clothes in the dishwasher?" Dale goes in for a job interview, trying to explain away the twenty-two-year gap in his employment record in a manner that confuses his interviewer: "You went Kerouac on everyone's ass?" He stipulates that he is willing to do any-

thing as long as it does not involve bear traps or having sex with elderly women for money.

It is at this moment that *Step Brothers* executes a brilliant rhetorical flourish. We have been prompted to root for Brennan and Dale to receive their comeuppance, to be forced into our familiar straitjacket of conformity. The movie's music turns wistful and its tone grows markedly less antic as we watch Brennan and Dale settle into their new lives. Dale still wears his Chewbacca mask, one last shred of dirtbag fidelity as he does his taxes, reads a self-help paperback, and turns off the lights at 8:37 p.m. Brennan is shown to a horrifically dingy apartment by a real estate broker, discovers himself to be out of toilet paper as he sits on the toilet, and settles his butt on the edge of the sink as he wets a bath mat being pressed into service to clean his rear end.

We next see Brennan pumping his fist in triumph as he exits a big-box store with a giant pack of toilet paper clutched in his arms. Brennan's erstwhile dreams of musical stardom are desperately sad, but telling his odious brother Derek, "I want to make bank, bro. I want to get ass. I want to drive a Range Rover," is yet sadder. The ladder of success is somehow even worse than the chute of failure.

And when Dale and Brennan are at last reunited, at the quasi-legendary Catalina Wine Mixer, they have lost all their juvenile panache. Dale has had to sell his night-vision goggles in order to pay for car insurance, and Brennan is no longer breaking boards or kicking pumpkins. Dale now takes baby aspirin "to reduce [his] risk of heart attack," and the two men laugh awkwardly in agreement that it is time to put childish things away: "You gotta knock off the sweets." Dale and Brennan shake hands like distant colleagues when their conversation comes to an end, and we see that adulthood has imprinted itself on Brennan like a faulty template.

Brennan and Dale exist at the opposite end of the spectrum of success from Ron Burgundy but are similarly jerked awake from their familiar rut and forced to confront new, uncomfortable circumstances. The two films follow a similar pattern of comfort-discomfort-resolution, but where *Anchorman* embraces Veronica's yearning for success as a feminist role model, Brennan and Dale serve as reminders of the emptiness and secret despair of the neverending hustle. McKay and Ferrell occasionally give themselves the opportunity to speak through their characters, and Dale is granted the chance to give voice to their desires: "I'm going to make beautiful music for a sad world."

These comedies are each their own beautiful melodies, their characters filled with the desperate hope to succeed on their own terms. Brennan and Dale take to the stage at the Catalina Wine Mixer, Brennan singing Andrea Bocelli's "Con te partirò" as Dale goes full Bonham on his drum kit. Adulthood is a sham, and it is okay to eschew its unending requests to bank your immature inner fires.

"Sometimes I think I am living in a nightmare," Roger Ebert huffed in his pan of *Step Brothers*. "I like vulgarity if it's funny or serves a purpose. But what is going on here?" Others, though, immediately understood *Step Brothers*. When the New Orleans Saints, at long last, won their first Super Bowl in 2010, Ferrell called McKay and asked him if he had read the article about their victory. He hadn't, and Ferrell told him to search for it while he waited. McKay pulled up the story and read that after winning the Super Bowl, the Saints returned to their locker room, and one of the players shouted a single line that summed up their commingled feelings of awe and grandeur regarding this singular moment of triumph: "It's the fucking Catalina Wine Mixer!"

McKay and Ferrell were now established comedy stars but missed

some of the on-the-run aesthetic and dashed-off bonhomie of their *Saturday Night Live* days. While they were writing *Step Brothers*, they were approached by CAA head of business development Michael Yanover, who pitched them on a standalone internet-comedy site. They were skeptical of the idea, and of the internet as a whole, but eventually agreed to give it a try, along with their compatriot Chris Henchy, who had written for *The Larry Sanders Show* and served as the co–executive producer of HBO's bro comedy *Entourage*. The site they created was ultimately called Funny or Die, offering viewers two choices for how they might respond to videos.

McKay noticed that his toddler daughter, Pearl, was at the age where she was willing to repeat everything she was told, from Nietzsche quotes to hip-hop lyrics. He called his friend Drew Antzis and asked him to come to Ferrell's guesthouse with a camera. The resulting effort took all of forty minutes to shoot and required Ferrell to occasionally wrangle Pearl and prevent her from walking away.

The Landlord (2007), with Pearl playing a belligerent member of the rentier class bossing around Ferrell's tenant, became an instant internet smash. Pearl, infinitesimally small next to the towering Ferrell, reduces him to tears by threatening to evict him. "I want my money, bitch," Pearl shrieks, and goes on to inform Ferrell that she needs to get paid, saying, "I need to get my drink on." The video wound up being viewed more than eighty-four million times on Funny or Die and was one of the biggest internet videos of its era.

Funny or Die became a phenomenon. After John McCain mentioned Paris Hilton in a 2008 presidential campaign ad, McKay recruited Hilton to shoot her own response. Funny or Die was also a sneakily successful branding mechanism. Pabst, which owned the Old Milwaukee brand, asked Funny or Die to promote their beer

in any way they liked, and Ferrell jetted off to Terre Haute, Indiana, to shoot ads for the brew, including one in which he wakes up on top of a building in Terre Haute after being jumped by strangers and discovers some Old Milwaukees left behind by construction workers. The ads ran on local stations for a pittance, but the presence of Ferrell guaranteed enormous publicity online.

Where McKay and Ferrell's first three collaborations were sui generis, *The Other Guys* (2010) slots the star into the familiar beats of a cop movie while seeking to undermine the genre's conventions. All the pieces do not fully congeal, but the buddy-cop comedy is substantially funnier than its reputation might suggest, and while it is not quite *Anchorman,* or even *Step Brothers,* Mark Wahlberg is a deft comedian, and his bonbons-and-pickles relationship with Ferrell is winning.

The Other Guys begins with the death of beloved daredevil cops Danson and Highsmith (played with a wink by action-movie veterans Dwayne Johnson and Samuel L. Jackson), who leap off a skyscraper in hot pursuit of bad guys. The void sets off a competition among their erstwhile colleagues to succeed them. Ferrell's Allen Gamble is an exceedingly mild-mannered police accountant whose big case involves a potential scaffolding-related infraction, and Terry Hoitz (Wahlberg) is a former hotshot whose career came crashing down when he accidentally shot New York Yankees star Derek Jeter during Game 7 of the World Series.

The Other Guys hits all the familiar beats of the police thriller—the street shootouts, the slow-motion flying bullets, the stern captain who shuts down the big case, the mercenary foreign villains—while deliberately eschewing much of the macho bluster that accompanies these stories. Allen is repelled or confused by all the dick-measuring. He drives a zippy red Toyota Prius, wears unflattering

square glasses, and vastly prefers paperwork and research to pulse-pounding action. Allen's scaffolding investigation leads them to a Bernie Madoff–esque financier (Steve Coogan) who is seeking to cover up a $32 billion loss by raiding the state lottery fund.

The initial draft of *The Other Guys* cast Derek Jeter himself as "a kind of left-wing Deep Throat," according to a *Jacobin* profile of McKay. McKay planned to have the all-American sporting hero telling the audience that "the whole damn system is clogged up with dirty money. And the news doesn't say a word about it. 'Cause who owns them? The same corporations who own the government." The presence of the Captain did not deter anyone from loathing this conclusion, which was shot but ultimately jettisoned. "The audiences hated it," McKay told *Jacobin*. "We would screen it, and it would just thud."

McKay cut the Jeter sequence and came up with something else to end the movie. Critics were baffled, but McKay was stretching his wings, demonstrating his comfort with the issues of economic justice and burgeoning American imperialism that would define the second stage of his directorial career. The credit sequence was a series of pie charts, graphs, and visualizations about the fallout of the 2008 financial crisis over the shredding bass line of Rage Against the Machine's cover of Bob Dylan's "Maggie's Farm." Rather than a perverse non sequitur, this was a dramatic restating of the same principles that underscored the film. The credits compared the maximum retirement benefit of NYPD officers like the film's protagonists with those of the average CEO. What kind of world was it where some people retired with $43,000 and others with $83 million?

Critics and audiences were not used to McKay as a social commentator, or the concept of a Will Ferrell action-film send-up that

was also a howl of outrage at the governmental and economic failures that had created the conditions for the 2008 financial meltdown. *The Other Guys* was treated as a silly comedy with a baffling conclusion. What it was instead was the beginning of McKay's second phase, as a political filmmaker whose preferred brand of criticism was feathered with comedic asides, broad japes, and absurd setups. McKay was not yet done exploring what had befallen the United States in the early years of the twenty-first century.

CHAPTER 13

I'm Ron Burgundy (Part 2)

THEY WERE IN agreement: There would be no sequel. Sequels were bland and unimaginative rehashes of an original, and with so many other ideas percolating, why waste time redoing what had already been done? But as the years passed, and *Anchorman* grew and grew in the estimation of audiences, the limitation came to feel like a challenge. With fans having so thoroughly enjoyed every moment of Ron Burgundy's adventures, Ferrell and McKay began to consider the possibility of another visit with the legendary newscaster. Were there further Ron Burgundy stories to tell? Once plans fell into place to produce a sequel (about which more soon), the character of Ron Burgundy was transformed into an all-purpose pitchman, raconteur, jester, and satiric figure.

In the nine years between installments of *Anchorman*, Ron Burgundy had gone from a movie character to an American institution. Everywhere we turned, there he was, wheedling his way into the collective American consciousness, from our commercials to our sports programming to our iPhone apps. Ron Burgundy was

our regular companion. He was a fictional character who had immersed himself in every quadrant of our world.

As part of the rollout of *Anchorman 2* in 2013, Ron Burgundy was summoned to serve as a pitchman for the Dodge Durango, appearing in a dizzying array of approximately seventy interconnected commercials for the boxy-looking SUV. Seeking to catch the draft of *Anchorman*'s genial ludicrousness, these efforts were reminiscent of the Joe Isuzu commercials of the 1980s, in which a lying huckster (played by actor David Leisure) was fact-checked and undermined by the very commercials in which he appeared.

Ron was present to mock some of the familiar clichés of the car commercial. An elegant pair of dancers comes onstage to the tones of dulcet classical music, and Ron chases them away from his Durango: "Get out of here, you dumb dancers!" He cruises through a warmly lit tunnel on an urban evening, touting the car's "hypnotic" sense of style before promptly falling asleep at the wheel. Ron was a failed salesman, constantly undermining the air of sleekness and elegance that the commercials were striving for.

Other bits worked just as well, including Ron's enthusiasm for obsessing over his Durango and pondering its mysteries. He was excited about the Durango's glove box, capable of holding six ball-peen hammers at the same time. "This glove box I've been talking about?" Ron enthuses. "It comes standard."

Ron had famously been unable not to read anything that appeared on the teleprompter in *Anchorman*; the commercials were extensions of that joke, with Ron stumbling over the proper pronunciation of "MPG" and insisting to an offscreen director that the proper pronunciation of the automaker was "Yodge," with a soft *D*. (Were you supposed to drive your Yodge before or after your daily yog?)

The Durango is presented as a mobile sex machine in numerous

commercials. Ron opens the trunk to display the fold-flat rear seats, wiggling his eyebrows as he asks, "And you know what that's for?" In another variant, he responds to his own question: "Of course, I'm talking about sax." Ron then settles himself in the back to play some sanitized, echo-heavy saxophone. (On-screen text declares Ron's efforts "Winner 2013 Best Saxophone Solo in a Dodge Durango.")

The thirty-second ads were supplemented by short films released under the umbrella of McKay and Ferrell's comedy website, Funny or Die, in which Ron tormented unsuspecting others with his obsessive Durango love. In one, Ron buttonholes a fictional senator at a political fundraiser he is hosting to gush over his Dodge Durango. When the senator challenges him to say one sentence without mentioning his Durango, Ron happily complies: "Dirty urine runs across Niagara gulch on—and that's the end of the sentence." The senator realizes Ron has spelled out "Durango," and the two men awkwardly wrestle before Ron is kicked out of his own home.

In *The Break Up?* Ron's girlfriend Cindy (Veronica's whereabouts go unmentioned) threatens to leave him, and he seeks to woo her with a list of the Durango's best attributes: "How can I live without your twenty-inch wheels?" Ron can apparently only perform sexually within the confines of his Durango, and Cindy is set to leave when he removes a small velvet box from his pocket and kneels. "I'm wondering," he asks, slowly opening the box, "if you will tell me if this looks like a miniature Dodge Durango?"

Ron Burgundy made an ideal twenty-first-century pitchman because his presence generated the precise mixture of intimacy and distance that allowed customers to feel invited to participate. We enjoyed the thought of Ron Burgundy selling us a car more than, say, Matthew McConaughey, perhaps because we could more readily chuckle at his absurdities. Ron Burgundy had begun as a parody

of a bygone era of the news; he had now returned as a beloved companion, a blowhard whose company we had come to enjoy. (Were the SUVs, like Ron, a relic that we loved even though we worried we shouldn't anymore?)

After the campaign premiered, Ferrell appeared on *Conan* as Ron to discuss his new role as pitchman. "What's so amazing about it is, it's a terrible car," he told Conan O'Brien. "I drove it four feet and the thing cracked in half."

The surreal bits continued. As part of the promotional effort for *Anchorman 2,* Ron was sent out into the real world, a mock reporter doing real reporting, with Ferrell's character a particular favorite of the sporting world. He made an appearance on Canadian television for the first day of the 2013 Olympic trials in curling, there to honor an obscure and distinctly Canadian sport with his presence, and to mock it, all at once. Ron pays tribute to himself as a "hard-hitting questioner" before asking the remainder of the broadcast team whether they do a lot of betting on the competitions. In 2019, Ron would also briefly appear on a Los Angeles Kings–San Jose Sharks broadcast, establishing himself as an unrepentant homer: "Take that, San Jose! Zero Stanley Cups! . . . They wouldn't even know what the Stanley Cup looked like if it fell on their head."

Ferrell was summoned in 2013 by ESPN, for whom Ron Burgundy had become a kind of surrogate mascot and spirit animal, to interview football star Peyton Manning. Ron tells Manning that without a mustache of his own, he looks like "a succulent baby lamb," and lists all the great mustachioed quarterbacks of the past, including Joe Namath, Jeff George, Burt Reynolds, and the guy from *Barney Miller.* Ron, forever trapped in the past, asks Manning what it was like to get sacked by Merlin Olsen, and Manning re-

plies that the Los Angeles Rams great retired when he was about four years old. But when Ron asks Manning whether there is a fourth Manning brother named Danieal, and a picture pops up on-screen of the Black Chicago Bears safety with the same last name, the joke now lands with a three-hundred-pound thud. Ron is supposed to be a holy fool, but is he supposed to underline and endorse our own foolishness, too?

Ferrell had already filmed a mock audition to serve as the network's first anchor of ESPN, or "Espin," as he calls it. "Around the clock? Sports all the time? That's never gonna work!" Ron chuckles at the idea of the network to an unseen producer. "Seriously, this thing is going to be a financial and cultural disaster." And others took up the mantle and continued the joke—sports figures from Kansas head basketball coach Bill Self to Idaho sportscaster Paul Gerke donned the burgundy sports coat and embraced their inner Ron. In 2012, Jacksonville news reporters had a real-life anchor showdown, hosting a dodgeball tournament for charity. The introductory video featured *Anchorman* narrator Bill Kurtis, and the grand prize was a golden trident.

Ron Burgundy was not limited to the world of sports. He turned up at the Comedy Central Roast of Justin Bieber in 2015, taking the stage to defend the pop star against his many critics: "This kid has spunk, moxie, and probably a few other STDs, okay?"

In perhaps the strangest and most memorable of his real-world turns in the runup to *Anchorman 2*, Ferrell made an appearance on North Dakota's KX News, guest-anchoring a genuine local-news broadcast as Ron Burgundy. As cohost Amber Schatz reports on a Black Friday shoplifter in Grand Forks, Ron slowly leans into her shot until his mustache appears to fill the left third of the screen.

You can hear his co-anchors chuckling to themselves as Ron delivers his report on a trash fire outside a Sam's Club in Bismarck. "Amber, you look lovely tonight. Are you married?" he asks Schatz. Schatz tells him she is not, and he responds, "Well, I am, so don't get any ideas."

Ron is asked how long it took him to grow his mustache, and he tells the audience about twenty minutes. Ron—or is it Ferrell?—clears his throat at length at the close of the broadcast, perhaps to avoid the inevitable "Stay classy . . ." sign-off on the teleprompter. (Schatz and her fellow anchors attempt to prod him into delivering the line, but he studiously ignores them.)

It is a remarkable high-wire act to see Will Ferrell attempt to actually deliver the news—traffic dummies! trash fires!—and also improvise with comedically untrained broadcast journalists, and the results are like a series of crossed wires, where our favorite fictional newscaster is suddenly loose in the real world, delivering the most inconsequential local news imaginable.

In 2015, a former music manager named Zach Neil was interested in opening a bar but did not want to lean on any of the shopworn clichés of the nightlife industry. "It couldn't just be another candlelit swanky bar," Neil told *The Guardian*. "It had to be something really stupid." After rejecting the initial idea of a bar that was also a bounce house, Neil had a brainstorm: What if they were to open a bar whose theme was the cinematic oeuvre of Will Ferrell?

The bar, which debuted on the Lower East Side of Manhattan in the fall of that year, was called Stay Classy New York, and featured *Anchorman*-themed cocktails like Milk Was a Bad Choice (vanilla Stoli and milk), Smelly Pirate Hooker (jalapeño margarita, tequila, orange juice, sour mix, lime juice), and the Glass Case of Emotion (muddled rosemary and peach, whiskey, lemon juice, sim-

ple syrup). The bar eventually spread to Los Angeles, where a pop-up version opened in late 2016 in a multiplex theater in Hollywood.

If drinking in a Ron Burgundy–themed bar was not enough, there was always the prospect of bringing home a Ron Burgundy–themed alcoholic beverage. The bottle for Great Odin's Raven scotch, made in Scotland in anticipation of *Anchorman 2* for Riviera Imports, featured Ron's iconic phrase "scotchy scotch scotch" on the label, along with a baronial "RB" on gold medals. Ben & Jerry's got in on the scotchy fun, marketing a limited-edition ice-cream flavor, also called Scotchy Scotch Scotch, a butterscotch ice cream with butterscotch swirls.

It was telling that Ron was associated with indulgences like alcohol and dessert. Here he was, this relic of the ancient past, brought back to life to grant us permission to temporarily put the kale smoothie down and embrace our crass appetites.

Game designers Jason Lautenschleger and Barry McLaughlin were Mad Libs buffs who were approached by some Paramount executives to see if they had any ideas for board games based on one of their properties. They got to thinking about Ron's unconscious willingness to read anything placed in front of him. Lautenschleger and McLaughlin designed an "improper teleprompter" *Anchorman* game where contestants would have to read messages placed on the board by their fellow contestants. And the mechanical timer? A version of Brian Fantana's Sex Panther cologne.

Anchorman even played a small but notable part in the story of American politics in the era of Trump. In the fall of 2017, journalist Ashley Feinberg identified what she believed to be then–FBI director James Comey's secret Twitter account. It was, and Comey responded with a link to the official FBI jobs page, and an *Anchorman* meme: Ron Burgundy saying, "Actually I'm not even mad.

That's amazing." Later, Comey would pose with a cardboard cutout of Ron Burgundy. How funny you found all this was likely dependent on the extent to which you found the self-admiring G-man responsible for the outcome of the 2016 presidential election.

Let us take a final moment to consider the remarkable afterlife of Ron Burgundy and ponder the delirious weirdness of a book titled *Let Me Off at the Top!: My Classy Life and Other Musings*. It is a "memoir" written by Ron Burgundy, although the notions of authorship and biographical fidelity instantly shatter in the presence of the fictional character whose life story they are intended to elucidate.

In *Let Me Off,* published in 2013 and ghostwritten by former *SNL* writer Harper Steele (does it count as ghostwriting when the author is a fictional character?), with the occasional idea contributed by Ferrell and McKay, Ron details his hardscrabble upbringing in Haggleworth, Iowa; his studying jazz as a preteen with Chet Baker and Gerry Mulligan; his attendance at Our Lady Queen of Chewbacca High School, overseen by Monsignor Morty Grossman; and his early days in San Diego: "I spent my first night out on the fire escape trying to stay cool in the midnight air, playing my flute as police sirens and gunshots went off all over town."

Tea is spilled. Ron slept with Katie Couric, after she drove up to his lake house in her cigarette boat, the *Blazin' Bitch*. George Stephanopoulos "wears women's underwear when he delivers the news." Ron ran a cockfighting ring with Vice President Walter Mondale. His penis has been nicknamed Pegasus, "after the winged horse of Greek mythology," and while Veronica's love has taught him how to relate to women, it remains true that "before 1970 women were here on this earth to cook food and give men boners."

We hungered to imagine Ron in other places and other times, to picture him overspilling the boundaries of the movies in which he had been engendered. For what else did we want to grant to our favorite fictional characters than the very thing they had given us: more life?

CHAPTER 14

Twenty-Four-Hour Dawn

YOU'RE *WELCOME AMERICA* had been such a joyous experience to create that McKay and Ferrell were initially intrigued by the notion of a stage version of *Anchorman*. What if they took a page out of the Marx Brothers' playbook and toured the country, performing a live musical version of their show, all the while buffing the material and perfecting their jokes?

Adam McKay imagined doing the show for six months, polishing it relentlessly, and then filming it. The stars were game, and the plan was to rehearse in the spring of 2009, tour in the summer, and shoot the film in the fall. None of the film's creative team had previously worked on a musical, and the challenges of writing and performing a new musical were a delicious mystery to them. Soon after conceiving this idea, Ferrell had dinner with Josh Gad, the star of Trey Parker and Matt Stone's Tony-winning musical *The Book of Mormon*. He was taken aback to discover that the show had been workshopped for four years before making its way to Broadway. Four years!

Paramount (which controlled the rights to a potential sequel) was surprisingly amenable to the unorthodox plan, but then financial difficulties intervened. McKay approached Paramount with a budget of $80 million. "Are you crazy?" McKay remembered the Paramount executives responding to his original budget. "I was like: 'All right, fine, sixty million dollars and we can make it work, we'll all take pay cuts,' and they were still like, 'Are you out of your mind?'"

The theatrical tour was canceled, and the film itself appeared to be doomed as well. Paramount was convinced that a potential *Anchorman* sequel would struggle internationally, and the budget had to match its limited box-office possibilities. The studio offered $35 million. By early 2012, it was looking like an *Anchorman* sequel was dead, a victim of the costs of bringing the gang back together and Paramount's uncertainty about the box-office potential of the film.

Adam Goodman had been an executive at DreamWorks during the production of *Anchorman* and was named the president of Paramount Pictures in 2009. Goodman had another film on his 2013 schedule fall through unexpectedly, and when powerful agent Ari Emanuel called him to discuss the possibility of *Anchorman 2*—now no longer a musical but a straightforward comedy—he was unexpectedly enthusiastic. He offered McKay a $50 million budget, with the possibility of additional income on the back end for the film's stars and director. They would be taking a roughly 60 percent pay cut from their usual fees to make the film, but there was enough excitement about the project—and enough optimism for future earnings once the film made a profit—to keep everyone onside. Ferrell came in to sign the contracts for the sequel wearing a ten-gallon hat made entirely out of the sort of foam used for a "WE'RE #1" finger a fan might purchase at a football game.

Before there was even a script, the actors got together and filmed

a teaser trailer, seeking to spur enthusiasm. McKay and Ferrell began meeting daily in the guesthouse behind Ferrell's home, trading jokes and ideas for where an *Anchorman* sequel might go. The general concept came together fairly quickly, with a first draft written in two months. They would advance the clock from the 1970s to the 1980s, and have Ron and his team arrive in New York at the dawn of cable news.

The delays in finalizing a budget and schedule had offered the writers additional time to rework and polish the material, and some plotlines were jettisoned. The original ending of the sequel was cut. It was to have been an elaborate disaster-film tribute to Irwin Allen, the producer responsible for such lumbering giants of 1970s filmmaking as *The Poseidon Adventure* and *The Towering Inferno*, that would include the collapse of an underwater hotel and the firing of live sharks at guests.

As it was filmed, *Anchorman 2: The Legend Continues* begins with Ron and Veronica, blissfully in love, raising a son together and at the top of their careers as newscasters at the WBC network in New York. Legendary newscaster Mack Tannen (played with verve by Harrison Ford) calls Ron and Veronica into his office, for what they can only assume will be a promotion to lead anchors. And there is a promotion—for Veronica. Ron, already crowing about becoming the first-ever lactose-intolerant network-news anchor, is summarily fired.

Ron, instantly sinking into a morass familiar from the first film, breaks up with Veronica, returns to San Diego, and leaves the news business. He is fired from his dead-end gig at SeaWorld (perhaps throwing up in the shark tank and feeding the seals a chicken gyro was unwise) and attempts suicide. When the sequence was shot, the rope around Ferrell's neck did not initially give way, leading to

a tremulous split second when McKay and the crew panicked, thinking Ferrell would be injured by malfunctioning equipment.

Ron is discovered prostrate on the ground by Freddie (Dylan Baker), a scout for a new twenty-four-hour cable-news network called GNN, who offers him a job reading the news. Ron is, needless to say, skeptical: "No offense, but you are a stupid asshole." A glimpse of his weekly pay packet turns Ron around with maximal efficiency: "By the hymen of Olivia Newton-John!" Ron has been put on earth for two things and two things alone: to "have salon-quality hair and read the news."

The extended getting-the-band-back-together montage is charming, with Champ passing off bat meat as chicken for his distinctly unappetizing fast-food restaurant and Brick appearing at his own funeral to deliver a tearful eulogy for himself. Brian is even sleazier looking than we remember, a camera draped around his neck, moaning and grunting suggestively as he snaps photos of cats toying with balls of yarn. All he needs to hear is that New York has all-nude strip clubs, and he steps aboard Ron's Winnebago.

The first *Anchorman* had felt scrappy, pulled together with string and wire, the product of a first-time director with a lifetime of pent-up comic ideas and the vigor of underappreciated performers. The second had the burden of nearly a decade of building expectations on the part of the audience, for whom the first *Anchorman* had been transformed from a pleasing trifle to a solid-gold comedy classic.

After nine years away, returning to the world of *Anchorman* felt surprisingly comfortable to David Koechner, as if no time had passed at all. It was a delight to be back on set with this group of performers, to be re-creating the absurd vision of Adam McKay and Will Ferrell once more. Koechner remembered wishing that instead of

shooting a movie sequel, they were making a television show and doing this every week.

There was a certain unspoken ease among the reunited performers that allowed them to experiment, to try different versions of a scene and to trust in their fellow actors. When Ron visits Champ at his fried-chicken restaurant, Koechner grabbed on to Ferrell and refused to let go, physically expressing the hunger that Champ still feels for Ron. Koechner hadn't cleared it with Ferrell or run it by him in advance, and yet Ferrell did not tell him to stop or to talk it through. He was happy to figure out the game—Ron struggling to break free of Champ's stifling embrace and unable to—as the cameras rolled.

The atmosphere felt different when Koechner showed up to the set and ran into Drake, there to film a cameo as a bystander who compliments Veronica Corningstone on her beautiful butt. "Oh, hey, man," Drake said to Koechner, and the actor who had performed alongside some of the most bankable and beloved stars in contemporary comedy—who was working with them right at that moment, in fact—was still a bit starstruck at the sight of Drake. "Oh, shit," Koechner thought about the "One Dance" singer, "he fucking knows me." Koechner's children were exceedingly impressed that he had met Drake, and that Drake—possibly—had some idea of who he was.

It was often McKay's job to kick off the alts, and even when he was dissatisfied with his options, he would toss one out anyway, hoping to convince others to pitch in. "When you've got an ass like a Porsche," McKay suggested Ron say after catching Drake ogling Veronica, "people are going to want to take it for a spin." (He also offered, "When you have an ass like a Barcalounger, people are going to want to use the footrest.")

For one scene after Ron's Winnebago overturns, McKay grabbed his microphone and began calling out suggested lines for the performers. What if Carell, wearing a dog cone around his neck, said, "I can't scratch my cut anymore"? Carell adapted it for his own use, saying, "I'm not supposed to be scratching my wound, so they got this collar on me." Rudd, similarly clad in a neck brace, and on crutches, offered, "My urine looks like watered-down ketchup."

Alts often built on, or responded to, the efforts of others. Ron and his crew were supposed to celebrate their ratings success, and McKay offered "By the buck knuckle of Elliott Gould!" as a delirious expression of joy. (A buck knuckle is when a man's pants are too tight, and . . . well, it doesn't really matter. It just sounds funny.) Ferrell swapped in Tony Danza, and Rudd tried Bert Convy. McKay came up with one more suggestion: "By the bedpan of Gene Rayburn!" "There's the T-shirt!" Carell called out enthusiastically.

Of the primary cast, Steve Carell had the most difficulty re-inhabiting his character. During the shoot for *Anchorman 2*, Carell—now a huge star, with the success of *The Office* and films like *The 40-Year-Old Virgin* and *Little Miss Sunshine*—repeatedly pulled McKay aside to register his concern that he was not finding his way back to Brick Tamland. McKay reassured him that his Brick was perfect, and as the shoot progressed, Carell realized that feeling lost served the character well. Brick was always lost.

And Ferrell was fearless as ever, in a fashion that was endlessly energizing and inspiring, even to performers who had worked alongside him for years. One day during the shoot, they were filming on the Georgia coast for a scene in which Ron goes into the water to search for the shark he has befriended after going blind and re-treating to live alone in a lighthouse. (Perhaps unsurprisingly, the plot gets weird.) There were at least ten enormous, stinging jellyfish

in the water, and another actor would have begged off on the scene and been deeply justified in doing so. Ferrell didn't say a word about the jellyfish. He got in the water and shot his scene.

Seeking to outdo James Marsden's titanically egotistical anchor Jack Lime ("I bet his poop smells like sandalwood," Ron says) and take over his coveted prime-time slot, Ron and his GNN team hold a meeting in which Ron casually tosses away prescient stories about global warming and the rise of China in search of meatier fare. ("What if we show a porno instead of the news?" Brian wonders.) McKay's camera pushes in on Ron's face as he has his fateful (and disastrous, by the movie's lights) realization: "I just don't know why we have to tell the people what they need to hear. Why can't we just tell them what they want to hear?" This is so essential to the film's thesis that Ferrell is summoned to repeat his line again, in case anyone missed it the first time.

Instead of hard news, the erstwhile Channel 4 team will give the audience a smorgasbord composed of only dessert: stories on patriots, cute animals, home runs, slam dunks, earthquakes, tornadoes, and absolutely no soccer. "Tonight's top story is America," Ron begins, to the distinct pleasure of a nation of viewers in bars and ER waiting rooms. Brian delivers a special report on "the power and mystery of the human vagina," Champ offers a montage of context-free home runs, and Brick stands in front of the Triborough Bridge on what appears to be a mild night, shouting: "The wind is really windy!"

The news, as crafted by Ron Burgundy, is all thrills and no information, an overblown, pulse-pounding thrill ride with little connection to the world, or to anything of importance. *Anchorman* was a critique of the news media couched in the terms of a broad comedy; *Anchorman 2* is more earnest in its attempts to lambaste the

media landscape. "Don't just have a great night," Ron signs off from his virgin broadcast. "Have an American night!" This meaningless tripe is the quintessence of Ron's success, and soon enough he and his team have taken a prime-time slot, the slide toward terminal stupidity continuing unabated. Ron demands more and more on-screen graphics, until his broadcast is a toxic jumble of sports scores and stock tickers and talking heads.

Ron, all-purpose purveyor of insults and clueless misogynist, had notably avoided the trip wires of race in *Anchorman*. The movie was aware that its blithe embrace of insult comedy had distinct limitations and that Ron Burgundy could not be as crude in his understanding of race as in his hatred of women without fatally undermining the movie. *Anchorman 2*, to its credit, leans into the initial film's discomfort and gives Ron a Black love interest after he and Veronica temporarily part ways: his show's head producer, Linda Jackson (Meagan Good).

Ron is introduced by his producer and handler, Freddie, to his new boss, and promptly turns and stretches out his arm to shake hands with her white male assistant, preferring to believe his name is Linda rather than accepting that a Black woman is his superior. On realizing his mistake, Ron has a visceral, uncontrollable reaction. "Oh," Ron says. "Black. Black." Ron's lips catch on the plosive *B* of each *Black,* as if the pressure is building up inside of him and bursts out. "I'm terribly sorry. I don't know why I can't stop saying *Black.*"

Ron's lips quiver, and each *Black* emerges as if expelled out of a desperate desire to purge his body of this singular thought. The word comes out in a shout and as a question, and then, after a short respite, in which we might hope that Ron is finally finished, as if he had a case of hiccups, it bursts out once more. "If I don't say it,"

he tells Linda, "I'll pass out." Linda's Blackness is news that stays news.

Ron's friends jump in, equally pained in their attempts to prove their bona fides. Champ tells Linda that he and his friends used to spy on girls in the showers when he was a teenager: "I'd look at all of them, no matter what color they were. So . . ." Koechner does something marvelous with his hands here when he says *so*, lifting his palms up, as if to gesture at vast unspoken realms of racial tolerance hiding beneath his ten-gallon hat.

Ron simply cannot comprehend Blackness and refuses to attempt to grasp it as anything beyond a stale assortment of tired tropes rescued from mediocre television shows. At dinner with Linda's family, Ron looks out at an array of well-dressed upper-middle-class people and determines that his best option is to engage in the kind of white-man jive talk we might have seen last in the movie *Airplane!* "Ours is a new love," he tells Linda's mother when she asks how long they have been dating, "but it burns very brightly, and it gets hot and sweaty and stanky. There's some stank on that love." Ron, after failing to slap hands with her father, catches a glimpse of his intense dissatisfaction and attempts to give it voice: "Shit, look at this honky, sitting at my table, eating all my food, drinking my Ripple."

If the fundamental problem of *Anchorman* to be solved is that of misogyny, *Anchorman 2* sets out to address cable news's addiction to spectacle. Ron discovers huge audiences by cutting to an obscure car chase on his broadcast and speculating wildly about a situation he has no actual knowledge of, thereby stealing the audience away from Veronica's meaty interview with Palestinian leader Yasser Arafat.

Ron is later yanked away from attending his son's piano recital and summoned to the newsroom for a story of a sitcom star who

has cut off the penis of her philandering husband and is now lead-
ing a high-speed highway chase in a Ford Bronco (echoes of nine-
ties tabloid-news sensations Lorena Bobbitt and O. J. Simpson are
entirely intentional), but in a moment of surprising candor, he re-
fuses the task. "Real news is supposed to let people know what the
powerful are up to, so that that power doesn't become corrupt," Ron
tells his audience. "But what happens when the powerful *own* the
news?" Ron departs the anchor desk to find Veronica and his son,
signing off with unexpected forcefulness: "Good night, America,
and never forget, you deserve the truth."

One of the highlights of *Anchorman* had been the news-team
showdown, so it was no surprise that a bigger, more elaborate scrum
is a key feature of the sequel. Ron is waylaid en route to his son's
recital by Jack Lime and his gang, with Marsden doing his best
Wes Mantooth impression. Ron is rescued by the unexpected ar-
rival of the News Channel 4 team, with Champ wielding a mallet,
Brian clutching an iron hook, and Brick carrying—of course!—a
trident.

Anchorman 2 recruited a dizzying array of guest stars for an ex-
tended news-team showdown, including Sacha Baron Cohen, re-
splendent in a pin-striped suit, representing the BBC; Kanye West
as an MTV newsreader (Ron believes MTV is a kind of venereal
disease); Tina Fey and Amy Poehler as entertainment-news hosts;
Jim Carrey and Marion Cotillard as aggressively polite CBC an-
chors; Will Smith as a *SportsCenter* anchor; and Liam Neeson as a
History Channel talking head, accompanied by the ghost of Con-
federate general Stonewall Jackson (John C. Reilly, finally poking
his head into the Anchorman Cinematic Universe). Koechner ar-
rived at the set one day and was stunned to come across seventeen
full-size trailers in an underground parking garage. It was like a

holiday within the making of the movie, with the level of excitement pitched higher than on any other day of the shoot.

Everyone gets their quip or declaration of intent. Fey steps out of a retro open-sided Jeep alongside Poehler, her preference for light, fluffy news perfectly intact: "Today's celebrity birthdays? None. Today's celebrity deaths? All you trick-ass bitches." "We're going to gouge your eyes out and kick your head in," Cotillard tells her non-Canadian rivals. "Sorry!"

Aiming for the stars, McKay and Ferrell had reached out to Bill Clinton, Barack Obama, and Oprah Winfrey to offer them cameos in *Anchorman 2*. Clinton and Winfrey turned them down near-instantaneously, but McKay had a connection to the White House. There was a brief moment when it seemed as if it might be possible to feature the president of the United States in a Will Ferrell comedy. "The joke was going to be he was from C-SPAN, and he was going to say this thing about how C-SPAN is going to change news because it'll be stripped down. It will just be the truth and you'll see, someday everyone will be watching C-SPAN," remembered McKay. "Then of course someone underneath him was like, 'Are you fucking crazy? No, he won't do it. He's the president.'" Barack Obama did not appear in *Anchorman 2*.

McKay shot a mind-boggling 1.25 million feet of film on *Anchorman 2*—250,000 feet more than the first *Anchorman* and roughly equivalent to almost ten days of footage in total. The original cut of the film came in at four hours, and even after trimming extensively, McKay and Ferrell were left with a two-and-a-half-hour broad comedy. They considered releasing *Anchorman 2* in two parts, and even tested it that way in front of audiences, but the higher test scores for the single film convinced them not to go the *Kill Bill* route.

Seth Rogen, who had played a small role in the original *Anchorman* as Veronica's camera operator, was invited to the screening, which he enthusiastically enjoyed. When McKay and editor Brent White reviewed the recording of the audience after the screening, they discovered that Rogen's distinctive braying laugh was close to the only thing they could hear. The remainder of the audience's response to the film remained unknown. "I wish it would just play for three hundred million Seth Rogens," said McKay later. "I don't know what that would do to the world, but yeah."

Anchorman 2 wound up grossing $127 million at the box office, second only to *Talladega Nights* among McKay and Ferrell's collaborations, and the reviews were mostly solid, if also hesitant to deem it the equal of the first. Scott Foundas of *Variety* grasped that *Anchorman 2* was a return and an expansion, with a serious message underneath all the silliness: "McKay and Ferrell have scaled up 2004's 'Anchorman' without compromising its core of freewheeling prankishness, while making a not-unserious movie about the devolution of TV news into pandering infotainment. (Imagine 'Network' as directed by Mel Brooks, and starring Gene Wilder.)"

With the passage of almost a decade since the original, some critics had learned their lesson about how to watch. "Adam McKay's movies tend to play better on the 10th viewing than the first," argued Matt Singer of the Dissolve. "At the screening I attended," observed *New York*'s David Edelstein, "many of the jokes in the first half got no laughs. . . . Yet I had the strangest feeling: that somewhere in the universe, at some time in the future, they would bring down the house (or its alien equivalent)."

With so much attention lavished on promoting the film, it felt hard to see *Anchorman 2* for what it was. "*Anchorman 2: The Legend*

Continues is in danger of being overshadowed by its own marketing campaign," wrote A. O. Scott of *The New York Times,* and Betsy Sharkey of the *Los Angeles Times* noted that she preferred the sixty-second Dodge Durango commercials with Ferrell as Ron Burgundy to the movie itself: "That, I'd suggest, should be the recommended dosage."

Some critics, though, were bored by what felt like a rehash of a superior original. "*Anchorman 2* is like watching *Anchorman* being re-enacted by semi-professionals trying to cover up their lapses by being extra-emphatic, super-doofy: 2013 Steve Carell does a lousy impression of 2004 Steve Carell," argued the *New York Post*'s contrarian Kyle Smith.

With the original *Anchorman,* White had cobbled together enough additional footage to create *Wake Up, Ron Burgundy.* The sequel had less in the way of excised material, but White had something else to offer. "Actually, you don't have a second movie," White told McKay, "but you have a whole other movie with all-new jokes." McKay was intrigued and worked with White on putting together an entirely different cut of *Anchorman 2,* in which the plot remained the same but all the jokes—approximately 240 by McKay's count—were swapped out for alts. McKay saw comedy as a living thing, capable of being updated, replaced, or adapted at the pleasure of the filmmakers. "If someone told me it was *Pulp Fiction* with all-new story turns and new Sam Jackson monologues, there's no way I'm not going to see that."

The alternative cut featured numerous superb jokes that were easily the equal of anything in the original version. "Sometimes in life," Ron tells his six-year-old son after a professional setback, "you're going to have to drink a big, fat, stinking bowl of hot, frothy

horse piss." Champ refers to cats as the "chicken of the freeway underpass." Champ wails, "We're the news team! This can't end!" and Brian, in a self-referential aside, declares, sotto voce, "We'll see how this one does at the box office." Brian takes in Jack Lime and declares that he "bags a lot of P," and Champ dreamily responds, "I'd like to pee on him."

In one of the only remnants of *Anchorman 2*'s initial musical plans, the news team's rendition of an original number called "Big World" made the alternative cut. It was a tribute to diversity being sung by men with only the dimmest possible awareness of what people other than them might look like. The song pays tribute to a world "full of lots of different sinks" and takes an unexpected turn when a coworker declares he is gay.

"Do you eat gay food?" they cluelessly wonder. The men begin to imagine what it would be like to be "gay for a day," the name of the song-within-a-song that thrusts to the surface in the midst of "Big World." Brian drinks a froufrou drink with an umbrella as he muses about going all the way. The best response, though, belongs to Champ. Champ, looking particularly suave, enumerates the things he pictures gay men doing, which all sound suspiciously like things he already does: wearing a hat, wearing a three-piece suit, talking about sports, having a nice drink.

The alternative cut wound up getting a brief theatrical release shortly after the original version. McKay's *SNL*- and sketch-fueled taste for letting comedy breathe had made him simultaneously a filmmaker deeply attuned to the preferences and desires of mainstream audiences and a dazzlingly experimental one. What other A-list filmmaker would see fit to release a completely different version of their own film and allow audiences to sort out their favorite?

☆

ANCHORMAN AND ITS successors made Will Ferrell the definitive comic superstar of his era. Ferrell alternated between milquetoast types predisposed to unexpected moments of frenzy, and showboats with delusions of grandeur, and each model was replicated in the actor's collaborations with other filmmakers. There were the nostalgic throwbacks, à la *Anchorman*; the sports films in the vein of *Talladega Nights*; the two-handers hoping to catch some of that *Step Brothers* magic.

While none of his post-*Anchorman* work without McKay reached the peak of their collaborations, there were a few worthy exceptions. Pairing him with Jon Heder, *Blades of Glory* (2007) is more *Napoleon Dynamite* than *Talladega Nights,* and is cursed by its need to prove Ferrell's heterosexual virility within a story about an all-male pairs figure-skating team, but is a suitable showcase for Ferrell's physical comedy. And while *Semi-Pro* (2008) is a disappointing waste of a brilliant premise, the ABA comedy is worth tracking down if only for the sequence in which Ferrell's Jackie Moon has a ticket promotion gone awry: "Everybody panic! Oh, my God, there's a bear loose in the coliseum. There will be no refunds! Your refund will be escaping this death trap with your life. If you have a small child, use it as a shield. They love the tender meat."

Ferrell also had a sneaky anarchic streak that came out in the projects he pursued between the more high-profile films. Written by Ferrell's former *SNL* collaborator Harper Steele, 2012's *Casa de mi padre* was a single joke—what if Will Ferrell made a Spanish-language movie?—extended to feature length.

Outfitted with a cowboy squint and boxy sideburns, Ferrell is

the ne'er-do-well son who saves the family's honor in this *narcotraf-icante* parody. Turning a punch line into a feat, the entire film is performed in Spanish, with Ferrell costarring opposite the likes of Gael García Bernal and Diego Luna. Playing the lovelorn cowboy Armando, Ferrell demonstrates a surprisingly competent command of Spanish, which is—for better and for worse—the sole joke of the film. But the movie is zippy enough that the comic thrill of watching Will Ferrell speak Spanish—of watching Will Ferrell *emote* in Spanish—never gets old.

"Could it be that the ultimate comedic act is being in a Lifetime movie and *playing it totally straight?*" wondered the *Huffington Post*'s Lauren Duca. In an act of subversive marketing, Ferrell starred alongside Kristen Wiig in the 2015 Lifetime original film *A Deadly Adoption* (also written by Steele), which roundly mocked the conventions of the cable network's danger-at-home movies yet aired unironically on Lifetime. The joke was less in the subversion of stereotypes than in the presence of bankable comic stars like Ferrell and Wiig, inhabiting the shopworn material with barely a wink.

Anchorman brought people together, even as its creators were pulled apart. McKay and Ferrell continued working together on the Funny or Die platform after *Anchorman 2* and jointly oversaw their production company, Gary Sanchez Productions, which, in addition to their own efforts, was also responsible for films like *Bachelorette* (2012) and *The Goods: Live Hard, Sell Hard* (2009), which adapted the car-salesman-comedy shell of *August Blowout* and starred McKay's brother-in-law Jeremy Piven. But McKay left Funny or Die in 2015, disappointed that the site agreed to a sponsorship from Shell Oil.

Ferrell was ill inclined to take on nearly as many projects as

McKay was intent on. In 2019, the two erstwhile partners dissolved Gary Sanchez Productions, telling the press that the split was amicable. In reality, the company had already been riven by dissension between McKay's allies and Ferrell's, and the two men only had a "curt phone conversation" before agreeing to the split. McKay was increasingly attracted to more serious, less comedically oriented projects, and Ferrell felt stretched thin by the number of projects Gary Sanchez was handling. McKay's film projects post–*Anchorman 2* had little room for Ferrell as a performer, and Ferrell was still primarily interested in supporting comedies of the sort that McKay was moving beyond. The two partners no longer had a shared vision of their work.

McKay would go on to produce a host of wildly successful television series, including HBO's brilliantly scabrous mogul drama *Succession*. A longtime basketball fanatic, he executive-produced *Winning Time*, an adaptation of Jeff Pearlman's book about the 1980s Los Angeles Lakers. The series was set to feature Lakers owner Jerry Buss as the protagonist, and Ferrell wanted to play the role. McKay, describing the series as "hyperrealistic," did not think that Ferrell could adequately pass as Buss. Without telling Ferrell first, he offered the role to John C. Reilly. McKay thought it would all blow over quickly, given their twenty-five-year relationship. But when Ferrell found out, he was "infuriated," and the two men have not spoken since. "I fucked up on how I handled that," McKay told *Vanity Fair.*

Ferrell went on to star in 2020's *Eurovision Song Contest,* in which he and Rachel McAdams play Icelandic singers competing in the famous musical-cheese competition. The movie was festooned with ludicrous costumes and unavoidably catchy earworms. *Eurovision,*

with a sharp script by Ferrell and Harper Steele, was surprisingly funny and heartfelt, and featured Ferrell's most exuberant performance in years.

And while Ferrell had had mixed success in more dramatic roles like the one he played in *Stranger than Fiction,* in which he discovers he is a fictional character in a novelist's latest effort, the 2021 Apple limited series *The Shrink Next Door,* with Ferrell playing opposite his *Anchorman* costars Paul Rudd and Kathryn Hahn, was a career highlight. Ferrell starred as a Garment District entrepreneur in 1980s Manhattan who falls under the spell of Rudd's charismatic therapist.

The initial skepticism about Ferrell playing a neurotic Jewish man is overcome by the natural rhythm established by Ferrell and Rudd, reunited for the first time since *Anchorman 2.* (As they sit together in Dr. Ike's office, you can almost imagine them being on the brink of launching into a Ron-and-Brian interlude at any moment.) There is a good deal of humorous interplay here between the oily Dr. Ike and his well-meaning but fatally blinkered patient, but Ferrell creates a moving portrait of a man who has spent his entire life disappearing into the background. We had come full circle, with the very thing Ferrell's Groundlings and *SNL* castmates had noted about him—his milquetoast affect—becoming the source of his power.

IN THE SPRING of 2014, McKay convinced Brad Pitt, who owned the rights to Michael Lewis's *The Big Short,* to allow him to adapt the book, which followed the financial mavericks who had predicted, and ultimately profited from, the financial meltdown.

The sharp transition from *Anchorman 2* to *The Big Short* seemed bizarre, almost unprecedented. But the evidence for McKay's change of heart was everywhere in his work if you chose to look for it. McKay had demonstrated in *The Other Guys* that finance's secret weapon was its inscrutability. Once a CEO had bored you into tuning out, they could proceed as they wanted. McKay was an admirer of British documentarian Adam Curtis, and he realized that sneaking stray moments of political content into his comedies was not sufficiently scratching that itch for him.

"It was kind of a perfect stew of, holy fucking shit," McKay said in a *Jacobin* interview, referring to the confluence of the war in Iraq and the 2008 economic crisis. It was his intention with *The Big Short*, starring Ryan Gosling, Christian Bale, and—notably—Steve Carell as visionaries who foresee the impending collapse of the housing market, to make a dull topic funny and engaging, and he chose to do so by offering audiences the same things they always wanted: sex and celebrity. *The Big Short* asks us to care deeply about the details of financial arrangements so abstruse that veteran bankers struggled to follow them, and recruited the likes of Selena Gomez and Anthony Bourdain to help the medicine go down easy.

"Does it make you feel bored, or stupid?" the film's narrator (Ryan Gosling) asks us about the topic of subprime loans. "Well, it's supposed to. Wall Street loves to use confusing terms to make you think only they can do what they do. Or even better, for you just to leave them the fuck alone. So, here's Margot Robbie in a bubble bath to explain."

Robbie's dewy skin practically glows with rude good health as a butler tops off her champagne glass, and audience members would be forgiven for being distracted once more as the technical details of the financial crisis fly by them. This, too, was the joke. Every

industry had its techniques for distracting the attention of the rubes, and were we not, ultimately, all rubes? "Got it? Good," Robbie says after teaching us that *subprime* is another word for *shit,* a lazy smile drifting across her face. "Now fuck off."

It might feel peculiar to compare a movie about the financial meltdown to one about middle-aged men in treehouses, but for all its ripped-from-the-headlines momentum, *The Big Short* was functionally another version of *Step Brothers.* This is yet another story about the private language of men—their rivalries, confessions, insecurities, and fears—except here with the health and well-being of 330 million people riding on their dialogue.

As we watched the pileup of disastrously shortsighted decision-making, we began to root for a comeuppance for all the financial bad actors, fraudsters, and paragons of greed, only to be brought up short by what that might actually mean. "You just bet against the American economy," Pitt's elder statesman reminds his callow protégés after they begin prematurely celebrating their bet. "Which means, if we're right . . . if we're right, people lose homes. People lose jobs. People lose retirement savings. People lose pensions."

The Big Short (which was nominated for five Oscars, including a win for McKay and Charles Randolph for Best Adapted Screenplay) is a movie that watches as a wave builds and builds and builds, with bear-market outsiders riding their hunch that the real estate frenzy is constructed on a rotting foundation. At the precise moment when we anticipate maximal schadenfreude, McKay yanks the rug out from underneath our glee. Working for the first time with cinematographer Barry Ackroyd, McKay shifted away from carefully framing his performers, comedy-style, and let the camera roam free. A montage of tent cities and crying stockbrokers sets the

mood, and while our protagonists all become unfathomably rich, they do so at the expense of having been correct about the collapse of the American economy. Carell, ornery and indomitable when fighting his lonely fight as investor Mark Baum, now stands alone in his rooftop aerie, despondent at what is occurring in the streets below. Success comes bearing the taste of ashes.

With his air of unearned, grandiose self-mythologizing, and his propensity for mangling the English language, Ron Burgundy had been a kind of bargain-basement George W. Bush. *Talladega Nights* had similarly recast the know-nothing assurances of the Bush era for the world of NASCAR, so it was not entirely surprising when McKay's next project was a biopic of Bush's vice president, Dick Cheney. This story of an autocrat's rise to power plays with the looseness and verve of a comedy. "The following is a true story," the opening title card reads. "Or as true as it can be given that Dick Cheney is known as one of the most secretive leaders in history. But we did our fucking best." (It said something about the stress of making a film about a man who had famously received a heart transplant that McKay went into cardiac arrest during the making of the film.)

Vice (2018)—the title a reminder of the seven deadly sins, in addition to a part of Cheney's most prominent title—plays like a comedy dancing on the lip of unimaginable darkness, with its petty sycophants and stolid bureaucrats causing a chaos so vast that the film can only take it in at its margins. We catch brief glimpses of Abu Ghraib torture as Cheney (Christian Bale, nearly unrecognizable under copious makeup and without hair) snacks on a flaky pastry, or the image of a single foot shaking nervously as bombs rain down on Iraq. Carell returns to play Cheney's onetime mentor and later rival Donald Rumsfeld, who provides a nervous congres-

sional intern with his first lessons in Washington hardball. "KEEP YOUR MOUTH SHUT," Rumsfeld tells him, the words dancing across the screen in unison with his dialogue. "DO AS YOU'RE TOLD. BE LOYAL."

Vice (nominated for eight Oscars, including Best Picture) has a sneaky sense of humor that emerges at unexpected moments. To demonstrate the film's argument that the vice president had the ability to make the extreme sound palatable, Cheney suggests in one scene that everyone put miniature wigs atop their penises and jerk each other off on the White House lawn, and Henry Kissinger notes that he has always liked a good puppet show.

Partway through the film, Cheney's daughter Mary comes out to her parents in the 1990s, and Dick responds with unexpected grace. The valedictory music swells; a closing crawl informs us that Dick and his wife, Lynne, live in Virginia and breed golden retrievers; and the credits roll. Then we hear the phone ring and the credits cut out. The ending was a fake-out, and the story is not over yet. It is George W. Bush, offering Cheney the slot as his running mate for the 2000 election. The entire story, including the Cheneys' relationship with Mary, is about to go in another direction.

Not unlike *The Big Short*, *Vice* is invested in getting us to care about a fundamentally unsexy subject and is more than happy to draw from its arsenal of narrative surprises. *Vice* regularly offers puzzles to solve and historical jokes and fake-outs and slapstick comedy. Cheney and his minions go to a restaurant where they are read an unusual bill of specials, including the Enemy Combatant, Extraordinary Rendition ("Oh, that sounds delicious," enthuses Rumsfeld), and Guantánamo Bay. "We'll have 'em all," Cheney orders with a gruff nod of his head. The film's narrator (Jesse Plemons) is ingeniously revealed to be the donor for Cheney's heart transplant.

McKay is clearly horrified by Cheney and the trails of disasters he leaves in his wake but grants him the final word, with Bale turning to address the camera directly: "I will not apologize for doing what needed to be done so that your loved ones can sleep peaceably at night. It has been my honor to be your servant. You chose me. And I did what you asked." McKay is turning the film around on us in these final moments. Who has Dick Cheney ever been but our servant?

Don't Look Up starts with the sound of a wheezing teakettle, its wailing growing louder and more urgent with each passing second, a sonic irritant we have no ability to control. The hot water belongs to Kate Dibiasky (Jennifer Lawrence), a doctoral student in astrophysics on evening duty to watch the skies. A quote from British comedian Bob Monkhouse appears on the screen: "I want to die peacefully in my sleep like my grandfather, not screaming in terror like his passengers." In the first ten minutes of *Don't Look Up*, a climate-change fable filtered through MAGA politics, media irresponsibility, and scientific illiteracy, we are given a brisk summary of the film's changing moods: interstellar awe to raging anxiety to antic black comedy.

Everywhere Kate and her mentor Randall Mindy (Leonardo DiCaprio) turn in their effort to educate the public about the potentially life-ending comet hurtling toward Earth, from the White House to the news media, they come face-to-face with an American public fatally addicted to sugary fluff and profoundly uninterested in reality. "Keep it light, fun," a segment producer tells them before they prepare to inform the audience of a *Morning Joe*–esque news show about the imminent destruction of the planet. "Jack and Brie love having a good time." Kate loses her composure during the live broadcast, turning on the smiley-face anchors (Cate Blanchett

and Tyler Perry): "Maybe the destruction of the entire planet isn't supposed to be fun. Maybe it's supposed to be terrifying . . . when we're all one hundred percent for sure going to fucking die." Kate's new-media reporter boyfriend's story on the brouhaha is helpfully titled "You Know The Crazy Chick Who Thinks We're All Going To Die? I actually slept with her."

Like its predecessors, *Don't Look Up* (the third consecutive McKay film to be nominated for Best Picture) is a cry of rage partially disguised as a comedy routine. With the notable exception of Kate, who remains furiously unmoved by the collective desire to soft-pedal the end of the Earth, the world of *Don't Look Up* is almost entirely composed of mindless ideologues, shameless liars, petty entertainers, and mendicants before the awesome power of the political/cultural complex. With so little attention devoted to the massive questions of climate change and teetering democracy, McKay is to be lauded for his effort to tell this story. While it is not precisely a comedy, it preserves the tone and style of a comedy—its heightened action, its exaggerated characters, its echoing dialogue— to tell a profoundly unfunny story.

Art is the provision of imaginary solutions to real problems, and *Don't Look Up* offers no solution to the crisis of climate change—or the crisis of American democracy—other than decency and truth. Other global powers' efforts to destroy the comet fail. The tech-company-assisted effort to break the comet into profitable bits is a disaster. Even the dead-end MAGA types finally turn on their leader and pelt the president's son with bottles after spotting the comet, a moment of profound cynicism that still plays as timid when faced with the millions of Americans in 2021 perfectly content to tune out reality in favor of a preferred fantasy.

Kate and Randall arrive back at the home of his family, from

which he has grown estranged. He turns off the television, with its breathless reports of impending calamity, to enjoy one last meal with his wife and sons. In the film's loveliest moment, they go around the table to discuss what they feel thankful for. "I'm grateful," Kate responds, her voice trembling, "I'm grateful we tried." "We really did have everything, didn't we?" marvels Randall, and the impromptu party carries on until the moment the walls blow apart.

Coda

LAUGHTER WILL SOLVE precisely none of our problems, personal and collective. But if there is any salve for our pain and our grief that genuinely works, that lifts us out of our melancholy and provides us with brief snatches of bliss, it is comedy. Comedy has the capacity to *force* us to forget our troubles for a moment and be reminded of life's pleasures, of our collective, infinite capacity for foolishness and stupidity, and to take comfort in our idiocy. It is the closest thing to ecstasy on offer while clothed. And in the face of our collective struggles, I will fight anyone who seeks to stomp on comedy, to make it small or treat it as irrelevant or foolish. Comedy gave me life more times than I can count over the two COVID years, and I suspect it has done the same for you, too. Take that, motherfucking *Braveheart*.

Everywhere we look, we can catch glimpses of *Anchorman*'s impact and the ways in which its ideas and concerns have bled into the world.

☆

Matt Lauer. Charlie Rose. Mark Halperin. Les Moonves. The impact of the #MeToo movement was disproportionately felt in the worlds of journalism and television, a joint product of the television industry's liberal leanings and an unconscious desire to atone for the ways in which television had boosted Donald Trump—another television star and accused sexual predator—to the presidency. #MeToo changed the way we saw *Anchorman,* putting Ron Burgundy in conversation with current events in a fashion that audiences might not have anticipated in 2004. But what was surprising was that the film was already waiting for us once the news about Lauer or Rose broke, documenting—in deliberately exaggerated fashion—that it had already known about the malefactors in television journalism. Ron Burgundy was ludicrous where those others were malevolent, but *Anchorman'*s careful attention to masculine misbehavior, and its effects on women in the workplace, documented its abiding interest in what happened when men were given leave to mistreat their female colleagues.

Perhaps the only detail of *Anchorman* that felt harder to swallow, in light of #MeToo, was the film's tidy ending. Would Veronica choose to reunite with Ron after all she had endured from him? The film gestures at its about-face by having Veronica observe that there are probably thousands of men she should be with instead of Ron, but #MeToo made that number seem like a profound undercount. The happy reunion rings hollow now, coming after Ron's campaign of harassment. *Anchorman* knew all along that Ron's behavior was intolerable, but the passage of time made it harder to sidestep or forget.

Coda

★

VERONICA CORNINGSTONE'S DREAM is now commonplace. Once a stronghold of male dominance, the ranks of local-news anchors have become far more hospitable to women over the past half century. When Will Ferrell went to North Dakota in the guise of Ron Burgundy in 2013, the anchor he bantered with on the air, Amber Schatz, was a woman. The likes of Katie Couric, Elizabeth Vargas, Diane Sawyer, and Norah O'Donnell have all anchored nightly network-news broadcasts in recent years, occupying the chairs once filled by the likes of Walter Cronkite, Peter Jennings, and Tom Brokaw. At the same time, network news—the source of Veronica's deepest ambitions—has drastically shrunk in influence, and audience size, since the 1970s. How many Americans today can name the anchors of all three network broadcasts?

And yet, Veronica's desire to place her stamp on the world via the medium of television has been underscored by the omnipresence of cable news and its profound (and often pernicious) impact on contemporary American politics. One can imagine Veronica succeeding in the breathless environment of today's CNN or MSNBC—or even, if she felt ideologically flexible enough, Fox News. Cable news has become a haven for female voices, ranging across the political spectrum from Rachel Maddow to Christiane Amanpour to Jeanine Pirro. Veronica's ambitions helped pave the way for a television-news landscape that, while not yet a haven of gender equality, is nonetheless far less inhospitable to women's voices than it was in the 1970s. *Anchorman* is a helpful reminder that each time we see a female face reading the news on our televisions, it might be worth considering the sheer effort it took to get there.

★

We watch movies, and movies watch us, and with each new viewing, great movies tell us something different about ourselves. In its eagle-eyed depiction of hubris and combativeness, of the powerful and the insecure brought low by their own resistance to change, of ugly and cruel sentiments dredged up by threats to unchecked authority, *Anchorman* feels less like an elaborate, over-the-top comedy and more like a psychic exploration of the American mind of the past half decade.

Comedy, like democracy, is about coming together, in a cast or an audience or a nation, to create something bigger and smarter and better than we ever could have managed on our own. But what happens when comedy is wielded by malevolent forces that seek to tear us apart?

In June 2021, *The New York Times* published a forty-minute video investigation of the storming of the Capitol on January 6, 2021. The camera pans across protesters with Trump paraphernalia as the news spreads that the Capitol has been breached, and an impassioned male voice shouts, "You guys, they're storming on the other side. Let's go!"

Before he has even finished getting out the words, another voice is heard, undercutting the authority and urgency of the first voice. "We're going streaking!" this other voice bellows, with the sound of snickers muffling the end of his declaration.

Old School is not *Anchorman*, and Frank the Tank, who utters those words as he attempts to lead partiers to take off their clothes and run naked through the streets, is not Ron Burgundy. But it stunned me to hear someone, in this moment of maximal national

chaos and horror, yank out their binder of Will Ferrell quotes from the early 2000s. "We're going streaking!" meant that whoever was shouting it saw the storming of the Capitol as a heroic jape, an instantly iconic act of comedic rebellion.

All of which leads to the story of FBI suspect number 247. In the aftermath of the storming of the Capitol, people studied the FBI photos of the man with the distinguished-looking gray hair, the gaiter-style mask, and the green leather jacket. They jokingly posted links to Jay Johnston's IMDb page, suggesting that suspect number 247 bore a marked resemblance to the acclaimed comedian. But the joke curdled when it turned out that the comedian who had played Wes Mantooth's lieutenant had actually been part of the Capitol mob.

I could not stop thinking about Johnston, a man I did not know, and after a time, his face began to merge with the unseen face of the voice shouting, "We're going streaking!" in the *New York Times* video.

The horror of January 6 stemmed from the creeping belief that, for many of the participants in the chaos at the Capitol, sedition could be a hoot. If movies like *Old School* and *Anchorman* are about the antics of disaffected men finding comfort in the company of like-minded allies, January 6 was like the nightmarish inversion of those stories, with the presence of Johnston and the unidentified *Old School* fan serving as confirmation. None of which is to find any fault with *Anchorman* itself, or to lay any of the blame for the state of American society at its feet. But people who love these very comedies—people who helped make these comedies!—saw fit to participate in actions that put our democracy at risk.

Comedy is, at heart, the democratic spirit in action. It stipulates

that everyone is equal, if only in their capacity for foolishness, and that everyone is invited to participate in the work. If we want to protect comedy, we must protect democracy.

PRACTICALLY EVERY TIME he was with his friends, drinking or smoking or just hanging out, it was on. Everywhere he went in Bayonne, New Jersey, in the summer of 2010, there was Ron Burgundy again, and Lou Schiavello and his friends would spend their time bantering and trading quotes from *Anchorman,* which became a familiar and trusted friend. Someone had burned a DVD copy of the movie, and it was traded around like a precious amulet, shared and shared again as a source of pleasure and escape.

A few years later, Lou was going through a rough breakup and had retreated into drinking and drugs to treat his depression. *Anchorman* was there again, too, a trusted confidant who would always make him laugh, no matter how hopeless everything else might have felt. Lou was consumed by heartache, and he began to wonder how others managed to trudge through their days. What were they thinking about as they sat in rush-hour traffic or during the few seconds of enforced stillness at a red light?

The first time, he tried it freehand, and almost got caught. Lou was a talented artist, but he could not get it up fast enough. The next time, he used a stencil, cutting out an image of Ron Burgundy's face and using spray paint to affix the image to walls. The whole process took no more than twenty seconds. He began at the southern tip of Bayonne's three-mile-long peninsula, skateboarding from spot to spot and applying images of Ron everywhere, from First Street to Sixty-Third Street, on walls, bus stops, and train

stations. When Bayonne was thoroughly covered, Schiavello crossed the border into Jersey City and began decorating New Jersey's second-largest city with Ron Burgundys. After a time, he added some additional artistic flourishes, including splashes of color that gave his *Anchorman* tributes the feel of an Andy Warhol portrait.

Anchorman felt like a secret shared among initiates, and Schiavello wanted his street art to speak to the other diehards. He eschewed tags that would give away the game too easily; no "Stay Classy, Bayonne" for him. Instead, his Ron Burgundy portraits featured advanced-level *Anchorman* quotes like "The Human Torch was denied a bank loan" or just a single word: *lanolin*.

One summer morning in 2013, he was picked up at his house by the Bayonne police and spent eight hours riding around with them in search of all the spots he had tagged. Schiavello, depressed and struggling with substance abuse, could not remember every place he had been. Each time he would think he was done, the police found another spot, and they would come back and arrest him again. He was eventually charged with twenty-three counts of criminal mischief, with the Bayonne police, who had announced a zero-tolerance policy regarding graffiti, treating Schiavello as public enemy number one. Everywhere he went, he had to worry that he would be arrested again, paraded around the city and asked to locate more spots he had tagged.

Schiavello wound up spending eight days in jail for his graffiti work because he could not make bail. He was sentenced to three hundred hours of community service and forced to pay $5,000 in restitution. His paints and materials were taken away. The faces of Ron Burgundy were scrubbed from the streets of New Jersey.

This is a story about police overreach and a sad, troubled young man finding solace in comedy, but it is also about the exact thing

Lou Schiavello had hoped for when he first skateboarded the streets of Bayonne, spray paint in hand: human connection. The official Facebook page for *Anchorman* shared a story about Schiavello, with Ron Burgundy (or his social media doppelgänger) commenting: "Yes, he's a vandal but he's a vandal with fantastic taste."

Hundreds of people wrote in to comment on his story. "I will gladly donate money to this guy for either bail, or more paint," wrote one person. Many were prompted to quote *Anchorman* in his honor, including one commenter purporting to be the mayor of Bayonne: "I'm not even mad. That's amazing." Schiavello had imagined providing a small service to the residents of Bayonne, who might be able to orient themselves by suggesting to a friend that they meet by the Ron Burgundy on Thirty-Fifth Street.

The Bayonne Ron Burgundys are all gone now—or so the Bayonne Police Department thinks. But if you head to the corner of Avenue A and Thirty-First Street and glance down at the base of a small cinder-block wall next to a garage—well, let's just say that you may be amazed, too.

We turn to comedy to temporarily escape our troubles, to find community in the presence of others also seeking to momentarily set down their burdens and take pleasure in laughter. In the face of so much that seeks to tear us apart, we can still, like Lou Schiavello, look to comedy to find solace and communion. May comedy be a source of our future strength, giving us the courage to face our failings, chuckle at them, and imagine better. Here's hoping we find more ways to make each other laugh.

Acknowledgments

THIS BOOK BEGAN with my course Writing About American Comedy, which I have taught at NYU's Gallatin School of Individualized Study for the past seven years. My overwhelming thanks to all the students who have embraced the absurd and watched Ron Burgundy cannonball with me. Teaching has been one of the great unexpected pleasures of my life, and I am so thankful for every one of the students who have shown up in my class, excited to talk about comedy.

My students Aliya Jones, Xandi McMahon, and Julia Sachi Mates did remarkable work with interview transcriptions and research for the book, and I am immensely appreciative of all their efforts.

I am deeply grateful to everyone who spoke to me for my book, including Thomas Ackerman, Jeremy Alter, Richard Anderson, Mike Avery, Rick Avery, Maggie Baird, Matt Besser, Katisse Buckingham, Elizabeth Cantillon, Cindy Caponera, Blythe Cappello, Darcy Donavan, Michael Everett, Ali Farahnakian, Matthew Ferreira, Will Ferrell, Neil Flynn, Linda Gacsko, Harry Garvin,

Mark Graziano, Kim Greene, Charna Halpern, Jack Helbig, Alex Hillkurtz, Norm Hiscock, David Jahn, Roy Jenkins, Shawn Kerkhoff, David Koechner, Laura Krafft, Bill Kurtis, Jason Lautenschleger, Steve Lee, Kelly Leonard, Susan Lipson, Mark Mangini, Joe Mastrolia, Patrick McCartney, Debra McGuire, Adam McKay, Barry McLaughlin, Drew McWeeny, Jerry Minor, Lloyd Moriarity, Michael Nathanson, Darin Necessary, Holmes Osborne, Jan Pascale, June Diane Raphael, Amy Rhodes, Ian Roberts, Lou Schiavello, John Srednicki, Harper Steele, Kristen Sych, Ashley Theis, Fulvio Valsangiacomo, Craig Wedren, Brent White, Jim Wise, Alex Wurman, and Joy Zapata.

Debra McGuire invited me to tour her archive of costumes and drawings from the film at her home in Rhode Island. Tom Ackerman tracked down original documents from the shoot. David Koechner answered all my questions about *Anchorman* alts and everything else. Will Ferrell and Adam McKay graciously took time out of their schedules to answer my many absurdly detailed questions, of which I am overwhelmingly appreciative.

Thank you to Genevieve Maxwell at the Academy of Motion Picture Arts and Sciences for her research assistance.

I want to thank my friends and family for their support and companionship: Jeff Abergel, Annie Austerlitz, Jeremy Blank, Mark Fenig, Joanne Gentile, Alison Hammer, Marina Hirsch, Ari Holtzblatt, Charlie Jackson, Greg Jackson, Jesse Kellerman, Mo Lawrence, Helane Naiman, Josh Olken, Amy Plattsmier, Sarah Rose, Ali Rosen, Herbie Rosen, Lily Rosen, Rosie Rosen, Alex Schmidt, Eli Segal, Josh Seiden, Zack Seiden, Abby Silber, Carla Silber, Dan Silber, Reuben Silberman, Dan Smokler, Marc Tannen, Olia Toporovsky, Ari Vanderwalde, Adi Weinberg, Zev Wexler, and Aaron Zamost.

Huge thanks to the Is This Anything? crew for their editing advice and writerly camaraderie: Jennifer Keishin Armstrong, Erin Carlson, Thea Glassman, and Kirthana Ramisetti.

Thank you to the Brooklyn Resisters, for whom I am more grateful than I can fully say. Thank you for standing together with me in "the spaciousness of uncertainty."

My agent, Laurie Abkemeier, has changed my career for the better, and I am overwhelmingly grateful for her support and her wisdom. Jill Schwartzman has been an oasis of calm and brilliantly understated guidance, and I feel so lucky to have had the opportunity to work on two books together with her. I would also like to thank Charlotte Peters for all the care and attention she devoted to this project, and production editor Alice Dalrymple for her sterling oversight. Huge thanks to Aja Pollock and Amanda Walker for their thoughtful reads of the manuscript, which immeasurably improved the book.

My parents are only modestly aware of the existence of the movie *Anchorman*, but their unblinking support for my movie love goes all the way back to my father's heading to the bookstore to buy me a copy of the *Pulp Fiction* screenplay when I was sixteen. I am eternally appreciative of everything they did to make me the person I am.

My deepest love to Nate and Gabriel, my boon movie companions from 2020 forward. How many other ten- and six-year-olds love Harold Lloyd and Charlie Chaplin? My work here is done. I cannot wait to see what amazing things they do next.

My wife, Becky Silber, has always been my first and best reader. I could never have written this book without her love and support. I love her more than words could ever say.

☆

Source Notes

INTRODUCTION

Anchorman: The Legend of Ron Burgundy (Unrated), directed by Adam
 McKay (Hollywood, CA: Paramount, 2004).
Anchorman: The Legend of Ron Burgundy (The "Rich Mahogany" Edition),
 directed by Adam McKay (Hollywood, CA: Paramount,
 2010).

CHAPTER 1

Interviews with Maggie Baird, Matt Besser, Ali Farahnakian, Will Ferrell,
 Neil Flynn, Charna Halpern, Jack Helbig, David Jahn, David
 Koechner, Patrick McCartney, Adam McKay, Ian Roberts, Harper
 Steele, and Jim Wise, conducted by the author.
Judd Apatow, *Sicker in the Head: More Conversations About Life and Comedy*
 (New York: Random House, 2022).
Emma Brown, "Class Clown," *Interview*, December 18, 2013.
Mark Caro, "*Anchorman 2*: The Chicago Roots of Adam McKay," *Chicago
 Tribune*, December 6, 2013.
Richard Deitsch, "Q+A Will Ferrell," *Sports Illustrated*, May 16, 2005.
Lynn Hirschberg, "A Wild and Uncrazy Guy," *The New York Times
 Magazine*, November 12, 2006.

Connor Kilpatrick, "Adam McKay Is Mad as Hell," *Jacobin*, November 26, 2019.

Adam McKay, "What It's Like to Write for *SNL*," *Rolling Stone*, February 13, 2015.

Marc Peyser, "Comedian in Chief," *Newsweek*, February 18, 2001.

Scott Raab, "Will Ferrell," *Esquire*, December 1, 2003.

Jim Rutenberg, "Live, from New York, It's George Bush!; He's Victoriant! Will Ferrell's New Four-Year Gig as the 43rd President," *The New York Times*, January 25, 2001.

Mike Sacks, *Poking a Dead Frog: Conversations with Today's Top Comedy Writers* (New York: Penguin Books, 2014).

Tom Shales and James Andrew Miller, *Live from New York: An Uncensored History of* Saturday Night Live, (New York: Little, Brown and Company, 2002).

Staff, "Fast Chat: Where There's a Will, There's a Way To," *Newsweek*, February 23, 2003.

Staff, "The Art of Idiocy," *Newsweek*, July 11, 2004.

Tracy Swartz, "Adam McKay Talks Faking Suicide in a '90s Chicago Performance," *Chicago Tribune*, December 10, 2015.

David Wild, "Looking for the Heart of *Saturday Night Live*," *Rolling Stone*, November 27, 1997.

CHAPTER 2

Interviews with Elizabeth Cantillon, Will Ferrell, Laura Krafft, Adam McKay, Drew McWeeny, Jerry Minor, Michael Nathanson, and Jan Pascale, conducted by the author.

Roger Ebert, "Elf," RogerEbert.com, November 7, 2003.

"Elf," *The Movies That Made Us*, Netflix, 2021.

Lynn Hirschberg, "A Wild and Uncrazy Guy," *The New York Times Magazine*, November 12, 2006.

Drew McWeeny, "Moriarty Reviews *Hell House, Biggie & Tupac*, and *Interview with the Assassin*! Plus Two Script Reviews!," *Ain't It Cool News*, 2003.

Bill Simmons, "Will Ferrell on the Bizarre Path *Anchorman* Took to the Box Office," *The Ringer*, June 16, 2017.

CHAPTER 3

Interviews with Thomas Ackerman, Jeremy Alter, Will Ferrell, Kim
Greene, Alex Hillkurtz, David Koechner, Joseph Mastrolia, Debra
McGuire, Adam McKay, Jan Pascale, and Joy Zapata, conducted by the
author.
Anchorman: The Legend of Ron Burgundy (The "Rich Mahogany" Edition),
directed by Adam McKay (Hollywood, CA: Paramount, 2010).
Staff, "Q&A: Director Adam McKay Talks *Anchorman 2*, Casting
Memories & Kanye," *Baller Status*, December 10, 2013.

CHAPTER 4

Interview with Bill Kurtis and Adam McKay, conducted by the author.
J. Freedom du Lac, "'Skyrockets in Flight/Afternoon Delight': The Story
Behind Starland Vocal Band's One Big Hit," *The Washington Post*, July
10, 2018.
Ron Powers, *The Newscasters: The News Business as Show Business* (New
York: St. Martin's Press, 1977).
Scott Raab, "Will Ferrell," *Esquire*, December 1, 2003.
The Starland Vocal Band Show, aired July 31–September 4, 1977, on CBS.

CHAPTER 5

Interviews with Thomas Ackerman, Jeremy Alter, Will Ferrell, Linda
Gacsko, Harry Garvin, Kim Greene, David Koechner, Debra
McGuire, Adam McKay, Lloyd Moriarity, Holmes Osborne, and Joy
Zapata, conducted by the author.
Anchorman: The Legend of Ron Burgundy (Unrated), directed by Adam
McKay (Hollywood, CA: Paramount, 2004).
Anchorman: The Legend of Ron Burgundy (The "Rich Mahogany" Edition),
directed by Adam McKay (Hollywood, CA: Paramount, 2010).
Drew McWeeny, "Moriarty's Set Visit! Will Ferrell's *Anchorman*!!," *Ain't It
Cool News*, 2003.
Richard Rys, "Exit Interview: Adam McKay," *Philadelphia*,
June 1, 2005.

CHAPTER 6

Gail Collins, *When Everything Changed: The Amazing Journey of American Women From 1960 to the Present* (New York: Little, Brown and Company, 2009).

Alanna Nash, *Golden Girl: The Story of Jessica Savitch* (New York: E. P. Dutton & Co., 1988).

CHAPTER 7

Interview with Thomas Ackerman, Jeremy Alter, Rick Avery, Will Ferrell, Linda Gacsko, Harry Garvin, David Koechner, Joseph Mastrolia, Debra McGuire, Adam McKay, Drew McWeeny, Lloyd Moriarity, and Craig Wedren, conducted by the author.

Anchorman: The Legend of Ron Burgundy (Unrated), directed by Adam McKay (Hollywood, CA: Paramount, 2004).

Anchorman: The Legend of Ron Burgundy (The "Rich Mahogany" Edition), directed by Adam McKay (Hollywood, CA: Paramount, 2010).

Jennifer Vineyard, "Uh-oh! Here Comes Trouble: The Oral History of *Anchorman*'s Battle Scene," *Vulture*, December 17, 2013.

CHAPTER 8

Anchorman: The Legend of Ron Burgundy (Unrated), directed by Adam McKay (Hollywood, CA: Paramount, 2004).

Anchorman: The Legend of Ron Burgundy (The "Rich Mahogany" Edition), directed by Adam McKay (Hollywood, CA: Paramount, 2010).

Emily Nussbaum, "That Mind-Bending Phone Call on Last Night's *Breaking Bad*," *The New Yorker*, September 16, 2013.

Staff, "The Art of Idiocy," *Newsweek*, July 12, 2004.

CHAPTER 9

Interviews with Katisse Buckingham, Mark Graziano, Kim Greene, David Koechner, Bill Kurtis, Mark Mangini, Debra McGuire, Adam McKay,

Kristen Sych, Brent White, and Alex Wurman, conducted by the author.

Anchorman: The Legend of Ron Burgundy (Unrated), directed by Adam McKay (Hollywood, CA: Paramount, 2004).

Anchorman: The Legend of Ron Burgundy (The "Rich Mahogany" Edition), directed by Adam McKay (Hollywood, CA: Paramount, 2010).

CHAPTER 10

Interviews with Will Ferrell and Adam McKay, conducted by the author.

Anchorman: The Legend of Ron Burgundy (Unrated), directed by Adam McKay (Hollywood, CA: Paramount, 2004).

Harold Bloom, *Shakespeare: The Invention of the Human* (New York: Riverhead, 1998).

Roger Ebert, "*Anchorman* Delivers Comedic Goods," RogerEbert.com, July 9, 2004.

Stephen Hunter, "On the Spot News," *The Washington Post*, July 9, 2004.

Brian Lowry, "*Anchorman: The Legend of Ron Burgundy*," *Variety*, June 29, 2004.

Neil Miller, "Will Ferrell and the 'Funny or Die' Crew Rock Columbus!," *Film School Rejects*, February 9, 2008.

Chris Plante, "Why *Anchorman*'s 'That Escalated Quickly' Escalated Quickly," *Verge*, April 21, 2016.

Staff, "Media Mockers," *New York Post*, February 28, 2008.

David Sterritt, "*Anchorman*," *The Christian Science Monitor*, July 9, 2004.

Stephanie Zacharek, "*Anchorman: The Legend of Ron Burgundy*," *Salon*, July 9, 2004.

CHAPTER 11

Interview with David Koechner, conducted by the author.

Scott Feinberg, "'Awards Chatter' Podcast—Kristen Wiig ('Saturday Night Live')," *The Hollywood Reporter*, August 27, 2017.

Christopher Hitchens, "Why Women Aren't Funny," *Vanity Fair*, January 1, 2007.

CHAPTER 12

Max Chafkin, "For Doing Something Serious. (The Funny Stuff Is Great, Too.)," *Inc.*, December 2010/January 2011.

Roger Ebert, "The Feel-Bad Comedy of the Year!," RogerEbert.com, July 23, 2008.

Connor Kilpatrick, "Adam McKay Is Mad as Hell," *Jacobin*, November 26, 2019.

Brian Raftery, "Funny or Die at 10: An Oral History of a Comedy Juggernaut," *Wired*, April 2, 2017.

Alan Siegel, "Unadulterated Joy: An Oral History of *Step Brothers*," *The Ringer*, July 10, 2018.

CHAPTER 13

Interviews with Jason Lautenschleger and Barry McLaughlin, conducted by the author.

Jennifer Arellano, "Ron Burgundy's Dodge Ads: How They Were Made," *Entertainment Weekly*, October 9, 2013.

Ron Burgundy, *Let Me Off the Top! My Classy Life and Other Musings* (New York: Crown Archetype, 2013).

Rob LeDonne, "Will Ferrell Bar Owners: 'It Had to Be Something Really Stupid,'" *The Guardian*, November 9, 2015.

Julia Manchester, "Comey Poses with 'Anchorman' Ron Burgundy," *The Hill*, December 8, 2017.

Michael Woodsmall, "Ron Burgundy's Scotch Is for Sale: We're in a Glass Case of Emotion!," *Thrillist*, November 30, 2013.

CHAPTER 14

Interviews with Will Ferrell, David Koechner, Adam McKay, June Diane Raphael, and Brent White, conducted by the author.

Anchorman 2: The Legend Continues (Super-Sized Version), directed by Adam McKay (Hollywood, CA: Paramount, 2014).

Emma Brown, "Class Clown," *Interview*, December 18, 2013.

Mark Caro, "*Anchorman 2*: The Chicago Roots of Adam McKay," *Chicago Tribune*, December 6, 2013.

Lauren Duca, "If You Watched *A Deadly Adoption*, You Got Tricked into Watching a Regular Old Lifetime Movie," *HuffPost*, June 23, 2015.

David Edelstein, "To Siri with Love," *New York*, December 13, 2013.

Jay A. Fernandez, "*Anchorman* Sequel: A $50 Million Compromise," *The Hollywood Reporter*, April 20, 2012.

Scott Foundas, "Film Review: *Anchorman 2: The Legend Continues*," *Variety*, December 16, 2013.

Joe Hagan, "'Who the Fuck Cares About Adam McKay?' (We Do, and with Good Reason)," *Vanity Fair*, November 29, 2021.

Samantha Ibrahim, "Adam McKay Details 'Terrifying' *Anchorman 2* Accident with Will Ferrell," *New York Post*, December 9, 2021.

Dave Itzkoff, "The Doctor Is in Too Deep: Will Ferrell and Paul Rudd on *The Shrink Next Door*," *The New York Times*, November 10, 2021.

Connor Kilpatrick, "Adam McKay Is Mad as Hell," *Jacobin*, November 26, 2019.

Matt Pais, "Q&A: *Anchorman 2: The Legend Continues* Director/Co-Writer Adam McKay," *Chicago Tribune*, December 16, 2013.

Josh Rottenberg, "*Anchorman 2: The Legend Continues*," *Entertainment Weekly*, August 9, 2013.

A. O. Scott, "Ron Burgundy's Boob Tube Goes 24 Hours a Day," *The New York Times*, December 17, 2013.

Betsy Sharkey, "Review: In *Anchorman 2*, The Classy-or-Not Gags Continue," *Los Angeles Times*, December 17, 2013.

Matt Singer, "*Anchorman 2: The Legend Continues*," *Dissolve*, December 16, 2013.

Kyle Smith, "*Anchorman 2: The Legend Continues* . . . But the Laughs Don't," *New York Post*, December 17, 2013.

Steve Weintraub, "Director Adam McKay Talks *Anchorman 2: The Legend Continues*, Musical Numbers, Releasing an Alternate Cut with 240 New Jokes, and Much More," *Collider*, November 25, 2013.

Coda

Interview with Lou Schiavello, conducted by the author.

Dmitriy Khavin, et. al., "Day of Rage: How Trump Supporters Took the U.S. Capitol," *The New York Times*, June 30, 2021.

Anthony J. Machcinski, "Bayonne Man Charged with *Anchorman* Graffiti Throughout City: Police," *The Jersey Journal*, July 25, 2013.

Marlow Stern and Asawin Suebsaeng, "*Bob's Burgers* Actor Jay Johnston Confessed He Was at the Capitol Riot, Says Director," *The Daily Beast*, December 20, 2021.

Index

Index

Index

About the Author

Saul Austerlitz is an adjunct professor of writing and comedy history at New York University and the author of *Generation Friends*, named by *Vulture* as one of the fifteen best books about TV comedies, and *Just a Shot Away*, which *The New York Times Book Review* called "the most blisteringly impassioned music book of the season." He has a BA in film studies from Yale University and an MA in cinema studies from New York University's Tisch School of the Arts.